**IMAGE COMICS, INC.**
**Robert Kirkman** – Chief Operating Officer
**Erik Larsen** – Chief Financial Officer
**Todd McFarlane** – President
**Marc Silvestri** – Chief Executive Officer
**Jim Valentino** – Vice-President

**Eric Stephenson** – Publisher
**Ron Richards** – Director of Business Development
**Jennifer de Guzman** – Director of Trade Book Sales
**Kat Salazar** – Director of PR & Marketing
**Corey Murphy** – Director of Retail Sales
**Jeremy Sullivan** – Director of Digital Sales
**Emilio Bautista** – Sales Assistant
**Branwyn Bigglestone** – Senior Accounts Manager
**Emily Miller** – Accounts Manager
**Jessica Ambriz** – Administrative Assistant
**Tyler Shainline** – Events Coordinator
**David Brothers** – Content Manager
**Jonathan Chan** – Production Manager
**Drew Gill** – Art Director
**Meredith Wallace** – Print Manager
**Monica Garcia** – Senior Production Artist
**Addison Duke** – Production Artist
**Tricia Ramos** – Production Assistant
**IMAGECOMICS.COM**

# punk rock paper scissors

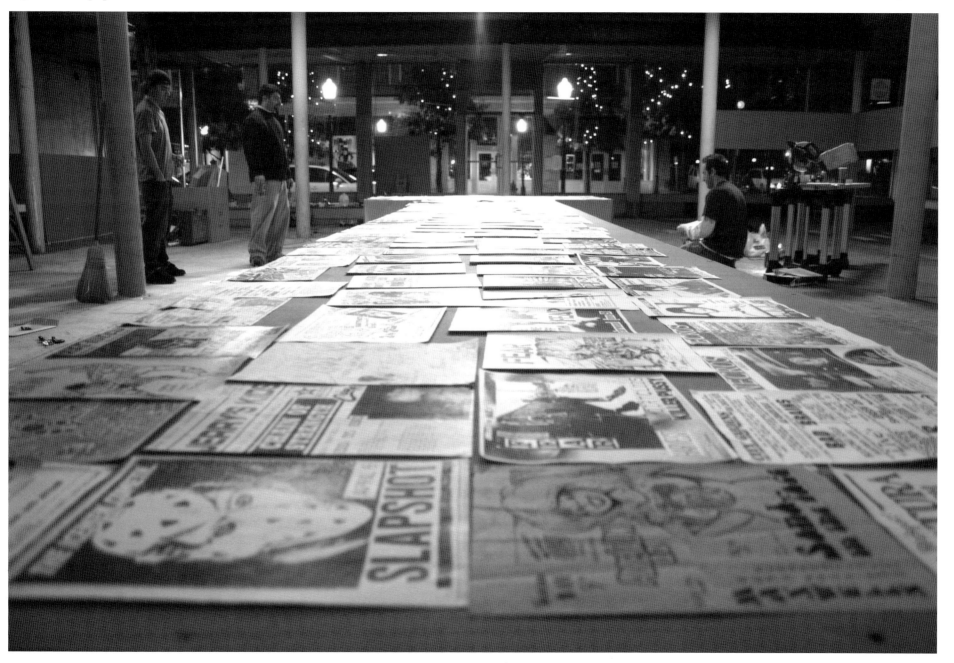

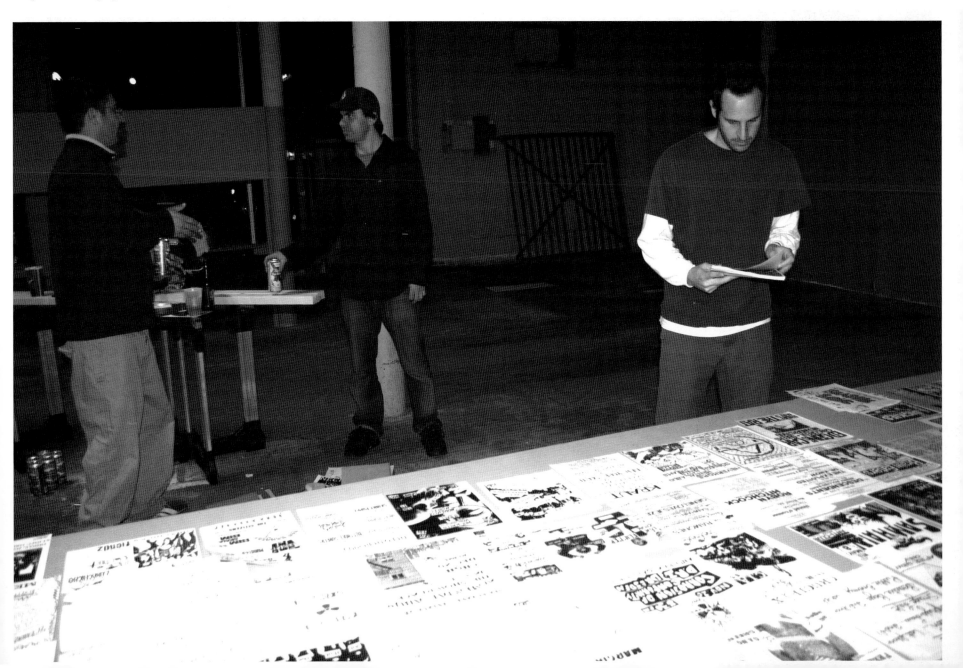

➡️ **If you were any part of the hardcore scene in the 80's, whether in a band, a promoter or a fan, you came across punk rock show flyers. You either made flyers or you plastered your bedroom walls with them. This book is a tribute to those flyers. There were no computers used back then to create them; they were penned, cut, taped, glued and posted on walls, telephone poles, car windshields or merely handed to you at a show.**

**We all collected flyers throughout the years and for some reason couldn't part with them. I knew I always wanted to do something productive down the line with them. So I decided to pool flyers of mine along with Danny, Art, Joe, Kevin, Greg and batting clean-up, Dave Schwartzman.**

**There is no real chronological order to the layout of the book. They fall in the order in which the scene unfolded to us at that time.**

**This book is flyers and flyers only Pure punk rock nostalgia.**

**Enjoy**
**Lee**

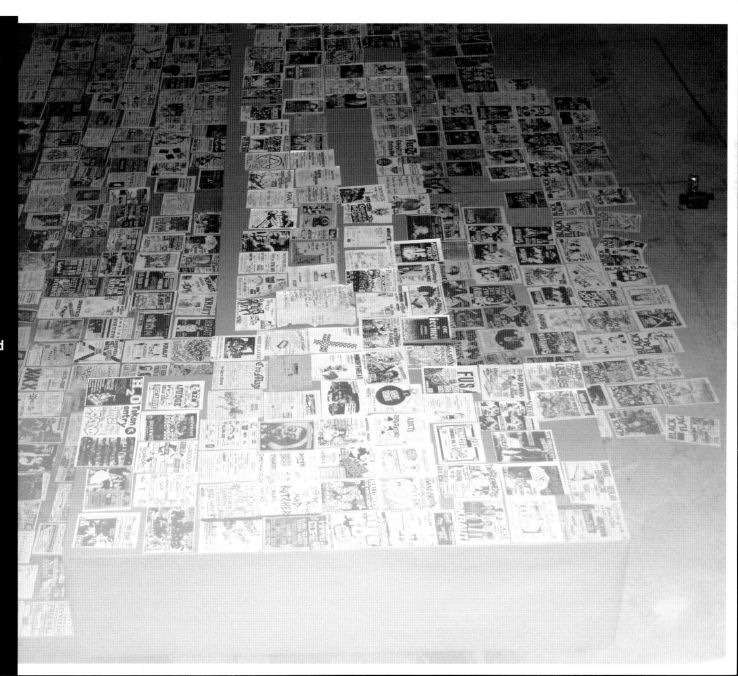

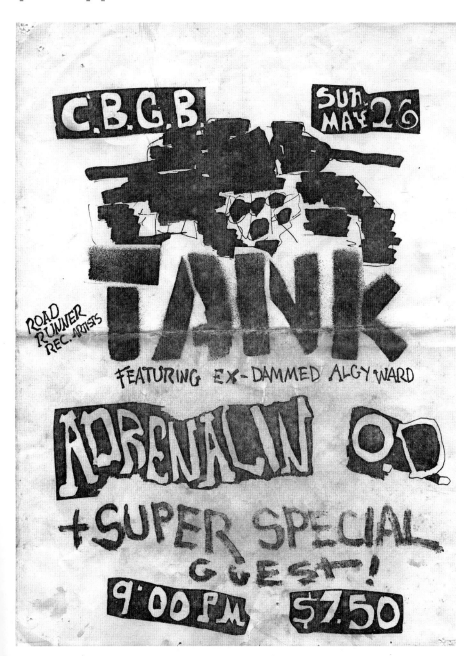

C.B.G.B SUN. MAY 26

TANK

ROAD RUNNER REC. ARTISTS

FEATURING EX-DAMMED ALGY WARD

ADRENALIN O.D.

+SUPER SPECIAL GUEST!

9:00 PM    $7.50

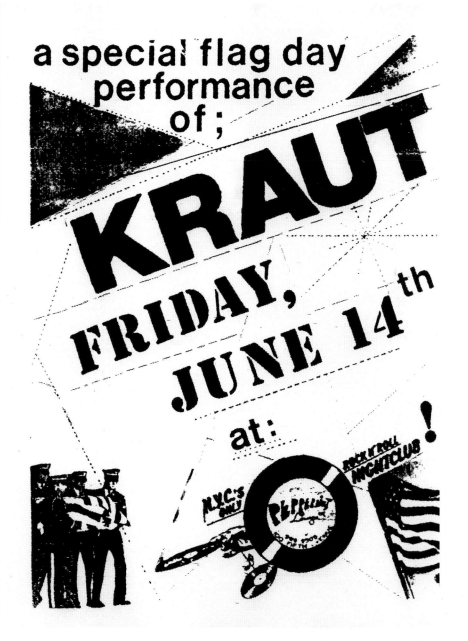

a special flag day performance of;

KRAUT

FRIDAY, JUNE 14th

at:

NYC'S ONLY PEPPERMINT ROCK N ROLL NIGHTCLUB!

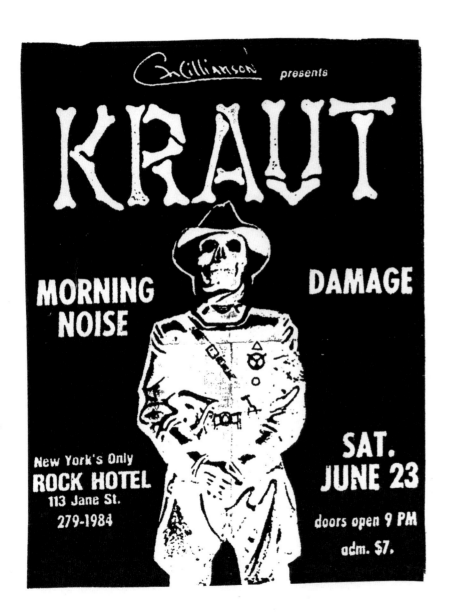

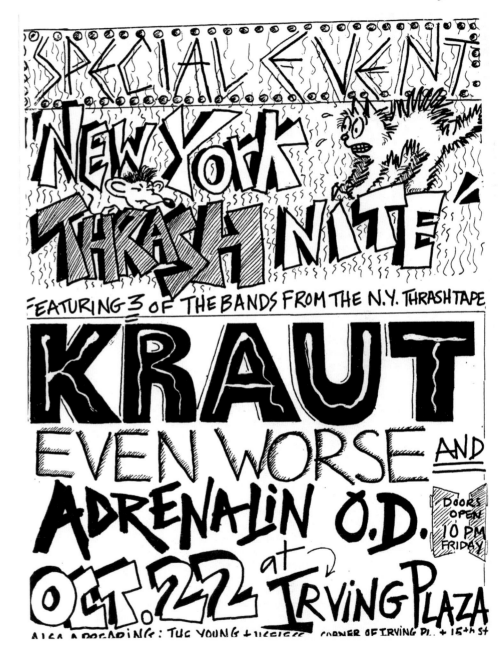

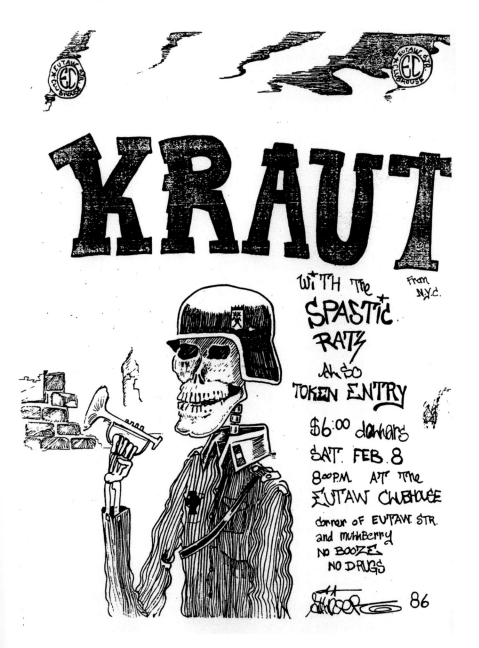

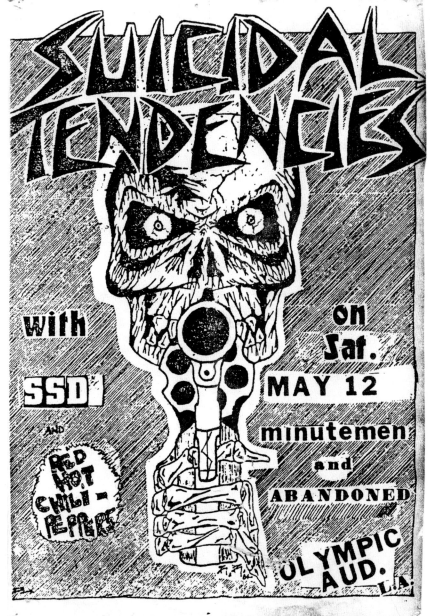

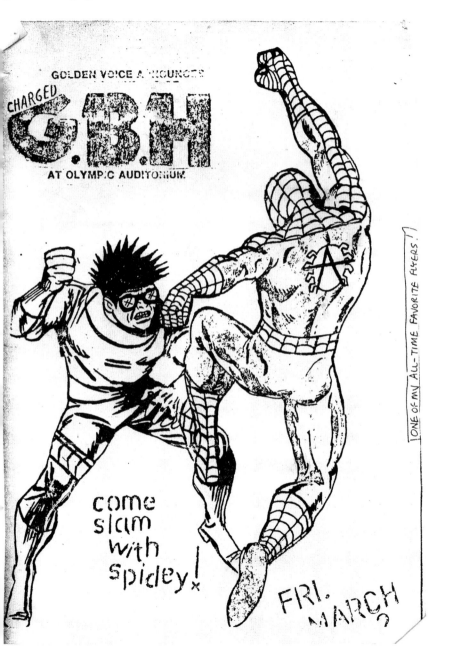

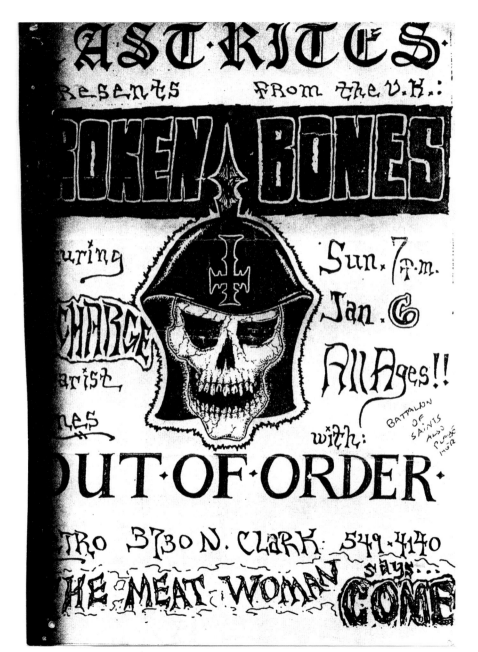

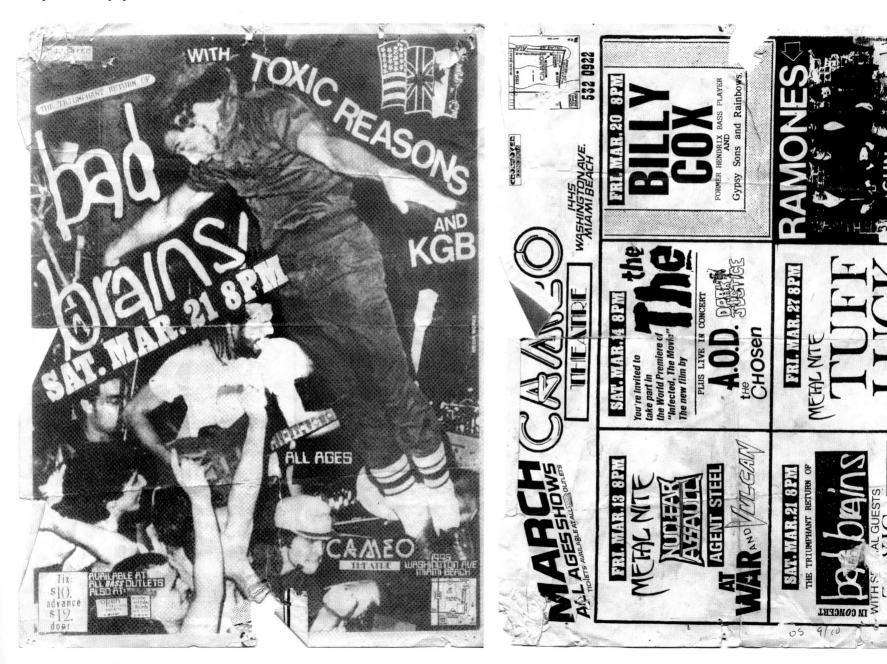

THE OTHER SIDE PRODUCTIONS
PRESENTS AT:
# City Gardens
1701 CALHOUN ST., TRENTON, N.J. 609-392-8887

SAT MAY 21   9PM   $10
# Throwing Muses
### Noise Petals       Plug

SUN MAY 22   6-10PM   $9   NO ALCOHOL
## Adolescents      Token Entry
### Didjits          Black Vomit

SAT JUNE 4   9-MID   $10   NO ALCOHOL
# BAD BRAINS     IGNITION

SUN JuNE 5   6-10PM   $8.50   NO ALCOHOL
# MDC     LUDICHRIST
### Witnesses      Trained attack dogs

FRI JUNE 10   9PM   $8.50   18 & UP / 21 - LOUNGE
# GWAR     She Males

SAT JUNE 11   9PM   $6   18 & UP / 21 - LOUNGE
## Miracle Legion
### Rettmans      Chucks!

```
COMING UP:
FRI JUNE 17 - REGGAE SUNSPLASH '88 WITH:
      YELLOWMAN & TOOTS AND THE MAYTALS PLUS 4 MORE ACTS!
      ADV TIXS $15.50   DAY OF SHOW $17   THIS IS A FIVE HOUR SHOW!
SAT JUNE 18 - CAMPER VAN BEETHOVEN & ROYAL CRESCENT MOB
FRI JUNE 24 OR SAT JUNE 25 - SOUL ASLYUM & LIVING COLOUR
      (WE WILL FIND OUT THE EXACT DATE NEXT WEEK)
SUN JUNE 26 - BROKEN BONES & U.K. SUBS
SAT JULY 9 - THIRD WORLD
SUN JULY 10 - THE MEAT PUPPETS
SAT JULY 16 - VOI VOD / TESTAMENT / VOOLENCE
SUN JULY 17 - RED KROSS / H. ROLLINS BAND
SAT JULY 23 - JIMMY CLIFF  /  SUN JULY 24 - CIRCLE JERKS / 7 SECONDS
```

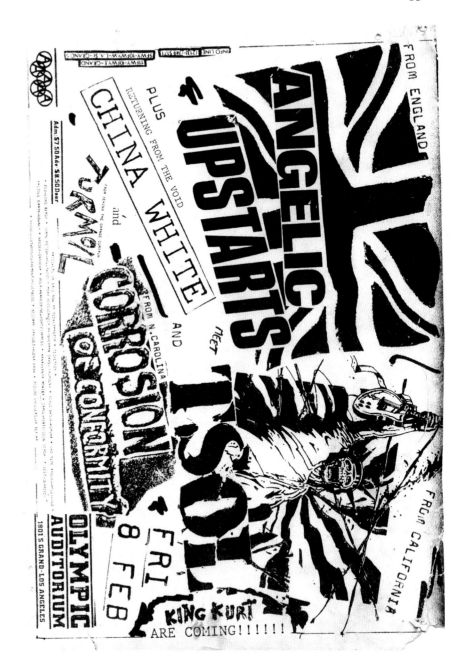

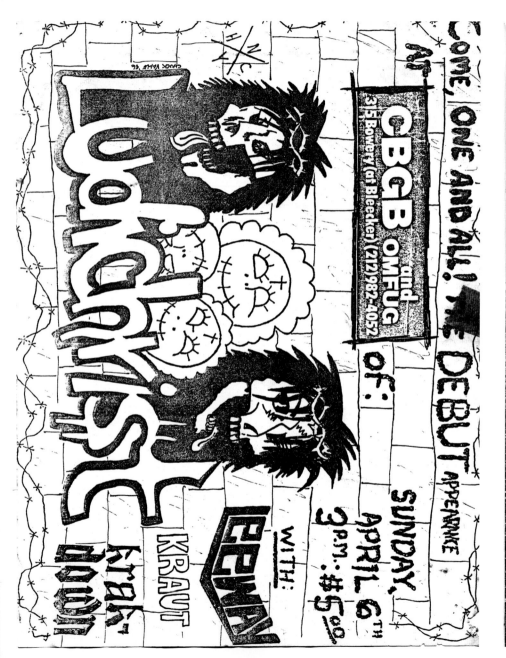

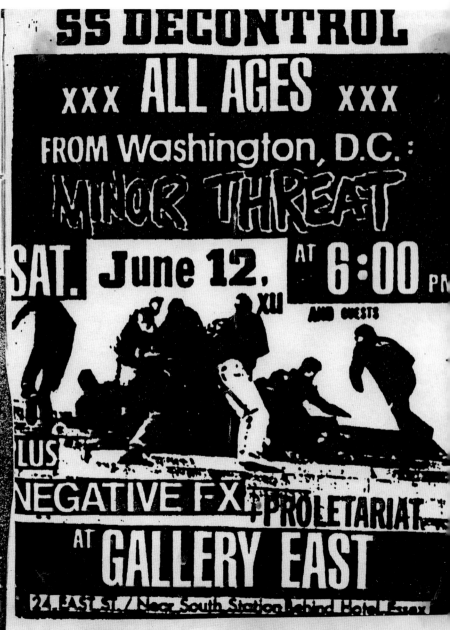

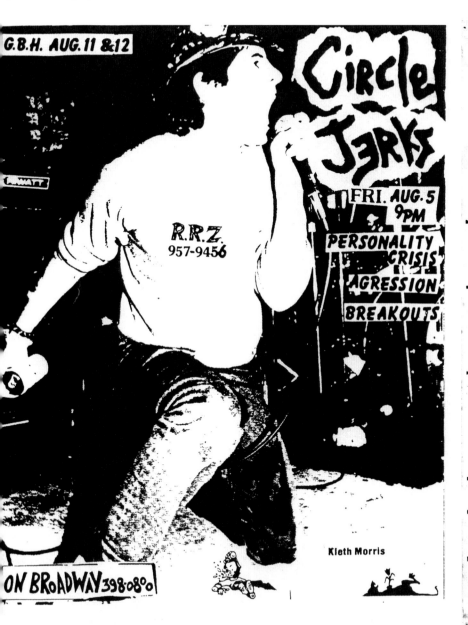

G.B.H. AUG. 11 & 12

# Circle Jerks

FRI. AUG. 5
9PM

PERSONALITY
CRISIS
AGRESSION
BREAKOUTS

R.R.Z.
957-9456

Kieth Morris

ON BROADWAY 398-0800

---

THE OTHER SIDE PRODUCTION
PRESENTS AT:
City Gardens
1701 CALHOUN ST., TRENTON, NJ 609-392-8887

FRI JUNE 26     8-12 mid     $10

# THE EXPLOITED
# DR. KNOW     PED     Insult To Injury

SAT JUNE 27  9pm  $6  THE **DESCENDENTS**
21 & up / 2 id's   BAR SHOW        & MIA

WED JULY 22     8-12 mid     $10

## 7 Seconds * Angry Samoans
### Flaming Lips

FRI JULY 31   9PM   $ 10 adv   FROM
                     12 day of

# GRAHAM CHAPMAN MONTY
PYTHON

SUN AUG 2 WHITE FLAG          10:30pm Showtime

SUN AUG 9 **GBH**       COMING UP
                        Dag Nasty  COC
                        Abbie Hoffman

FRI AUG 21             Tentative in July   ANTHRAX
DR. TIMOTHY                               FREHLEY'S COMET
LEARY

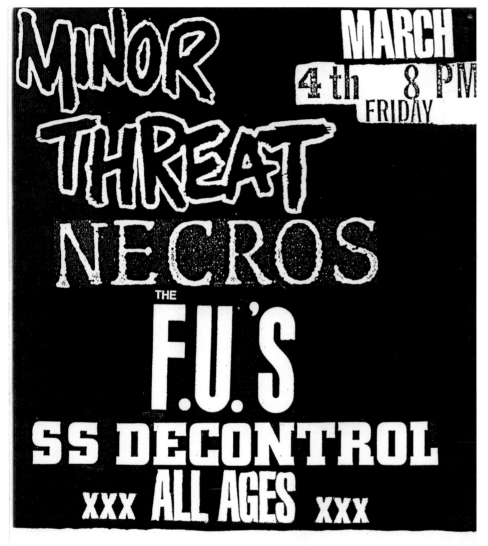

MINOR THREAT
NECROS
THE F.U.'S
SS DECONTROL
xxx ALL AGES xxx

MARCH
4th 8 PM
FRIDAY

ACHTUNG! Take the Red Line to Har—
vard Sq Take the Watertown Sq.(71) or
Waverly Sq. (73) bus to Star Mkt., go up
Belmont, take 2nd right, Cushing, all the
way to the end, left on Huron, look for the missle.

VFW Hall
mt auburn
Cambridge

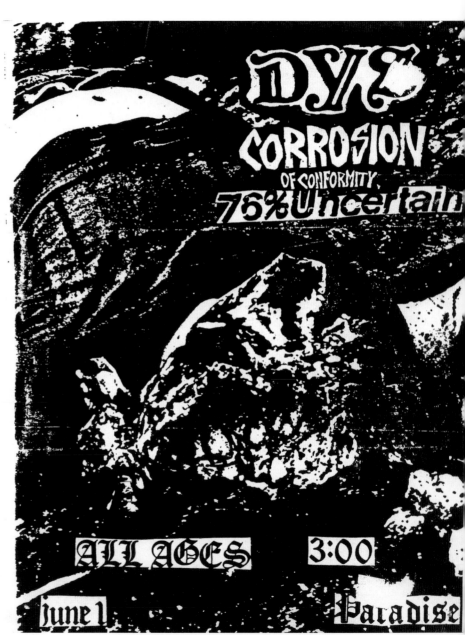

DYS
CORROSION
OF CONFORMITY
76% Uncertain

ALL AGES        3:00

June 1        Paradise

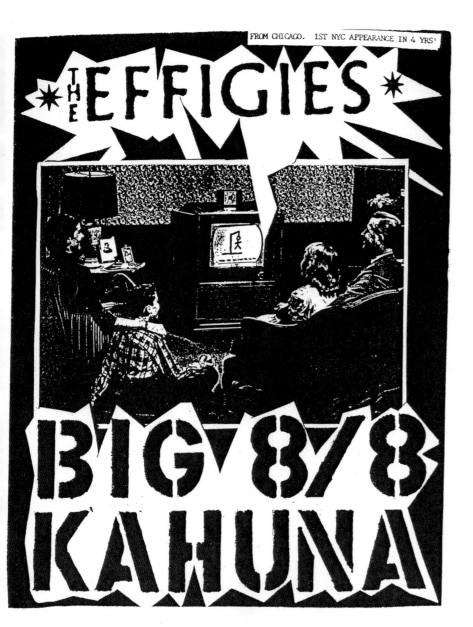

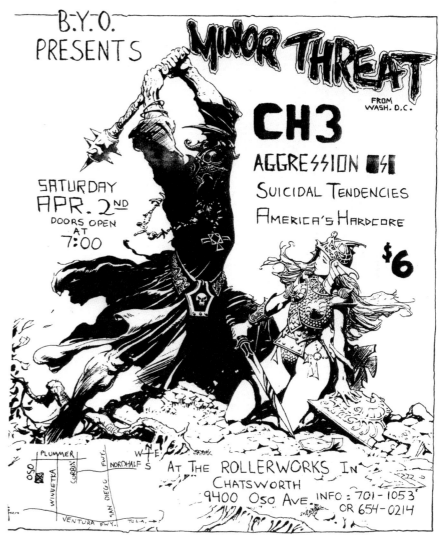

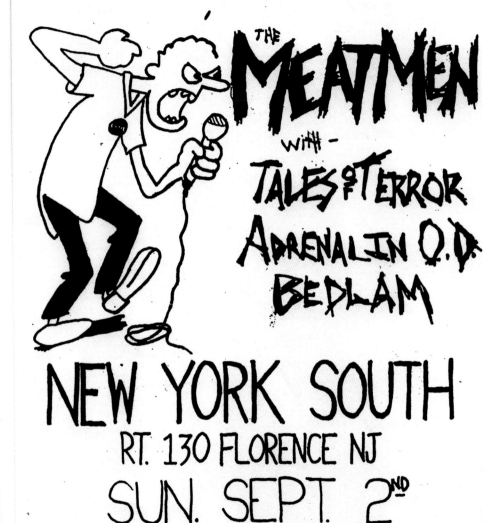

THE MEATMEN

with - TALES of TERROR

ADRENALIN O.D.

BEDLAM

NEW YORK SOUTH

RT. 130 FLORENCE NJ

SUN. SEPT. 2ND

ALL AGES - NO ALCOHOL

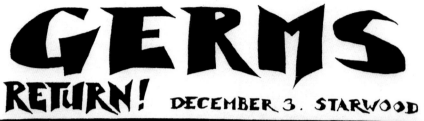

GERMS RETURN! DECEMBER 3. STARWOOD

(GI)

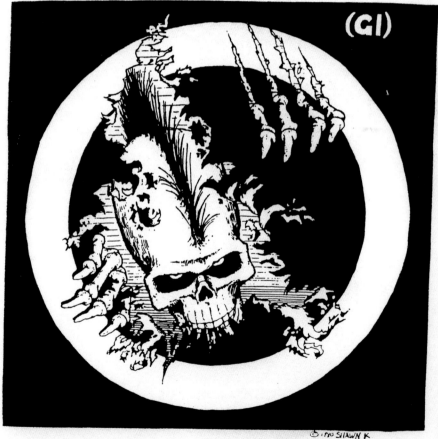

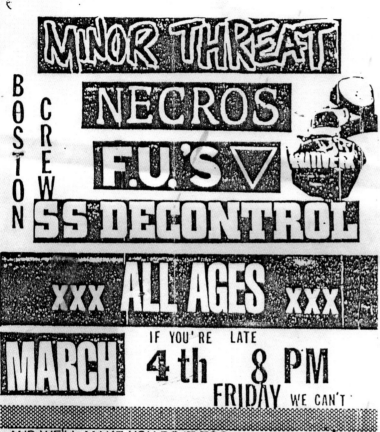

**MINOR THREAT**
**NECROS**
**F.U.'S** ▽
BOSTON CREW
**SS DECONTROL**

xxx **ALL AGES** xxx

**MARCH** IF YOU'RE LATE **4th 8 PM** FRIDAY WE CAN'T

AND WE'LL MAKE YOU DO IT, TOO.

**ACHTUNG!** Take the Red Line to Harvard Sq Take the Watertown Sq.(71) or Waverly Sq.(73) bus to Star Mkt., go up Belmont, take 2nd right, Cushing, all the way to the end, left on Huron. look for the missle.

wait!

VFW Hall mt auburn Cambridge

**FEAR**
**DILS**

**HONG KONG CAFE**
**FRI.** **OCT.12**

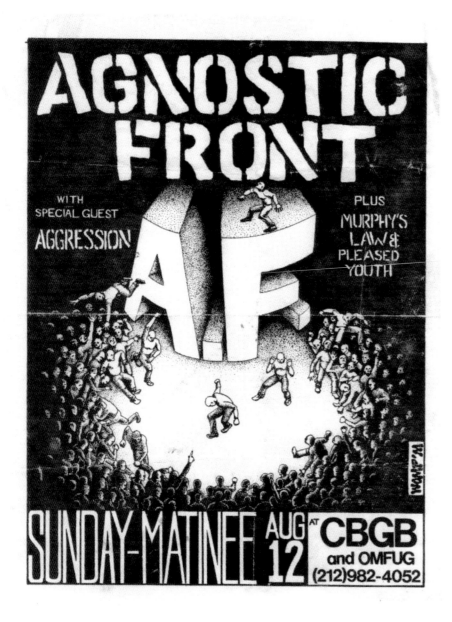

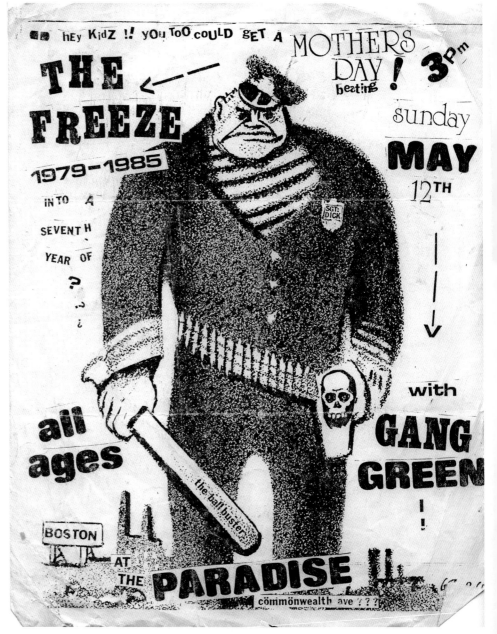

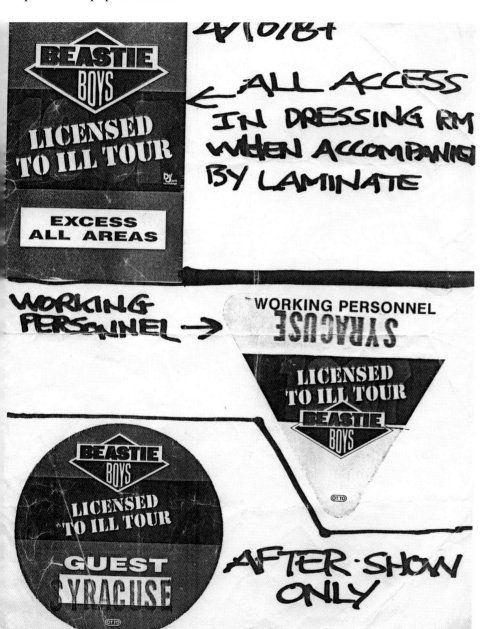

**BEASTIE BOYS**

**LICENSED TO ILL TOUR**

**EXCESS ALL AREAS**

4/10/84

← ALL ACCESS
IN DRESSING RM
WHEN ACCOMPANIED
BY LAMINATE

WORKING PERSONNEL →

WORKING PERSONNEL
SYRACUSE

LICENSED TO ILL TOUR
**BEASTIE BOYS**

OTTO

**BEASTIE BOYS**

**LICENSED TO ILL TOUR**

**GUEST**
**SYRACUSE**

OTTO

AFTER·SHOW ONLY

Stage Right
Production... 1st floor
Murphy's Law... 2nd fl.
Stage Left
Beastie Boys... 2nd floor
Public Enemy... 1st fl

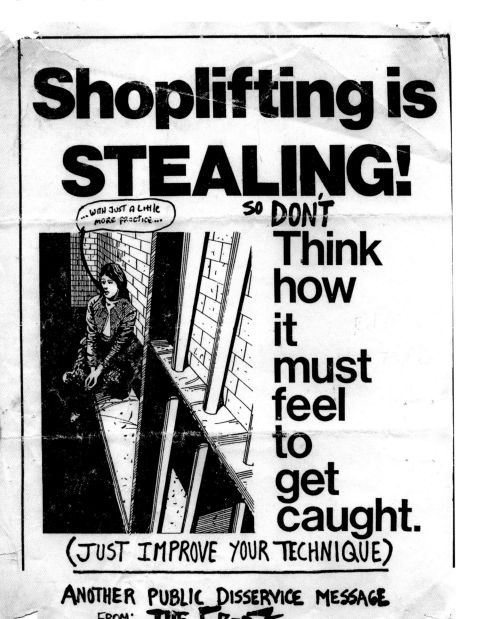

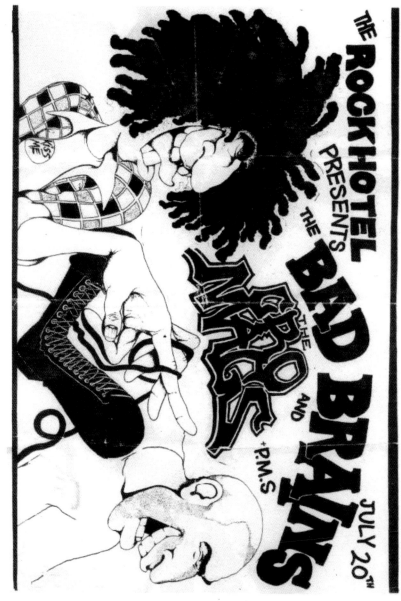

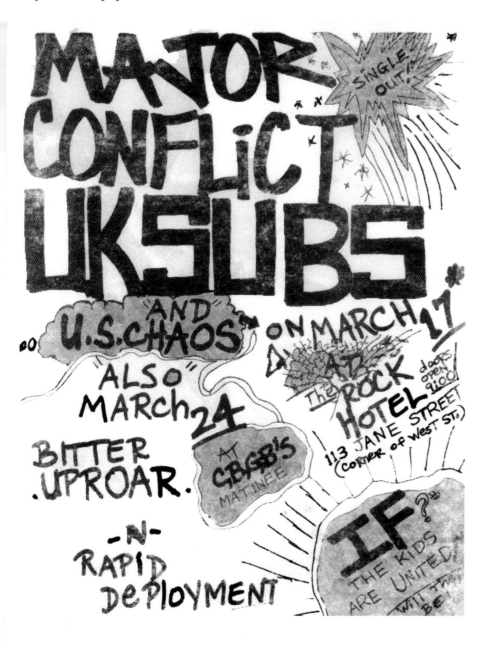

MAJOR CONFLICT UKSUBS

SINGLE OUT!

"AND" "U.S. CHAOS"

"ALSO" MARCH 24

BITTER UPROAR.

-N-
RAPID DEPLOYMENT

AT CBGB's MATINEE

ON MARCH 17 AT The ROCK HOTEL

doors open 9:00

113 JANE STREET (corner of West St.)

IF? THE KIDS ARE UNITED WILL THEY BE

DAMAGE

BEDLAM

D-GENS CAR

SUNDAY MAY 11

WITH SPECIAL GUEST COMEDIA LAZARUS 'AZEO

RIGHT TRACK INN

2 P.M.

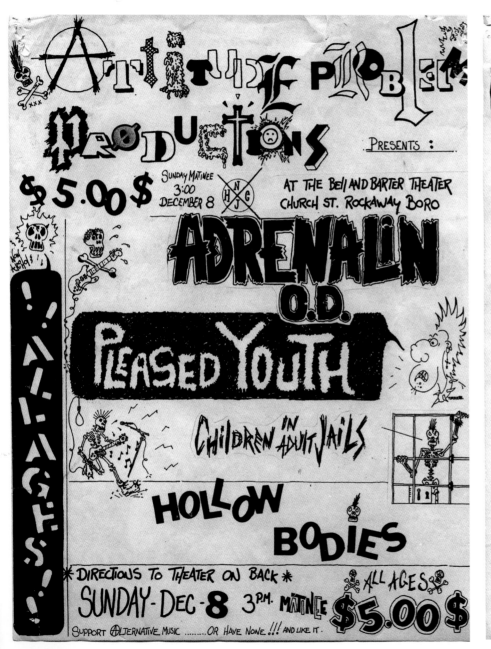

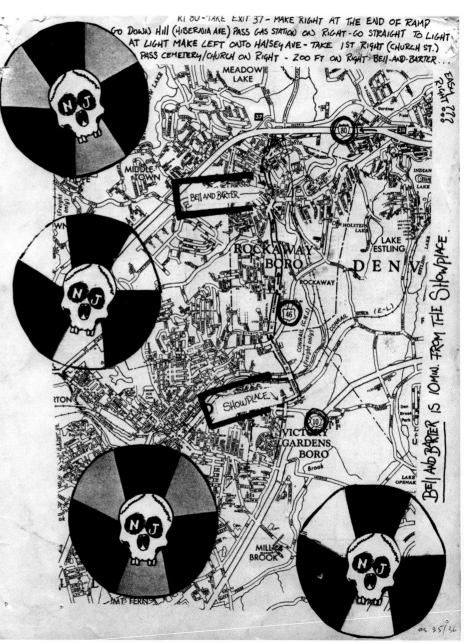

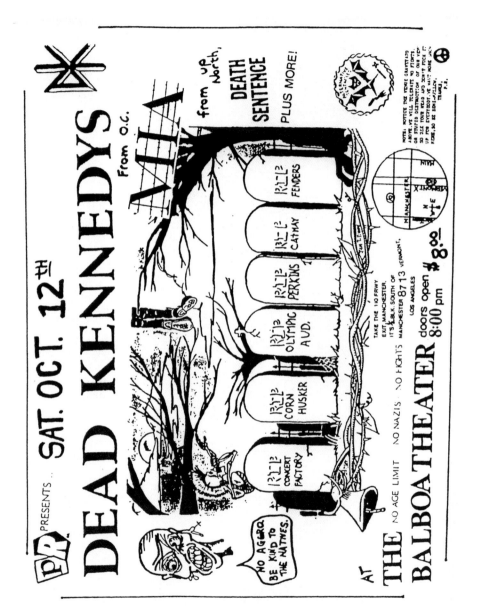

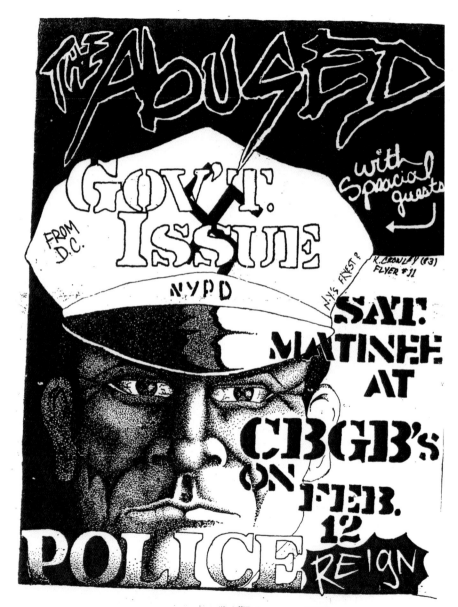

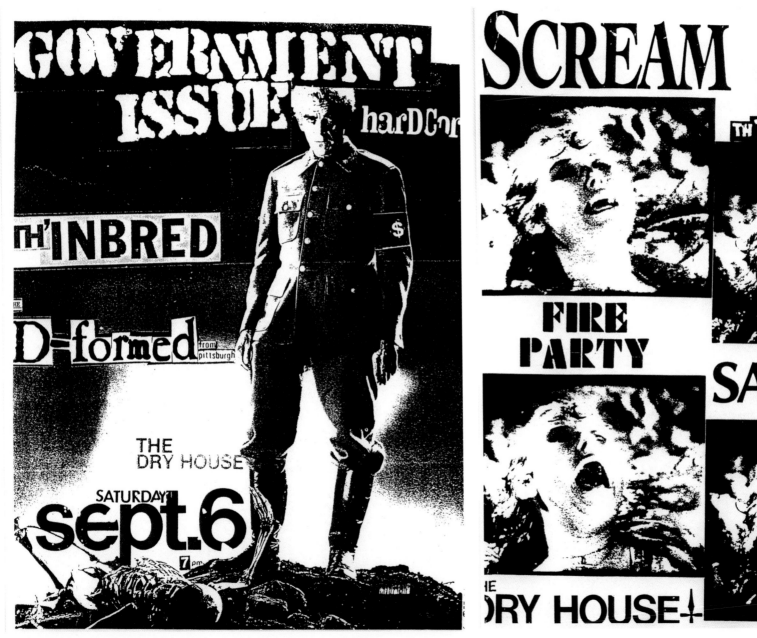

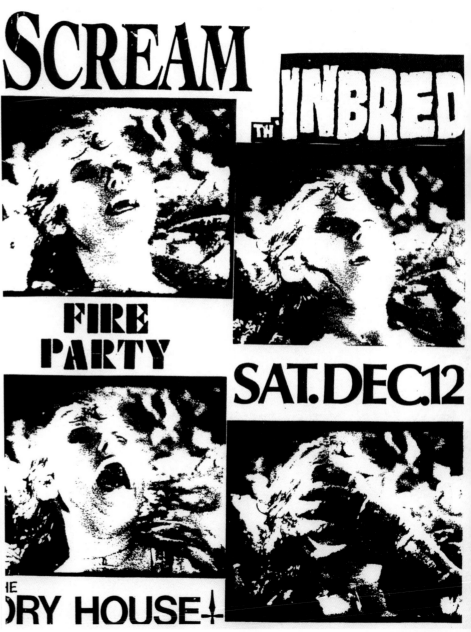

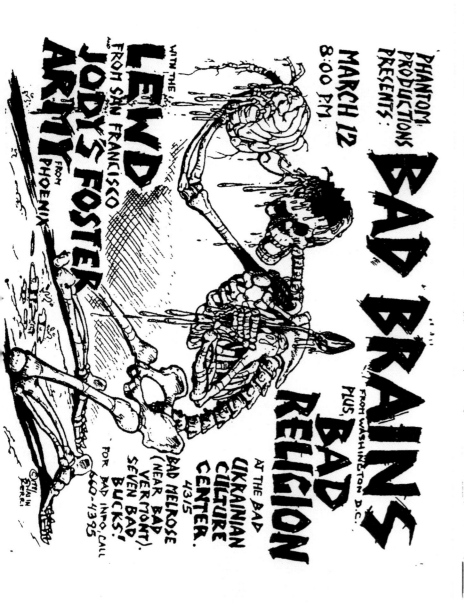

PHANTOM PRODUCTIONS PRESENTS:

MARCH 12
8:00 P.M.

**BAD BRAINS**
FROM WASHINGTON D.C.

PLUS,
**BAD RELIGION**

WITH THE L.A.

**LEWD**
AND FROM SAN FRANCISCO
**JODY'S FOSTER ARMY**
FROM PHOENIX

AT THE BAD
UKRAINIAN CULTURE CENTER.
4315 BAD MELROSE
(NEAR BAD VERMONT).
SEVEN BAD BUCKS!
FOR BAD INFO, CALL
660-4395

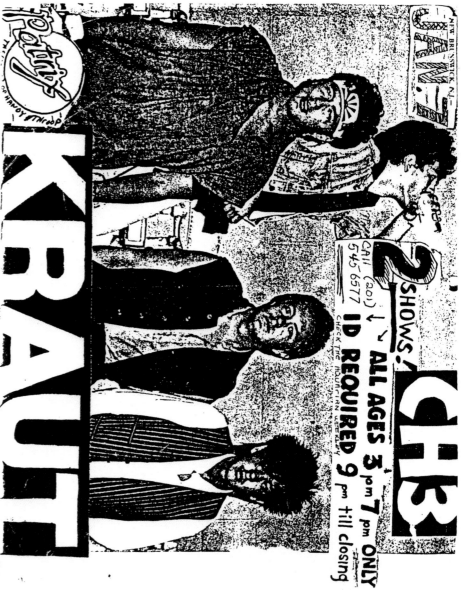

**KRAUT**

NEW BRUNSWICK N.J.
JAN 3

2 SHOWS:
ALL AGES 3 pm 7 pm ONLY
CALL (201)
545-6577
ID REQUIRED 9 pm till closing
CHECK THE AQUARIAN WEEKLY

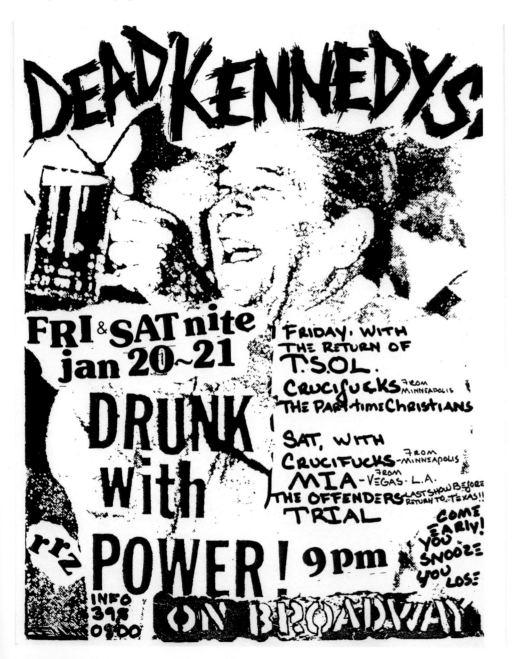

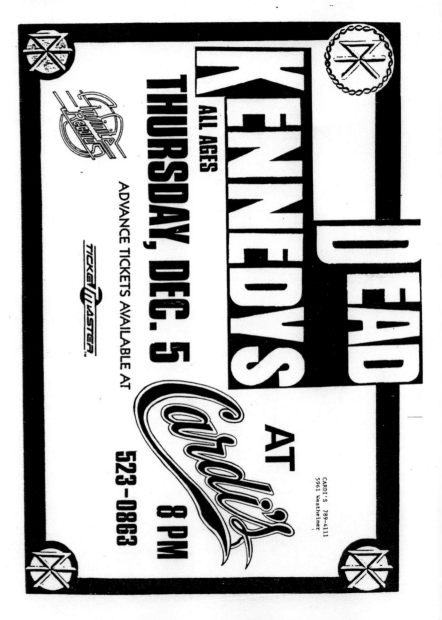

# THE NEW JERSEY ALTERNATIVE MUSIC SOCIETY

Proudly Presents
A
**Hardcore Holiday Bash**
With

**THE FU'S** From Boston
**ADRENALIN O.D.**
**CRIB DEATH & GUESTS**

Saturday Dec. 18th
At The
**N.I.V.P. Theater**
83 Elizabeth Ave.
Newark, N.J.

**SHOW STARTS AT
8:00 P.M.**

Tickets $5.00

*Available At:*
VINTAGE VINYL · Irvington
CRAZY EDDIES · Union
MICKEY MUSIC · Passaic
SOUND EXCHANGE · Wayne
TWO-TONE · Passaic
RAT CAGE · N.Y.C.

THE MOST IMPORTANT THING TO HIT N. JERSEY SINCE THE DISCOVERY OF **BAD ODOR**

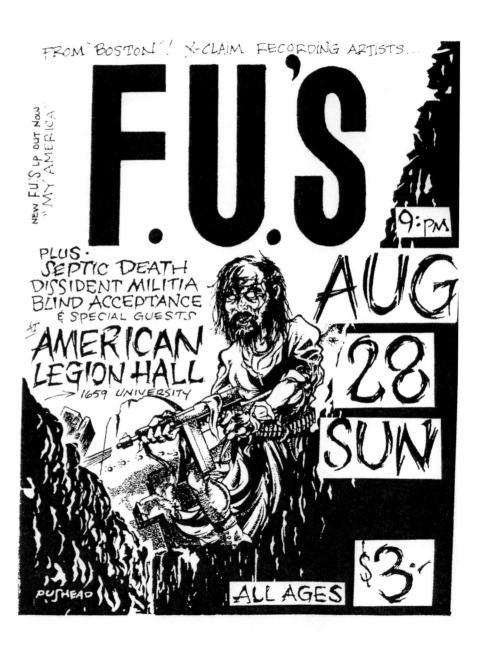

FROM `BOSTON`! X-CLAIM RECORDING ARTISTS...

NEW FU'S LP OUT NOW "MY AMERICA"

# F.U.'S

9:PM

PLUS·
SEPTIC DEATH
DISSIDENT MILITIA
BLIND ACCEPTANCE
& SPECIAL GUESTS

AT
AMERICAN LEGION HALL
→ 1659 UNIVERSITY

AUG 28 SUN

$3.⁰⁰

ALL AGES

PUSHEAD

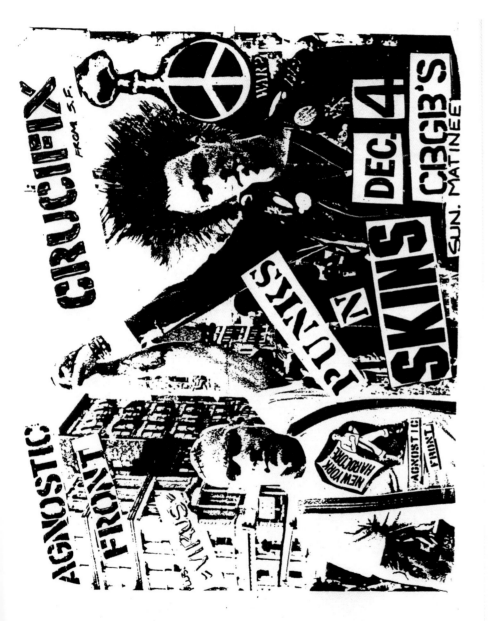

HYPE'S "LIFE IS HARD······THEN YOU DIE!" RELEASE PARTY !!!!

THE **FREEZE** from boston

**76% UNCERTIAN** from connecticut

**HYPE** L.P. out now!

**NEGATIVE GAIN** skate thrash

# FRI. JUNE 28TH

AT THE **DMZ**
337 SPADINA AVE.

# $5.00 AT THE DOOR

## ALBUMS/T-SHIRTS ON SALE

une 27.. stark raving mad from n.y. cancelled

une 29 the freeze, hype, 76% - uncertian, the unruled in montreal

uly 2 vampire lezbo's-hardcore from seattle washington

reuben king producti

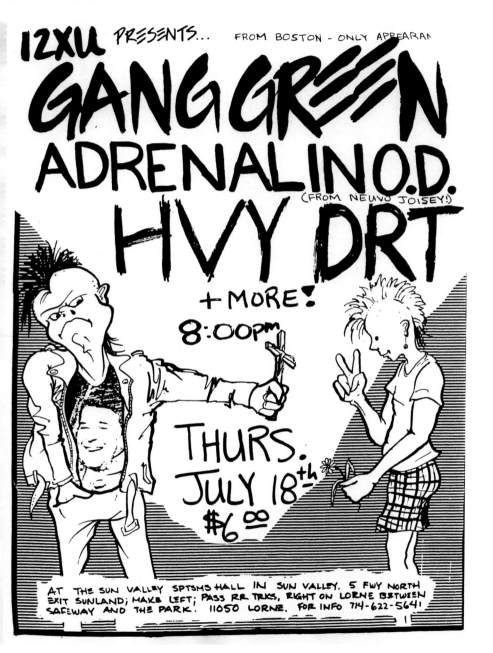

12XU PRESENTS... FROM BOSTON - ONLY APPEARAN

# GANG GREEN
# ADRENALIN O.D.
(FROM NEUVO JOISEY!)
# HVY DRT

+ MORE!
8:00PM

THURS.
JULY 18th
$6.00

AT THE SUN VALLEY SPTSMS HALL IN SUN VALLEY. 5 FWY NORTH EXIT SUNLAND; MAKE LEFT; PASS RR TRKS, RIGHT ON LORNE BETWEEN SAFEWAY AND THE PARK. 11050 LORNE. FOR INFO 714-622-5641

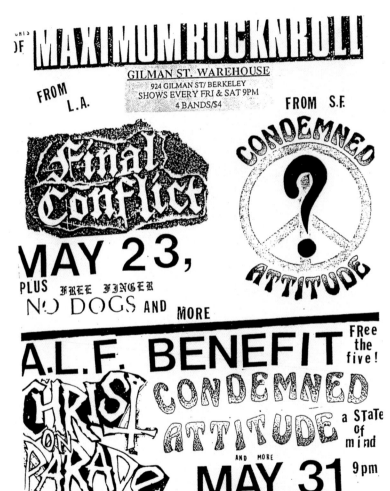

CHIS OF MAXIMUM ROCKNROLL

GILMAN ST. WAREHOUSE
924 GILMAN ST/ BERKELEY
SHOWS EVERY FRI & SAT 9PM
4 BANDS/$4

FROM L.A.

Final Conflict

MAY 23,

PLUS FREE FINGER
NO DOGS AND MORE

FROM S.F.

CONDEMNED ? ATTITUDE

A.L.F. BENEFIT FRee the five!

CHRIST ON PARADE

CONDEMNED ATTITUDE a state of mind

AND MORE

MAY 31 9pm

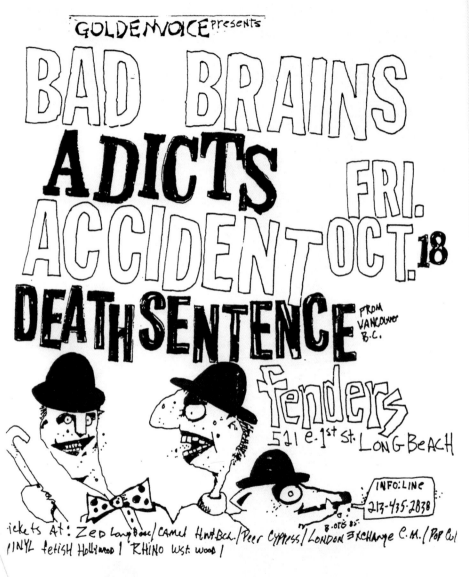

GOLDENVOICE presents
BAD BRAINS
ADICTS
ACCIDENT
DEATH SENTENCE
FROM VANCOUVER B.C.
FRI. OCT. 18

fenders
511 e. 1st st. LONG BEACH

INFO:LINE
213-435-2838

Tickets at: Zed Longbeach/Camel Hnt. Bch./Peer Cypress/London Exchange C.M./Pop Col
Vinyl Fetish Hollywood/Rhino West Wood/

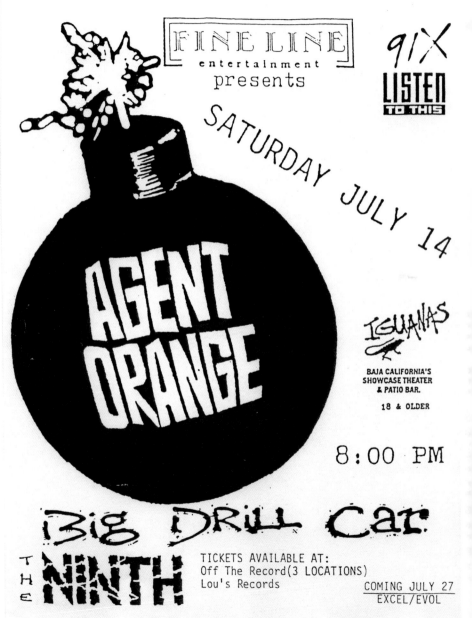

FINE LINE
entertainment
presents

91X
LISTEN TO THIS

SATURDAY JULY 14

AGENT ORANGE

IGUANAS
BAJA CALIFORNIA'S
SHOWCASE THEATER
& PATIO BAR.
18 & OLDER

8:00 PM

BIG DRILL CAR

THE NINTH

TICKETS AVAILABLE AT:
Off The Record (3 LOCATIONS)
Lou's Records

COMING JULY 27
EXCEL/EVOL

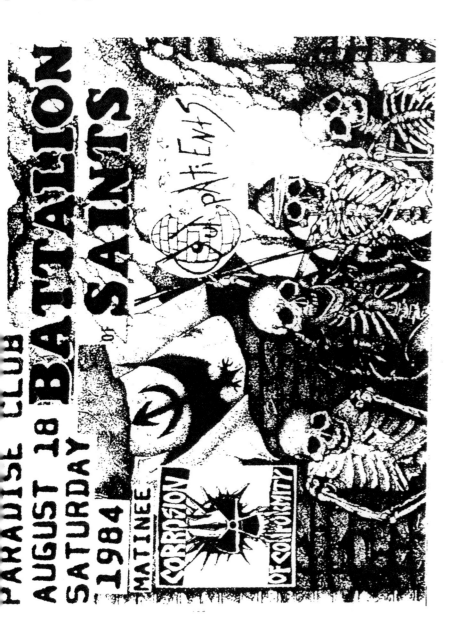

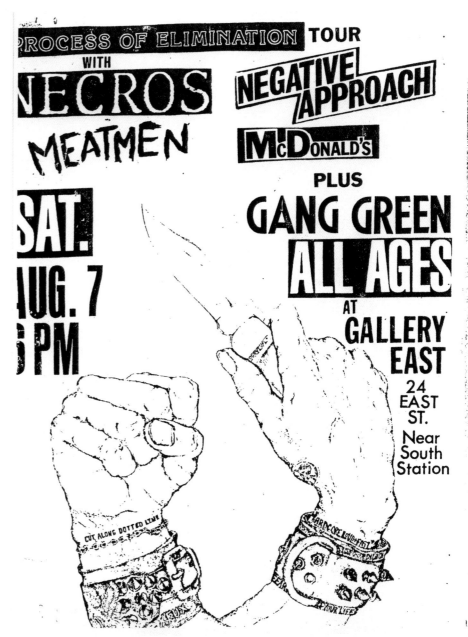

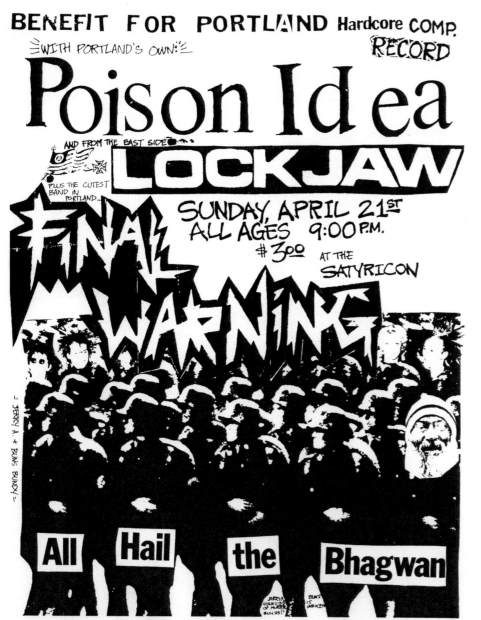

BENEFIT FOR PORTLAND Hardcore COMP. RECORD

WITH PORTLAND'S OWN:

# Poison Idea

AND FROM THE EAST SIDE

# LOCKJAW

PLUS THE CUTEST BAND IN PORTLAND...

# Final Warning

SUNDAY, APRIL 21ST
ALL AGES   9:00 P.M.
$3.00   AT THE SATYRICON

All Hail the Bhagwan

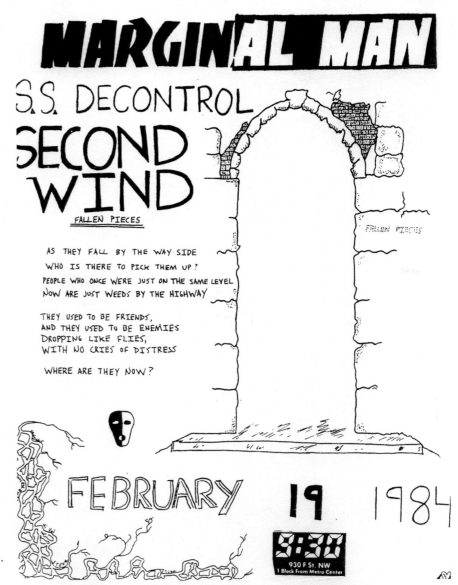

# MARGINAL MAN

## S.S. DECONTROL

# SECOND WIND

FALLEN PIECES

AS THEY FALL BY THE WAY SIDE
WHO IS THERE TO PICK THEM UP?
PEOPLE WHO ONCE WERE JUST ON THE SAME LEVEL
NOW ARE JUST WEEDS BY THE HIGHWAY

THEY USED TO BE FRIENDS,
AND THEY USED TO BE ENEMIES
DROPPING LIKE FLIES,
WITH NO CRIES OF DISTRESS

WHERE ARE THEY NOW?

FALLEN PIECES

FEBRUARY 19 1984

9:30
930 F St. NW
1 Block From Metro Center

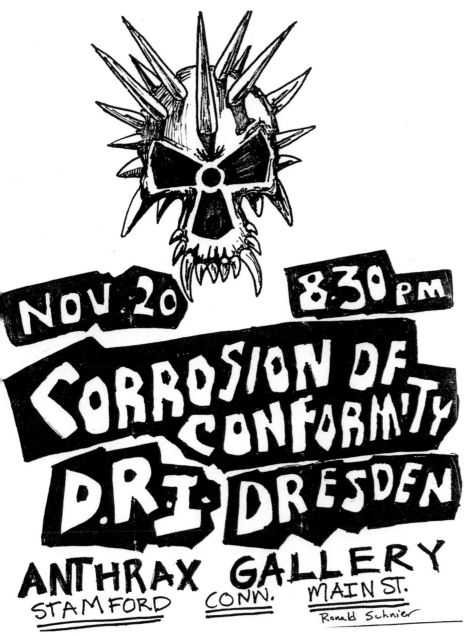

NOV. 20    8:30 PM
CORROSION OF
CONFORMITY
D.R.I. DRESDEN
ANTHRAX GALLERY
STAMFORD   CONN.   MAIN ST.
Ronald Schnier

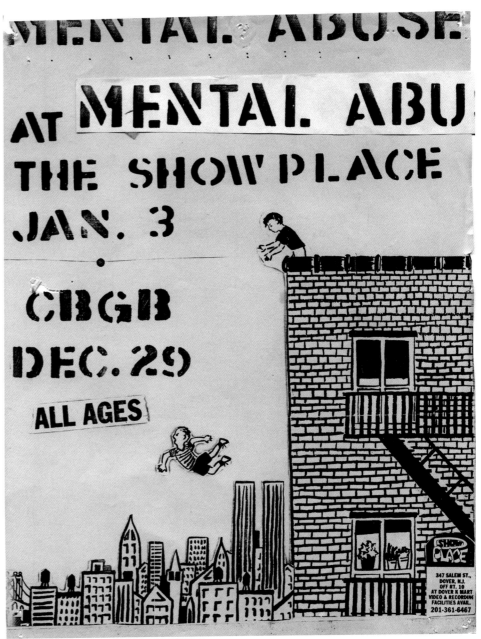

MENTAL ABUSE
AT MENTAL ABU
THE SHOW PLACE
JAN. 3
CBGB
DEC. 29
ALL AGES

SHOW PLACE
347 SALEM ST.,
DOVER, N.J.
OFF RT. 10
AT DOVER K MART
VIDEO & RECORDING
FACILITIES AVAIL.
201-361-6467

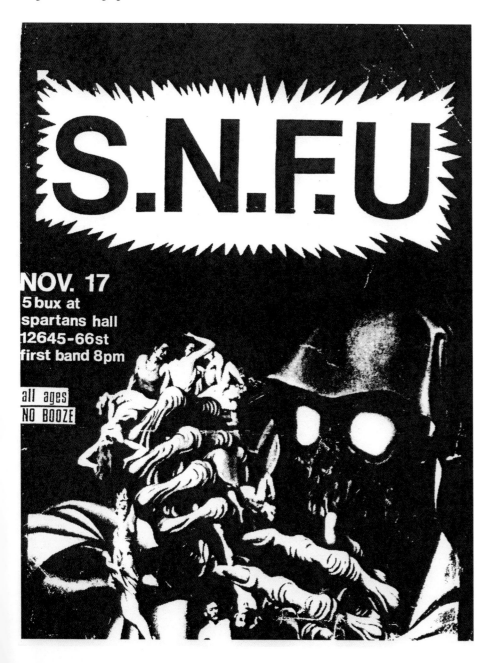

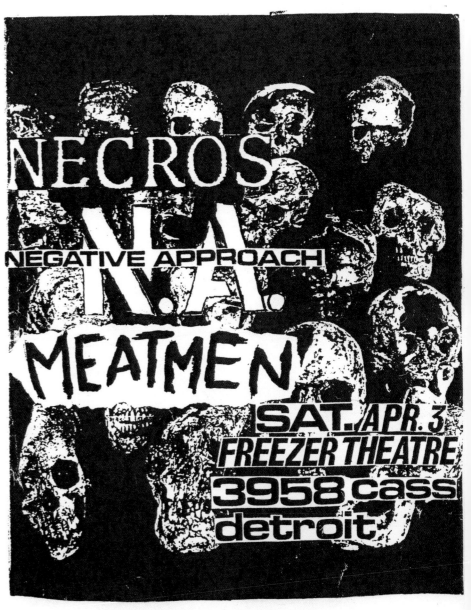

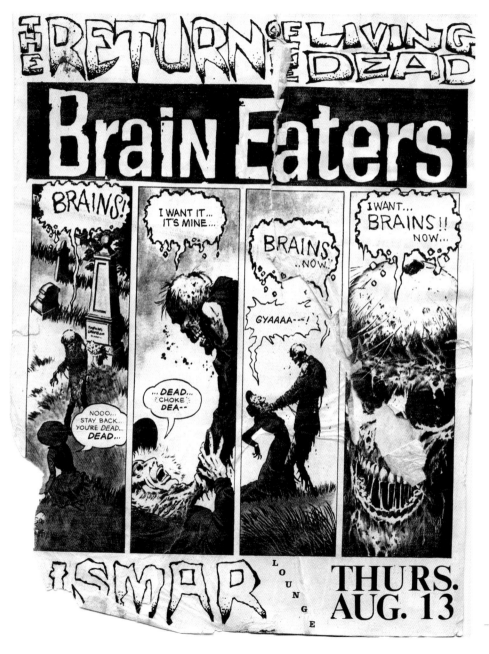

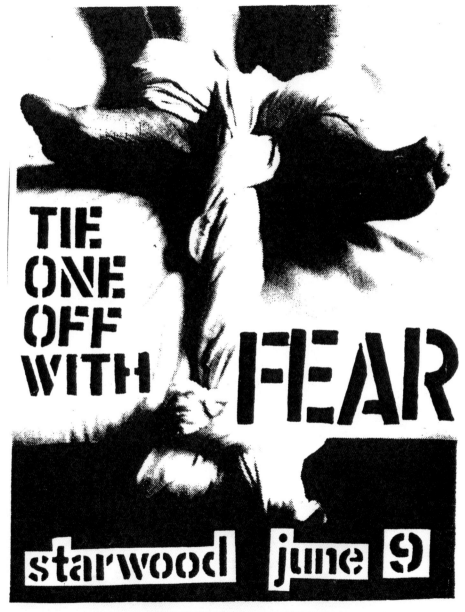

FROM BOSTON LEGENDARY GREATS:

TAANG! RECORDS

# JERRY'S KIDS

ALL THE WAY FROM CALIFORNIA:

# CHAIN OF STRENGTH

REVELATION RECORDS

THE CORE

ALSO FROM CALI.:

# END TO END

SUNDAY APRIL 1
DOORS OPEN AT 2
ADMISSION PRICE WILL BE DETERMINED
AT A LATER DATE.
?'S CALL 732-9923. $10.00

DIRECTIONS FROM READING:
TAKE 78 TO 81. GET OFF AT
WERTZVILLE RD. EXIT. AT STOP
SIGN GO LEFT. STAY ON RT.944.
GO PAST LIGHT. WHEN THE ROAD
ENDS,BEAR RIGHT. TURN RIGHT
ONTO LOCUST ST. CLUB IS AT
THE DEAD END.

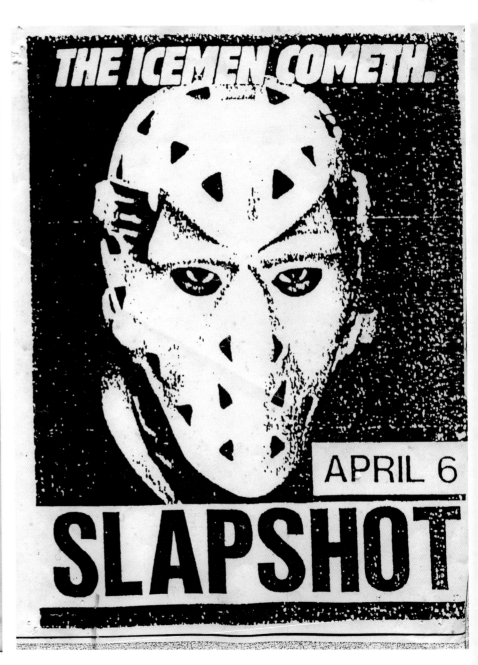

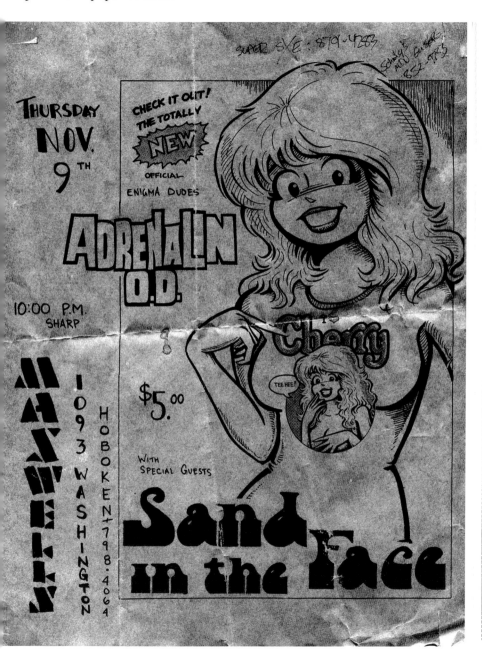

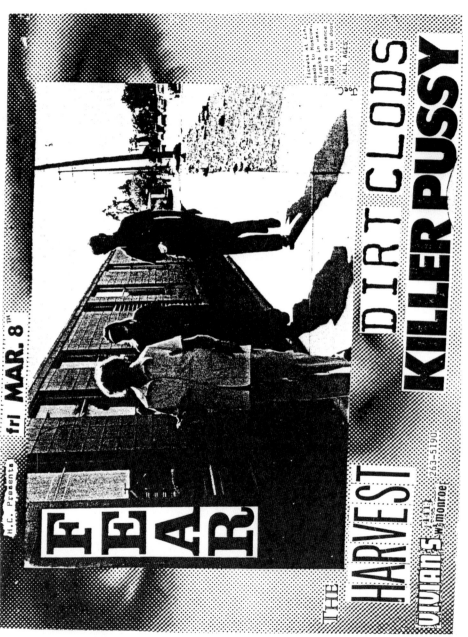

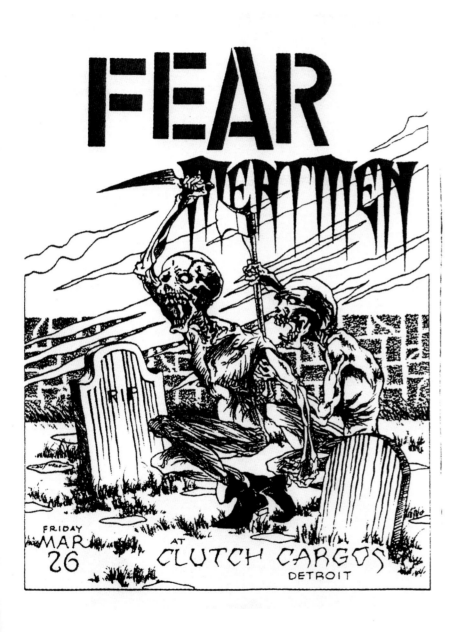

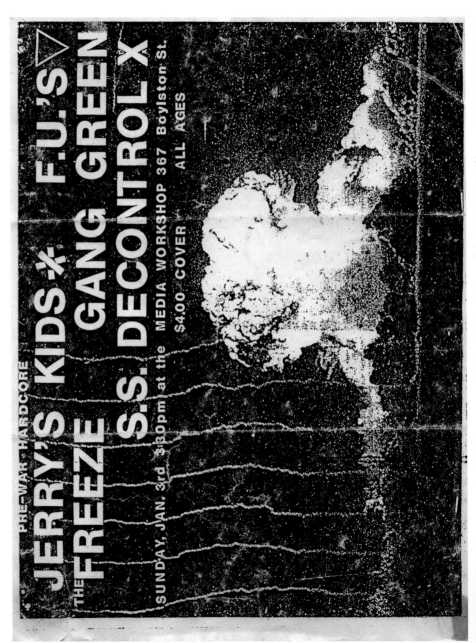

The HC Presents

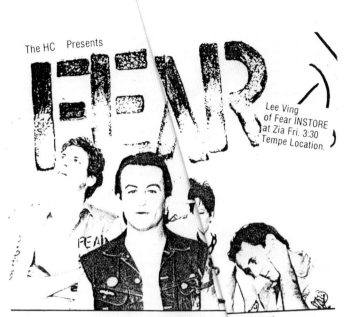

FEAR

Lee Ving
of Fear INSTORE
at Zia Fri. 3:30
Tempe Location.

**WITH SPECIAL GUESTS**
**Killer Pussy**
**The Harvest**
**The Dirt Clods**
**Friday, March 8, 1985 8pm**

**MINORS VELCOME**

## VIVIAN'S

441 W. Monroe Ave, Phoenix
(at the corner of Fifth and Monroe)
TICKETS AVAILABLE AT ALL THREE ZIA LOCATIONS
TRACKS N WAX, AND ROADS TO MOSCOW.

**this will be the last show to be held at VIVIANS**

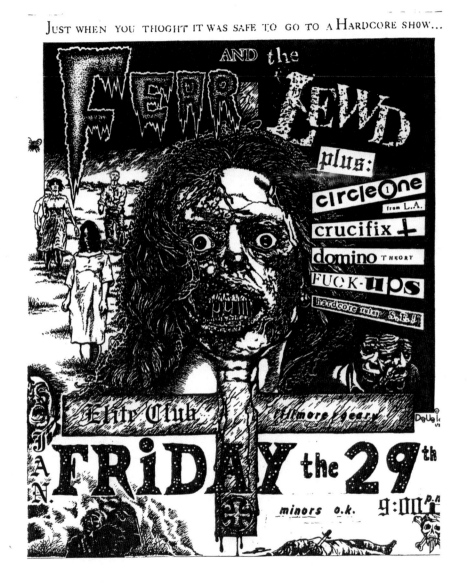

JUST WHEN YOU THOGHT IT WAS SAFE TO GO TO A HARDCORE SHOW...

FEAR AND the LEWD

plus:
circle One from L.A.
crucifix
domino THEORY
FUCK-UPS
hardcore rules S.F.!

Elite Club Fillmore & Geary

FRIDAY the 29th

minors o.k. 9:00 p.m

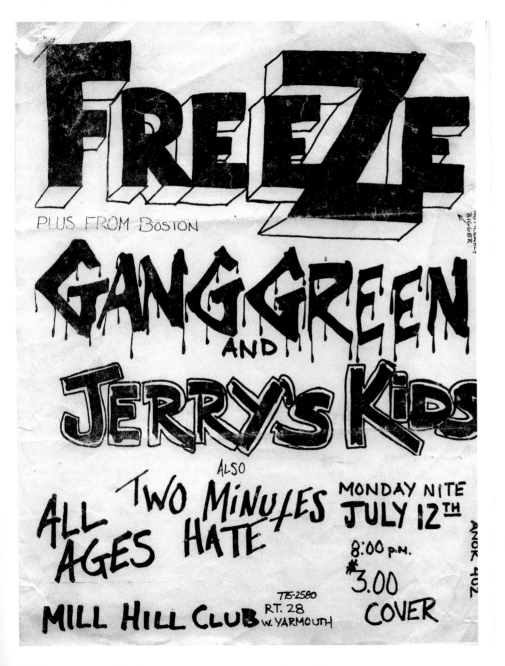

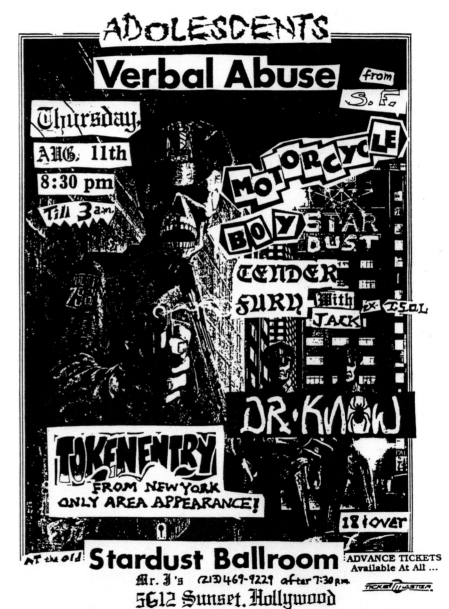

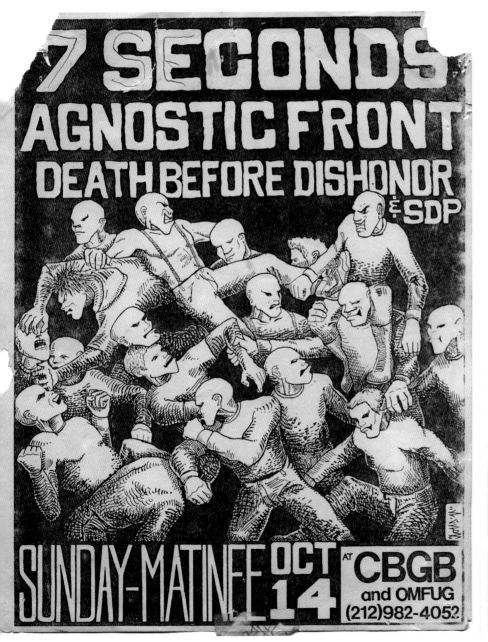

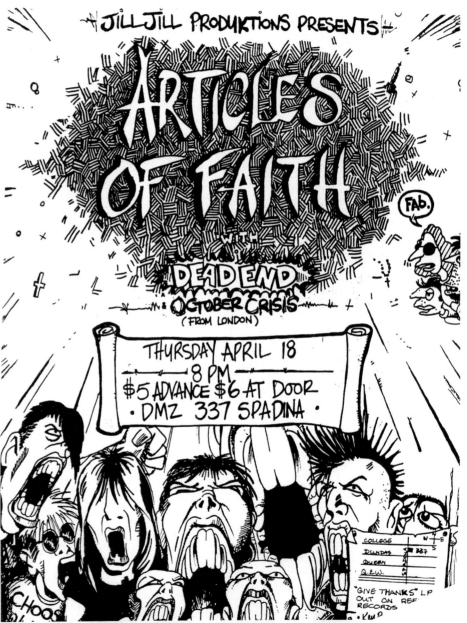

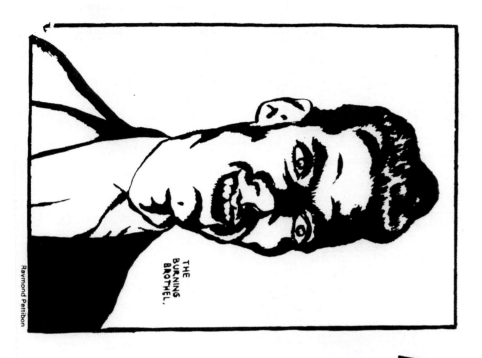

Raymond Pettibon

THE BURNING BROTHEL.

**RRZ** presents ▬▬▬▬ NIGHT

# MINUTEMEN
(from San Pedro)

# HÜSKER DÜ
(from Minneapolis)

# DICKS
(from Austin)

STAINS
(from East L.A.)

at the
ON BROADWAY
in San Francisco
**Saturday Oct 22**
9pm $6.00
All Ages

New Releases on SST Records
MINUTEMEN - Buzz Or Howl Under The Influence of Heat 12" EP
HÜSKER DÜ Metal Circus 12" EP
The STAINS LP
The DICKS Kill From The Heart LP
SST PO BOX 1 Lawndale CA 90260/SST Gig Info 372 1848

---

# flip side
## 45

**DETOX·DOGGY STYLE·C2D
SAMHAIN·JUSTICE LEAGUE
AGNOSTIC FRONT·A.O.D.
INCEST CATTLE·STEPS·SNFU
UNIFORM CHOICE·CORPSE
CHUMBAWAMBA**

$1

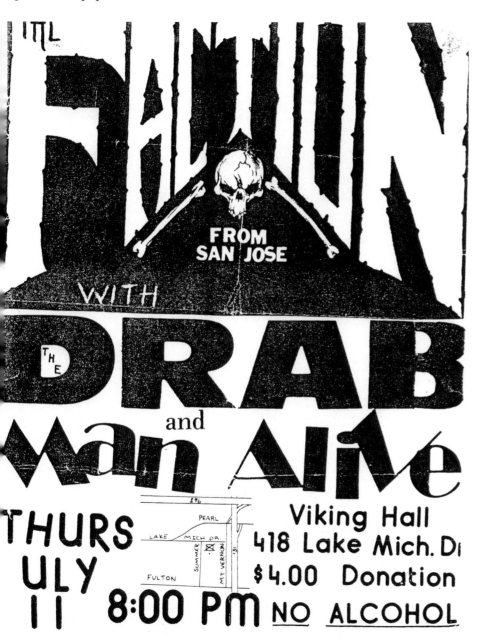

ITL FALUUN

FROM SAN JOSE

WITH

THE DRAB

and

MAN ALIVE

THURS
ULY
11
8:00 PM

Viking Hall
418 Lake Mich. Dr
$4.00 Donation
NO ALCOHOL

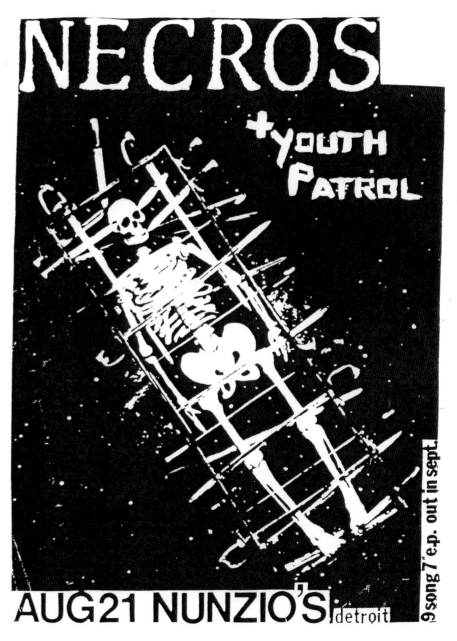

NECROS

+YOUTH PATROL

AUG 21 NUNZIO'S detroit

9 song 7" e.p. out in sept.

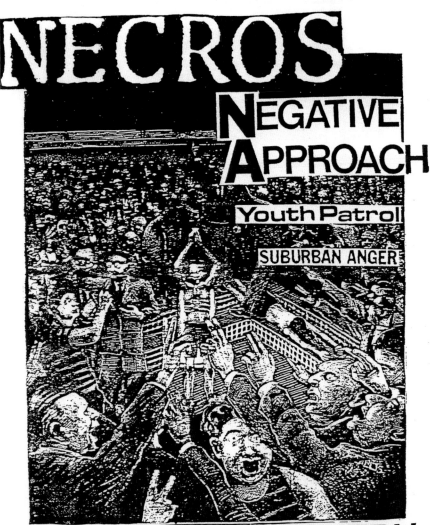

# NECROS
## NEGATIVE APPROACH
### Youth Patrol
SUBURBAN ANGER

# CORONATION TAVERN
windsor OCT 17 SAT

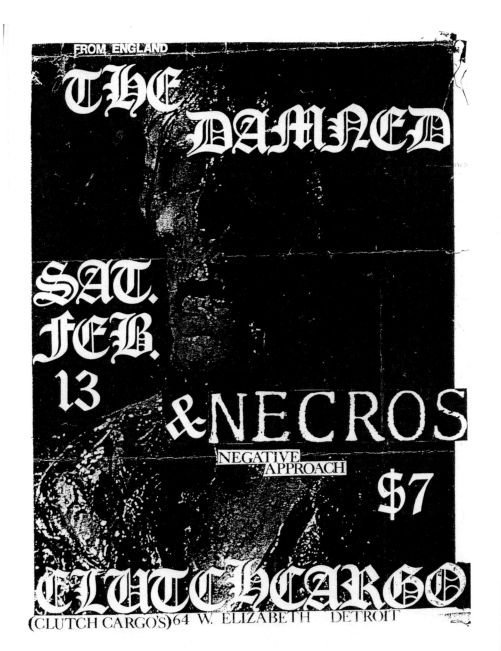

FROM ENGLAND

# THE DAMNED

SAT. FEB. 13

&NECROS

NEGATIVE APPROACH

$7

# CLUTCHCARGO
(CLUTCH CARGO'S) 64 W. ELIZABETH DETROIT

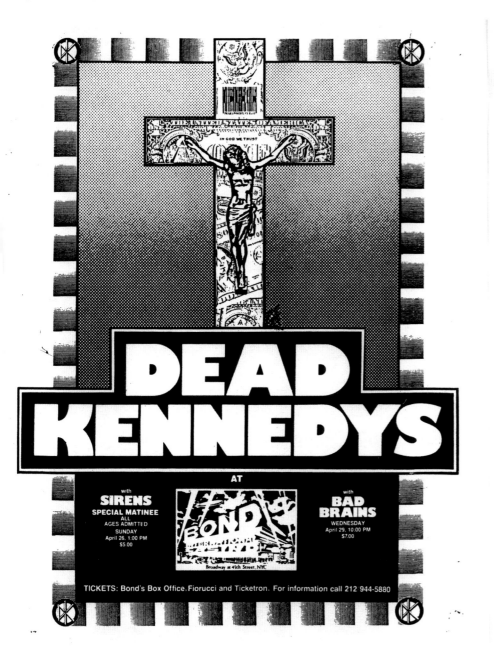

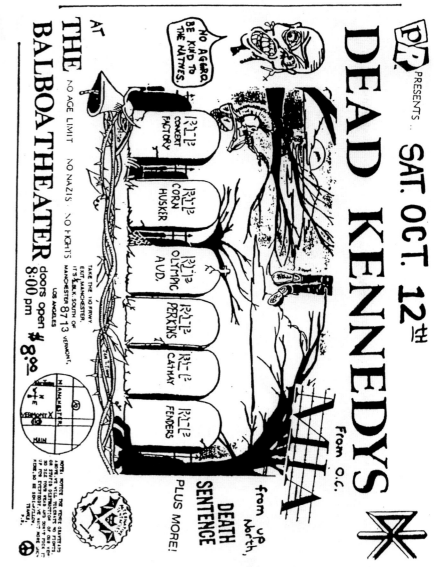

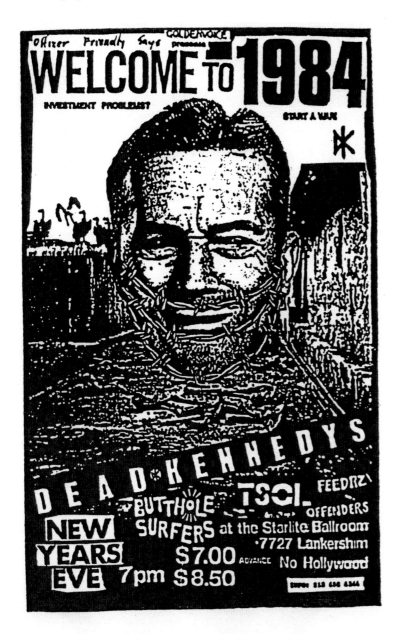

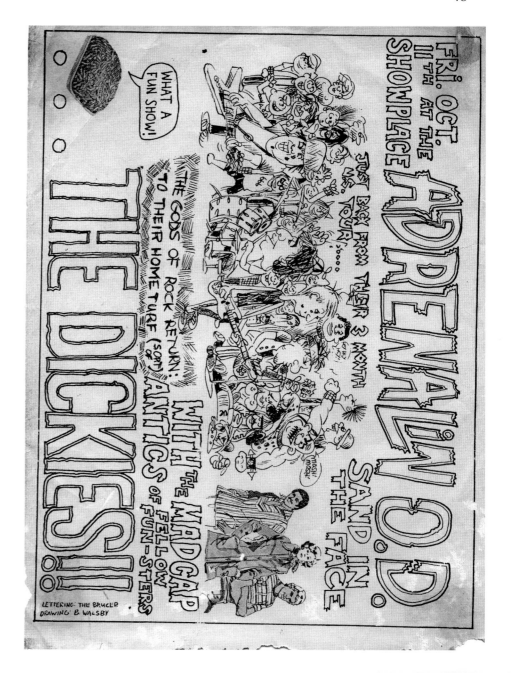

# NEGATIVE APPROACH

AND

# MINUS

PLUS

SPECIAL GUESTS

FRIDAY JUNE 8

AT THE

FIRST UNITARIAN

CHURCH

4605 CASS

at

FOREST AVE.

IN DETROIT

All AGES

LAST SHOW BEFORE N.A's 7 WEEK NATIONAL TOUR

GO TO THE RED DOOR AT THE SIDE!
$4.00
FOR INFO, CALL
833 3176

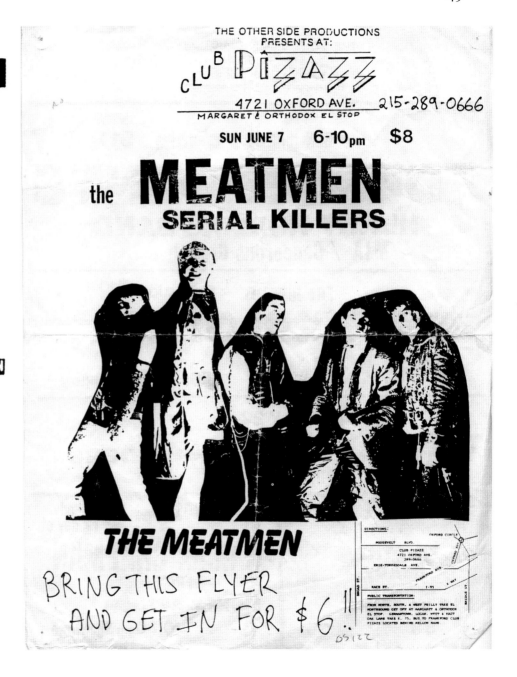

THE OTHER SIDE PRODUCTIONS
PRESENTS AT:

CLUB PIZAZZ

4721 OXFORD AVE.    215-289-0666

MARGARET & ORTHODOX EL STOP

SUN JUNE 7    6-10pm    $8

the MEATMEN
SERIAL KILLERS

THE MEATMEN

BRING THIS FLYER AND GET IN FOR $6!!

THE OTHER SIDE PRODUCTIONS
PRESENTS AT:
**City Gardens**
1701 CALHOUN ST., TRENTON, N.J. 609-392-8887

FRI MARCH 25   9PM   $10/ADV   $12/DAY OF SHOW
# sinead o'connor

SAT MARCH 26   9PM   $10
## The Gun Club   amor fati

SUN MARCH 27   7:30PM   $8.50/ADV   $10/DAY OF SHOW
## Men Without Hats   The CUCUMBERS

FRI APRIL FOOL'S DAY   9PM   $2   18 & UP/21 & UP - LOUNGE
THE BEST OF THE CD WAVE DANCE PARTY
ALL CD! NO TURNTABLES! NEW AND OLD WAVE! HONEST!

SAT APRIL 2   9PM   $11.50/ADV   $13/DAY OF SHOW
# ROBYN HITCHCOCK
## & The EGYPTIANS
### Big Dipper

FRI APRIL 8 - 9PM - THE TOASTERS / THE CITIZENS
SAT APRIL 9 - 9PM - DANZIG / HEATHENS RAGE / GWAR
SUN APRIL 10 - 6:30PM - ALL / DOUGH BOYS
FRI APRIL 15 - 9PM - ANOTHER DANCE PARTY
SAT APRIL 16 - 9PM - BILLY BRAGG / ROYAL CRESCENT MOB /
                        MICHELLE SHOCKED
SUN APRIL 17 - 9PM - SCREAMING BLUE MESSIAHS / DRAMARAMA
FRI APRIL 22 - 9PM - THE RAMONES / PRONG
SAT APRIL 23 - 9PM - PETER MURPHY
SUN APRIL 24 - 6:30PM - THE CRUMBSUCKERS
FRI APRIL 29 - 9PM - THE GODFATHERS (WTSR RADIOTHON) / THE RETTMANS
SAT APRIL 30 - 9PM - WTSR RADIOTHON CONTINUES!
SUN MAY 1 - 6:30PM - BROKEN BONES / UK SUBS / DAYGLO ABORTIONS
MON MAY 2 - 7:30PM - MOJO NIXON & SKID ROPER / WEEN

COMING: UNDERWORLD / THE WAILERS / JUDY MOWATT / DAG NASTY
SIGN UP ON THE MAILING LIST AT THE FRONT DOOR.

---

OTHER SIDE PRODUCTIONS
PRESENTS AT:
**City Gardens**
1701 CALHOUN ST., TRENTON, N.J. 609-392-8887

joey   johnny   dee~dee

$ 9 adv.
10 day of show   FRI OCT 10

# THE RAMONES
18 & up / ID needed   9pm

$7   SUN OCT 12   new hours   5-9pm
# GANG GREEN / MARGINAL MAN
## 76% UNCERTAIN / SLAP SHOT

$8.50   SUN OCT 26   5-9pm
# SAMHAIN / DR. KNOW
## DÄS YAHOOS / SERIAL KILLERS
from ENGLAND

3rd HALLOWEENIE PARTY
FRI OCT 31
COSTUME PARTY
$100 FIRST PRIZE

# GENELOVESJEZEBEL
9 adv / 10 day of show   "DESIRE"

18 & up

SUN NOV 2   6 bucks
# GONE
## SACCHARINE TRUST
### SCORNFLAKES

FRI NOV 7   9pm
# LOVE & ROCKETS

## COMING
# DAYGLO ABORTIONS / 7 SECONDS
## RAW POWER / PETER MURPHY / BURNING SPEAR

# ED GEIN'S CAR
## GANG GREEN • QUEERS
## MISUNDERSTOOD

# FRIDAY MAY 9 THE RAT

528 COMMONWEALTH AVENUE • BOSTON • MASSACHUSETTS • (617) 538-9438

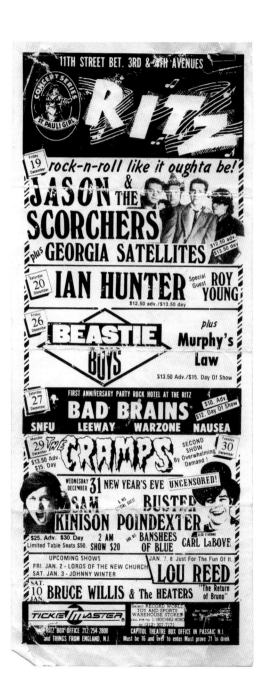

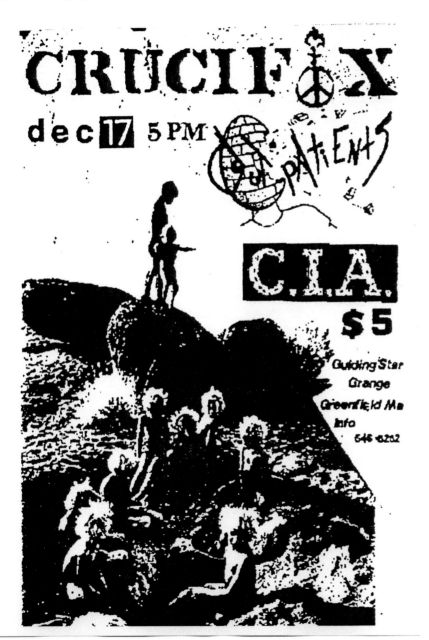

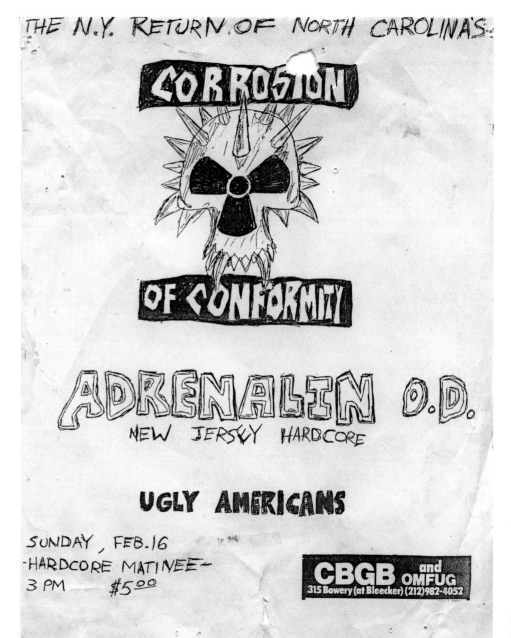

**SPRING THRASH**

**WILSON CENTER**
16th and Irving street N W
Friday April 30th
doors open at 8:00 pm

**MINOR THREAT**

**FAITH**
**ARTIFICIAL PEACE**
**IRON CROSS**
**VOID**
**DOUBLE-O**

DC
DC
DC
DC
DC
DC
DC
DC
DC
DC
**HARDCORE**
**HARDCORE**
DC
DC

**DEAD OR ALIVE**
presents

# MINOR THREAT

with
## HÜSKER DÜ
and
**SKULLBUSTERS**
plus special guest*

**FRIDAY JULY 9**

**8pm**

**KINGS ROAD**
4034 30th st.
$4.50 at the door

Bobby Lane '82

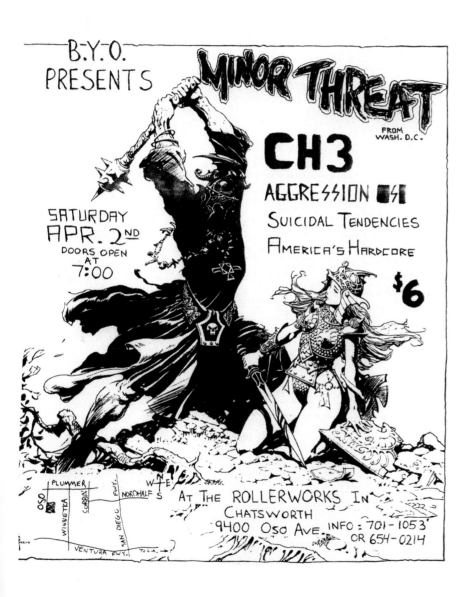

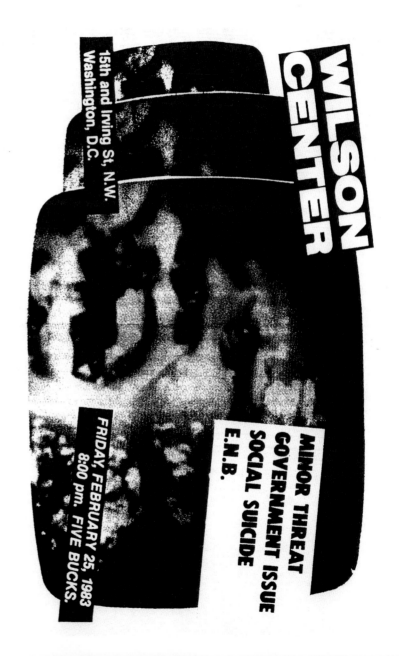

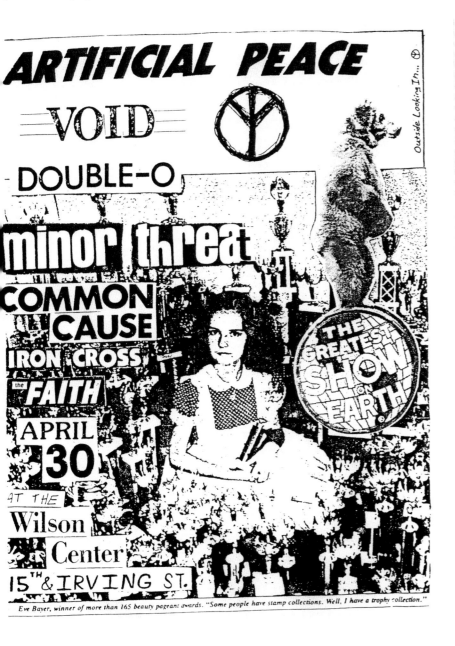

**ARTIFICIAL PEACE**

VOID

DOUBLE-O

minor threat

COMMON CAUSE

IRON CROSS

the FAITH

APRIL 30

AT THE Wilson Center

15TH & IRVING ST.

Outside Looking In...

THE GREATEST SHOW ON EARTH

*Eve Bayer, winner of more than 165 beauty pageant awards. "Some people have stamp collections. Well, I have a trophy collection."*

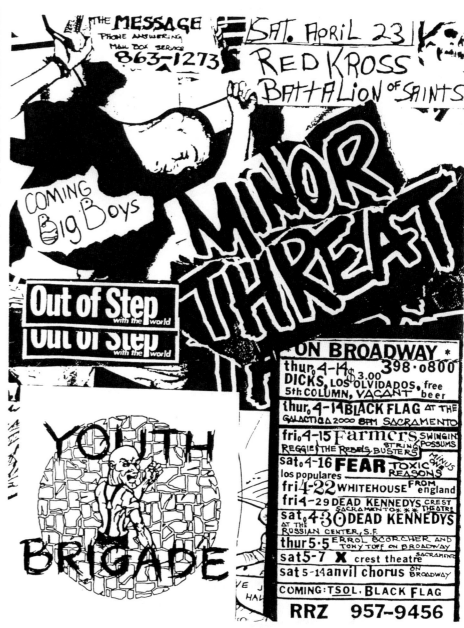

THE MESSAGE
PHONE ANSWERING
MAIL BOX SERVICE
863-1273

SAT. APRIL 23
RED KROSS
BATTALION OF SAINTS

COMING BIG BOYS

MINOR THREAT

Out of Step with the world

Out of Step with the world

ON BROADWAY *

thur. 4-14 $3.00 398-0800
DICKS, LOS OLVIDADOS, free
5TH COLUMN, VACANT beer

thur. 4-14 BLACK FLAG AT THE
GALACTICA 2000 8PM SACRAMENTO

fri. 4-15 Farmers SWINGIN
REGGIE THE REBELS BUSTERS STRING POSSUMS

sat. 4-16 FEAR TOXIC MINUS ONE
los populares REASONS

fri 4-22 WHITEHOUSE FROM england

fri 4-29 DEAD KENNEDYS CREST
SACRAMENTO ** THEATRE

sat. 4-30 DEAD KENNEDYS
AT THE RUSSIAN CENTER, S.F.

thur 5-5 ERROL SCORCHER AND
TONY TOFF ON BROADWAY

sat 5-7 X crest theatre SACRAMENTO

sat 5-14 anvil chorus ON BROADWAY

COMING: TSOL, BLACK FLAG

RRZ     957-9456

YOUTH BRIGADE

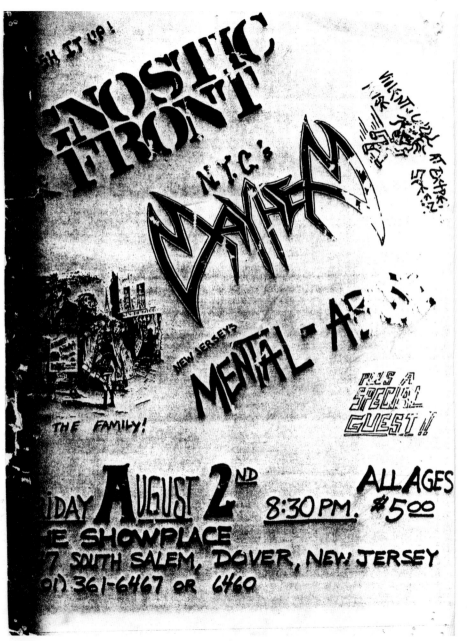

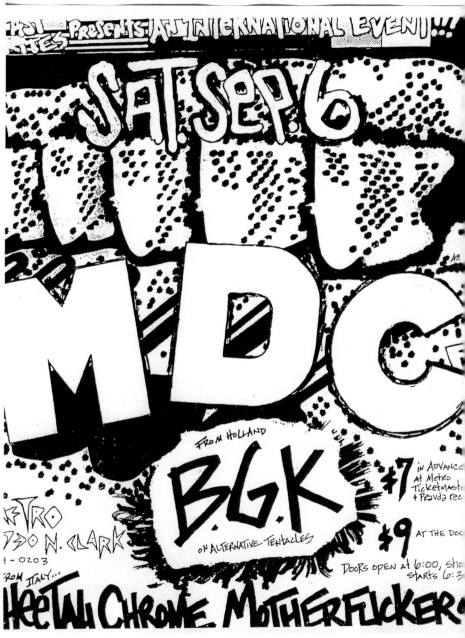

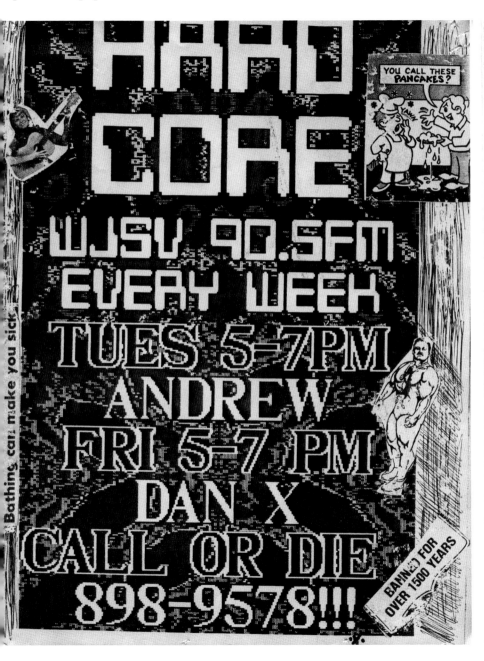

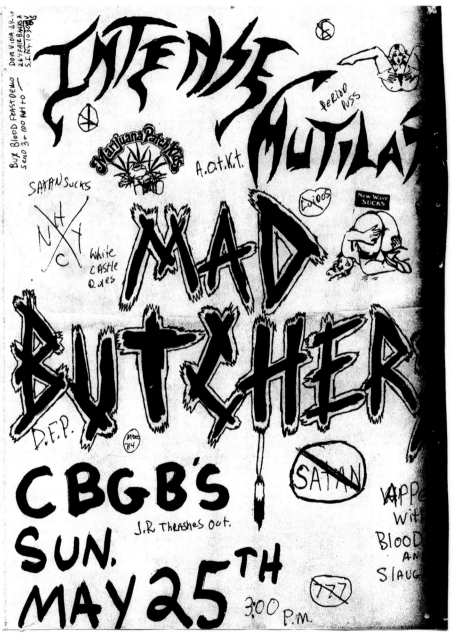

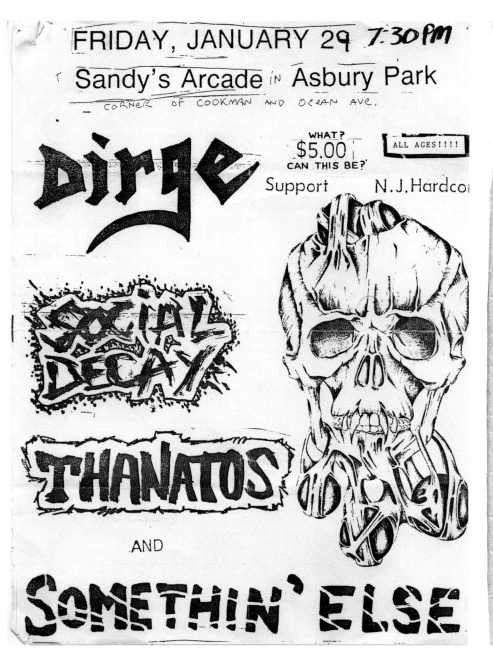

FRIDAY, JANUARY 29 7:30 PM
Sandy's Arcade in Asbury Park
CORNER OF COOKMAN AND OCEAN AVE.

dirge

WHAT?
$5.00
CAN THIS BE?

ALL AGES!!!!

Support    N.J. Hardcor

SOCIAL DECAY

THANATOS

AND

SOMETHIN' ELSE

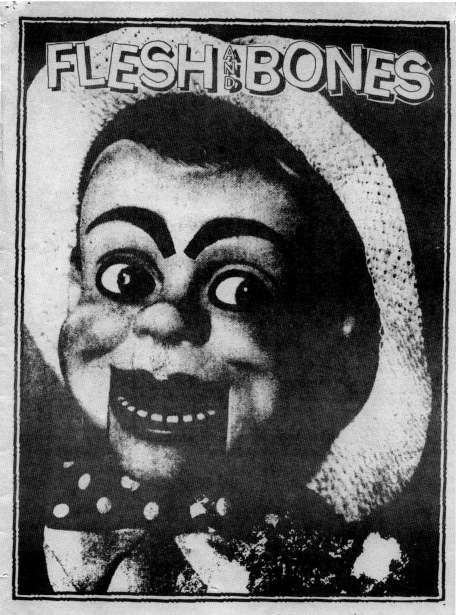

FLESH AND BONES

In This Issue: THE APRC FANZINE DIRECTORY

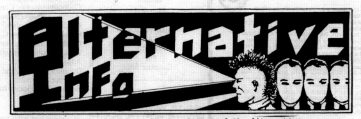

151 1st Ave.
Box A, NY, NY
10003

- The Newsletter of the Alternative
Press & Radio Council For Greater N.Y.

LESS THAN ZERO

**Year of the Ass**

by Jim Testa

HAPPY HOLIDAYS!
SUPPORT ALTERNATIVE INFO

We need YOUR contributions:
Opinions    Letters    Art   Poetry
Scene Reports        Unclassified Ads

It is increasingly obvious that, for whatever reasons, it is suddenly very *in* to be an asshole.

Assholes are everywhere - rude, obnoxious, unthinking, self-serving, unfunny. Comedians don't tell jokes anymore, they just stand on stage and scream. Writers sling cheap insults and call each other names and call that rock criticism. Sports figures are either one step ahead of the narcs or cheered for goon tactics that cripple fellow athletes. Whether it's Pee Wee Herman or Sam Kinison or Howard Stern or Charles Martin or Byron Coley, it's always the same. And what's worse, that stuff isn't even condemned anymore; it's lionized. Bullies and creeps and weirdos and jerks, once the bane of society, are our new national heroes.

Maybe it's time that the rest of us take a good look at what we've been applauding lately. Question the culture we support. Is that guy really funny - does his humor make some telling point about human nature, the essence of all *true* humor since the beginnings of civilization - or is he just acting like a jerk? Does the morning deejay really have to use words like 'spic' and 'nigger,' words that deny human dignity, rather than affirming it? Does it serve any real purpose for all the backbiting, cheap shots, and negativity that's pervaded fanzines this year?

I'm not arguing that assholes have no place in society. Troublemakers, geeks, and losers have often been on the cutting edge. The writings of Mykel Board and Steve Albini - two familar figures in the punk community, both columnists - often evoke extreme responses. Both these guys write things you can't believe any sane person would espouse. But even as the things they say & do make you think, "Asshole," they at least make you *think.* By their very outrageousness, they force you to rethink your own values and formulate a response. And that's a valuable role. In any community.

Thankfully, in the 6 months or so that we've been doing thisn newsletter, I've had the chance to meet or communicate with lots of people who aren't assholes. They're often anonymous and unsaluted, but behind the scenes, of their own accord, they're working hard for us: writing, promoting, supporting. If this newsletter has helped a little, it's been worth it. But what I think about most when I think about the kids out there struggling to find an identity and a voice in our scene is this:

They deserve better than assholes for heroes.

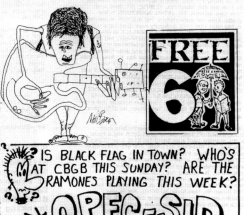

FREE
6

IS BLACK FLAG IN TOWN? WHO'S AT CBGB THIS SUNDAY? ARE THE RAMONES PLAYING THIS WEEK?

DIAL OPEC-SID
(212) 673-2743

THE UPCOMING SHOWS SERVICE OF THE APRC

Just dial OPEC SID (673-2743) and you'll hear a 3-minute message that will clue you in on all the shows, events of interest, and even parties, plus special new you want to know. From Long Island to Trenton, we'll tell you who is playing where and for how much.

CALL OPEC SID TODAY

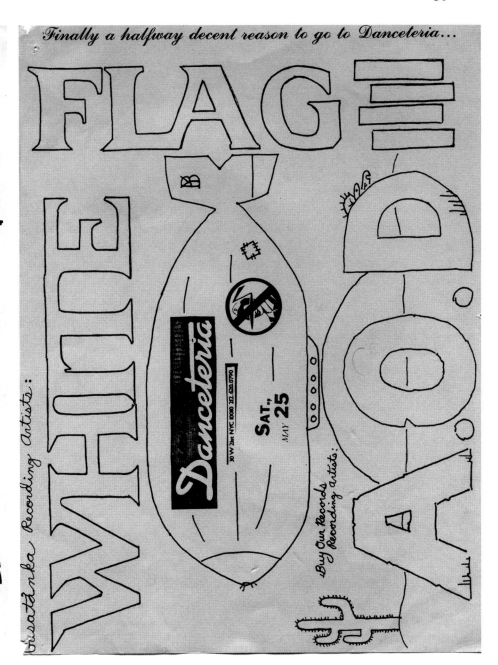

*Finally a halfway decent reason to go to Danceteria...*

FLAG WHILE A.O.D.

Danceteria
30 W 21st NYC 10080 212.620.0790

SAT., MAY 25

Gisatárka Recording Artists:

Buy Our Records Recording Artists:

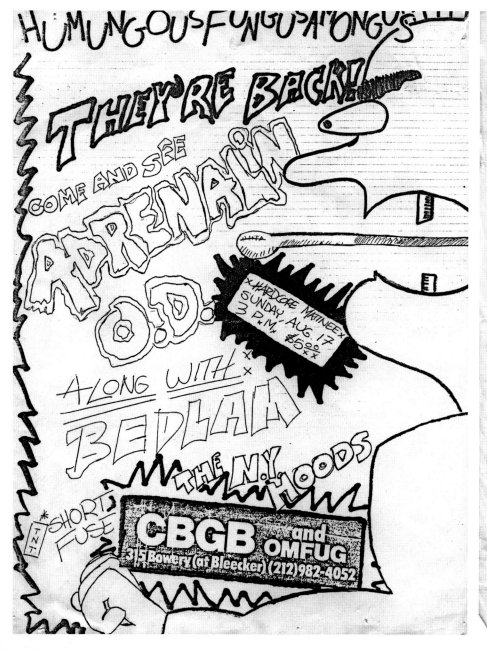

# CITY GARDENS
### 1701 CALHOUN STREET TRENTON, NJ
CALL (609) 392 - 8887

THUR & SAT NIGHT 10PM / 95¢ DRINK SPECIALS
DJ & VJ - CARLOS  21 & UP

## 85¢ DANCE NITE

EVERY FRIDAY NIGHT 9PM 18 & UP / 21 & UP - LOUNGE WITH 75¢ DRINK SPECIALS
$1 OVER 21 / $2 UNDER 21 WITH A COLLEGE ID / $3 ALL OTHERS
TECHNO - HIP HOP - POST MODERN - RAP - HOUSE - RAVE - INDUSTRIAL

FRI DEC 18 - BRING A CAN OF FOOD FOR THE HOMELESS & GET A "LIVE" CASSETTE
FRI DEC 25 - XMAS NIGHT - WE'RE OPEN ! (A BIG NIGHT) - OVER 100 CD'S & CASSETTES GIVEN AWAY
FRI JAN 1 - NEW YEAR'S NIGHT - WE'RE OPEN ! - 20 PAIRS OF PASSES FOR JANUARY SHOWS GIVEN AWAY

RANDY NOW - DJ & VJ
10 FT. VIDEOSCREEN
### ALL-TERNATIVE DANCE
GIVE IT A TRY ! !

2 nites  SAT & SUN DEC 26 & 27  6:30PM  $8.50/ADV  $10/DAY OF SHOW  2 NITES
THE RETURN OF

# BAD BRAINS
SATURDAY NIGHT | SUNDAY NIGHT

## BOUNCING SOULS
### SUBURBAN HOODZ

## TESCO VEE'S HATE POLICE
### BLACK TRAIN JACK

WED DEC 30 7:30PM $10/ADV $12/DAY OF SHOW

## +LIVE+
### SEMI-BEINGS

### NEW YEARS EVE
$3 DANCE $3
MUST BE 21   LOUD MUSIC   OPEN TILL 4A

SUN JAN 3 6:30PM $8.50/ADV $10/DAY OF SHOW | SUN JAN 17 6:30PM $7/ADV $8.50/DAY OF

## SHELTER
### RESSURECTION
### LIFETIME

## GREEN DAY
### Shades Apart  Head Stron

SUN JAN 24 7:30PM $10/ADV $12/DAY OF SHOW | SAT JAN 30 7:30PM $7/ADV $9/DAY OF SHO

# FEAR
### THE SKATENIGS

# SHUDDER TO THINK
### SEVERIN

COMING UP : HENRY ROLLINS SPOKEN WORD / WEEN / G.B.H. /
ADV TIX WITH NO SERVICE CHARGE AT CITY GARDENS ON WEEKENDS / NOW & THEN - NEW HOPE
ROCK DREAMS IV - PLAINSBORO / TRENTON RECORD COLLECTER / PAT'S MUSIC - BENSALEM /
& NOW AT BURNING AIRLINES - NOTTINGHAM WAY - HAMILTON NJ
ADV TIX WITH A SERVICE CHARGE AT ALL TICKETMASTER LOCATIONS OR CALL (609) 520-8383

## TURN THIS FLYER OVER ➜

# NECROS
## + HEART OF IDEALS

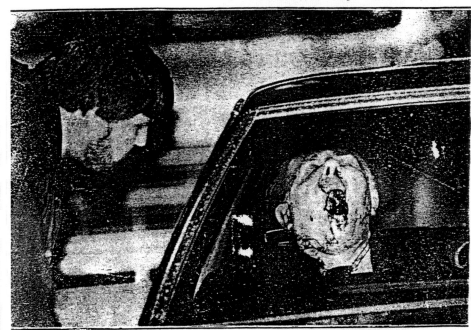

**WED JULY 29**

IS THE LIFE YOU'RE LEADING THE
ONE YOU TRULY DESIRE?
MAKE YOUR OWN DECISIONS
BAD THOUGHTS ARE THOUGHTS NONE THE LESS

BOOKIE'S Club 870

870 W. MCNICHOLS 2½ blocks west of Woodward DETROIT 862-0877 862-081F
B.C.H. 1981

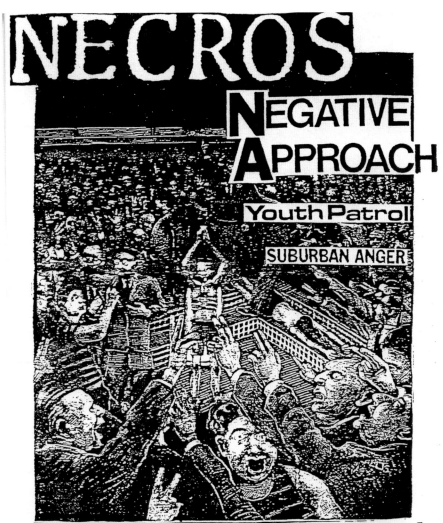

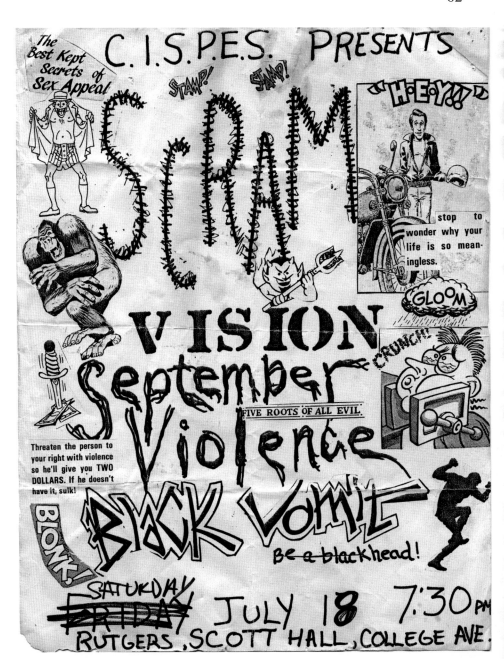

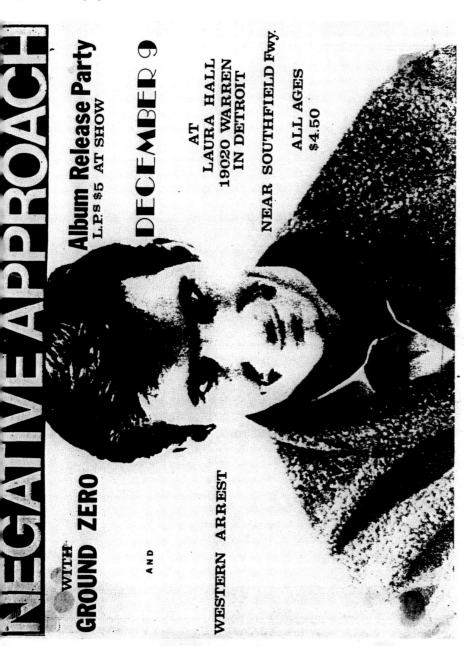

NEGATIVE APPROACH

**Album Release Party**
L.P.s $5 AT SHOW

DECEMBER 9

AT
LAURA HALL
19020 WARREN
IN DETROIT

NEAR SOUTHFIELD Fwy.

ALL AGES
$4.50

WITH GROUND ZERO

AND

WESTERN ARREST

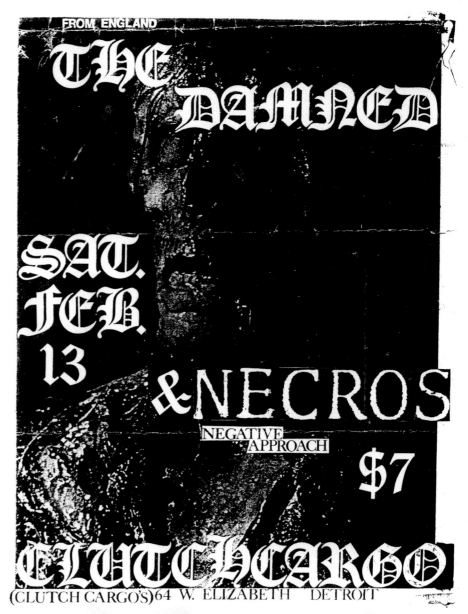

FROM ENGLAND

THE DAMNED

SAT. FEB. 13

&NECROS

NEGATIVE APPROACH

$7

CLUTCHCARGO

(CLUTCH CARGO'S) 64 W. ELIZABETH DETROIT

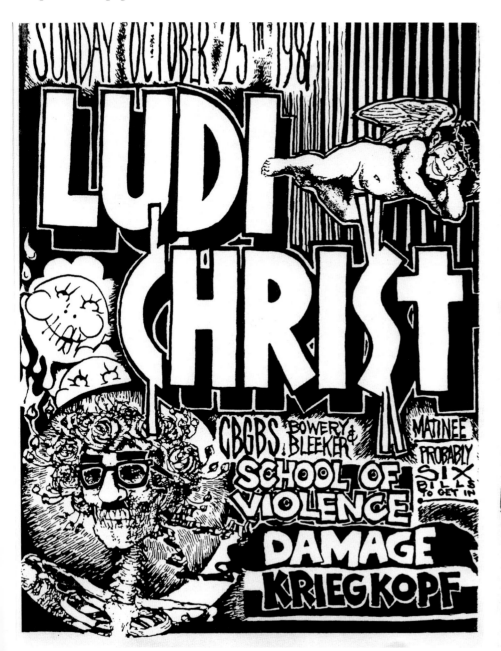

SUNDAY OCTOBER 25 1987
LUDI CHRIST
GBGBS BOWERY & BLEEKER
SCHOOL OF VIOLENCE
DAMAGE
KRIEGKOPF
MATINEE PROBABLY SIX BILLS TO GET IN

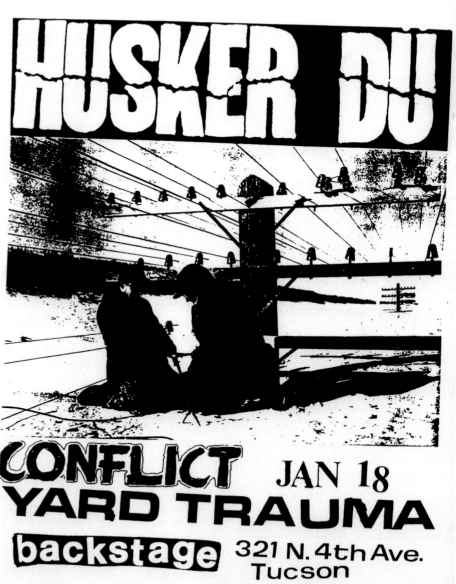

HUSKER DU
CONFLICT
YARD TRAUMA
JAN 18
backstage 321 N. 4th Ave. Tucson

THE OTHER SIDE PRODUCTIONS
PRESENTS AT:
## City Gardens
1701 CALHOUN ST., TRENTON, NJ 609-392-8887

SAT MAY 21 ~9PM  $10
## Throwing Muses
### Noise Petals     Plug

SUN MAY 22  6-10PM  $9  NO ALCOHOL
## Adolescents     Token Entry
### Didjits     Black Vomit

SAT JUNE 4  9-MID  $10  NO ALCOHOL
## BAD BRAINS     IGNITION

SUN juNE 5  6-10PM  $8.50  NO ALCOHOL
## MDC     LUDICHRIST
### Witnesses     Trained attack dogs

FRI JUNE 10  9PM  $8.50  18 & UP / 21 - LOUNGE
## GWAR     She Males

SAT JUNE 11  9PM  $6  18 & UP / 21 - LOUNGE
## Miracle Legion
### Rettmans     Chucks!

COMING UP:
FRI JUNE 17 - REGGAE SUNSPLASH '88 WITH:
   YELLOWMAN & TOOTS AND THE MAYTALS PLUS 4 MORE ACTS!
   ADV TIXS $15.50  DAY OF SHOW $17   THIS IS A FIVE HOUR SHOW!
SAT JUNE 18 - CAMPER VAN BEETHOVEN & ROYAL CRESCENT MOB
FRI JUNE 24 OR SAT JUNE 25 - SOUL ASLYUM & LIVING COLOUR
   (WE WILL FIND OUT THE EXACT DATE NEXT WEEK)
SUN JUNE 26 - BROKEN BONES & U.K. SUBS
SAT JULY 9 - THIRD WORLD
SUN JULY 10 - THE MEAT PUPPETS
SAT JULY 16 - VOI VOD / TESTAMENT / VIOLENCE
SUN JULY 17 - RED KROSS / H. ROLLINS BAND
SAT JULY 23 - JIMMY CLIFF / SUN JULY 24 - CIRCLE JERKS / 7 SECONDS

FUNFIX & GOLDENVOICE present FRI. JULY 24
The Last Ever Show Of The
# DESCENDENTS
with special guest
from San Francisco
# SOCIAL UNREST
## CAPITAL PUNISHMENT
&
## TEEN-AGE PSYCH ON LUDES

MILO GOES TO COLLEGE, M.I
NO AGE LIMIT
TICKETS AVAILABLE AT
TICKETMASTER

ALSO AT THE USUAL
GOLDENVOICE & FUNFIX
TICKET OUTLETS!

at Fender's
521 E. First St.  Long Beach (213) 435-2836
FOR MORE INFO. CALL
(213) 374-8798

GOLDENVOICE presents

# Circle Jerks

## Summer Skankoff

### With
### Channel 3

### M D C
### The Dicks ⎬ TEXAS
### D. R. I.    ⎬ BOYS

## Perkin's Palace
## Friday, August 26, 1983

INFO: 213-796-7001            TICKET PRICE:              DOORS OPEN: 7:00 P.M.
ADDRESS: 129 N. RAYMOND AVE.  ADVANCE: $7.50             MUSIC STARTS: 7:30 P.M.
CITY: PASADENA, CA.           AT DOOR: $8.50             SHOW OVER: 11:45 P.M. SHARP

available at Ticketron, and these record stores

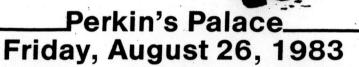

*Zeds · Long Beach · Middle Earth · Downey · Toxic Shock · Pomona · Moby Disc · Pasadena, Canoga Park, Sherman Oaks · Record Shed · Laguna · Vinly Fetush · Hollywood · Aarons · Hollywood · 2nd Time Around · Hollywood · Discount · Costa Mesa · Camel · Huntington Beach · Music Box · Fullerton, Fountain Valley · RTC Record · Orange · Peer · Anaheim

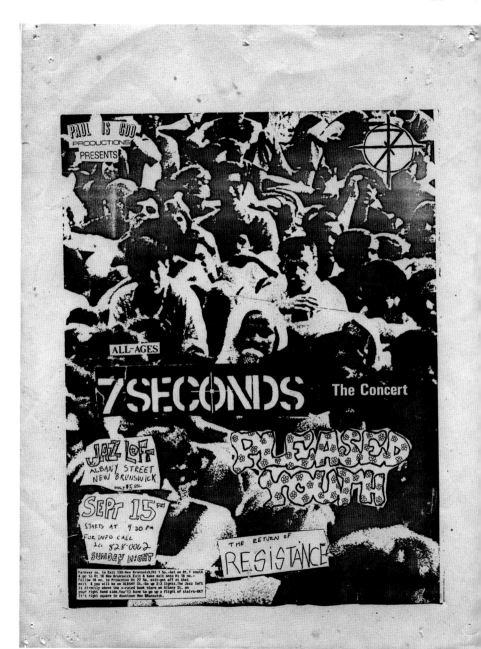

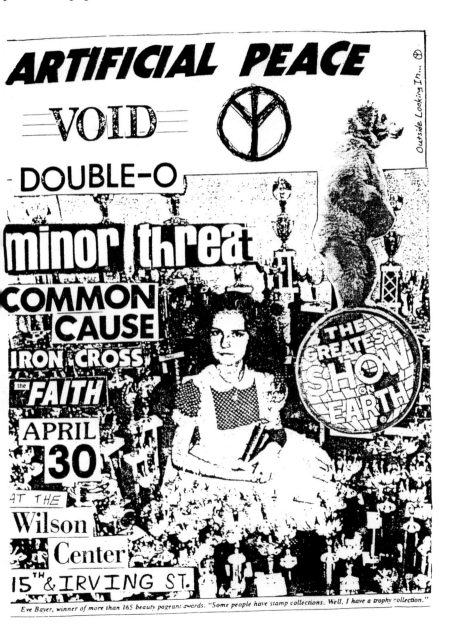

Eve Bayer, winner of more than 165 beauty pageant awards. "Some people have stamp collections. Well, I have a trophy collection."

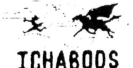

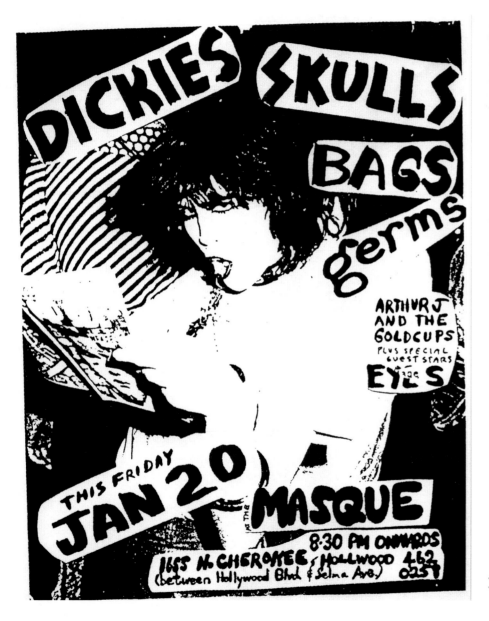

DICKIES SKULLS BAGS germs

ARTHUR J AND THE GOLDCUPS PLUS SPECIAL GUEST STARS EYES

THIS FRIDAY JAN 20 at the MASQUE

8:30 PM ONWARDS

1655 N. CHEROKEE Hollywood 462 (between Hollywood Blvd & Selma Ave) 0259

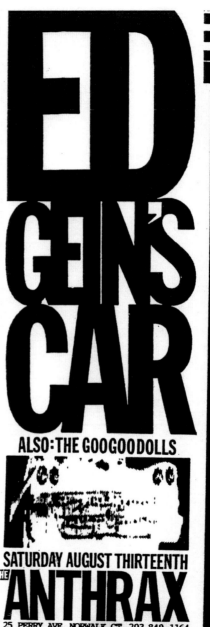

ED GEIN'S CAR

ALSO: THE GOO GOO DOLLS

SATURDAY AUGUST THIRTEENTH

THE ANTHRAX

25 PERRY AVE. NORWALK CT. 203 849-1164

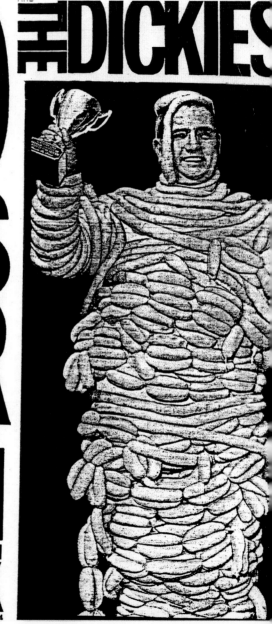

THE DICKIES

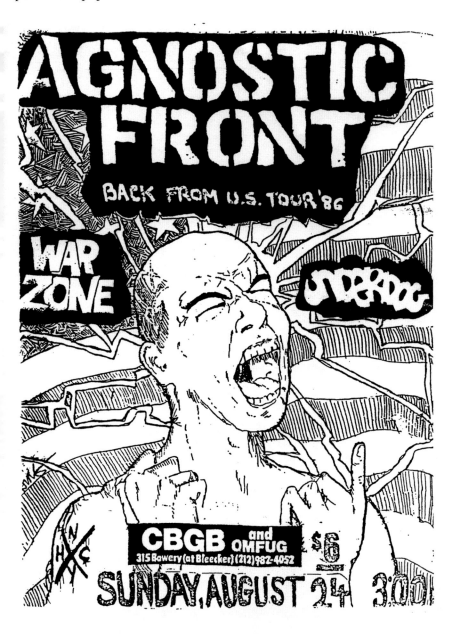

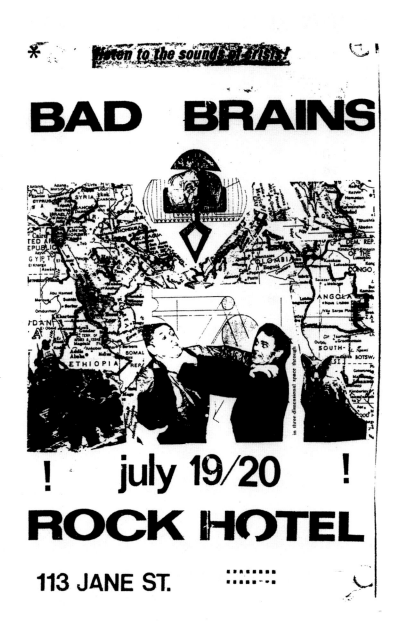

THE OTHER SIDE PRESENTS AT:
City Gardens
1701 CALHOUN ST., TRENTON, N.J. 609-392-8887

FRI MAY 1   9 pm   $10
fishbone   A.O.D.
SHOWTIME: 10:30 PM

SUN MAY 3   6:30-10 pm   $10
BUTTHOLE SURFERS
CLEFT PALATE        WEEN

SAT MAY 9   9 pm   $8
MEAT PUPPETS
Electric Love Muffin

SUN MAY 10   6:30-10 pm   $10
SUICIDAL TENDENCIES
McRad / Jersey Fresh

WED MAY 20   8 pm - MID   $8
wtsr nite
SKINNY PUPPY
SHOWTIME: 10 PM

SST RECORDS PRESENTS:
FRI MAY 22   9 pm   $9
SONIC YOUTH
DAS DAMEN / DINOSAUR

COMING: SUN JUNE 7: THE MEATMEN/ED GEIN'S CAR $8 6:30--10PM
SUN JUNE 21: THE DESCENDENTS/THE HENRY ROLLINS BAND/M.I.A.

SUICIDAL TENDENCIES WILL BE AT "ROCK DREAM RECORD STORE" FOR AN
IN-STORE APPEARANCE SUN MAY10 4PM-5PM CALL (609)890-0808

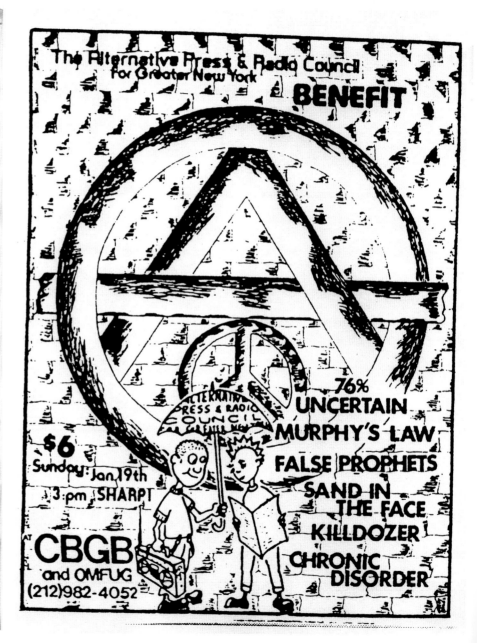

The Alternative Press & Radio Council
for Greater New York
BENEFIT

76% UNCERTAIN
MURPHY'S LAW
FALSE PROPHETS
SAND IN THE FACE
KILLDOZER
CHRONIC DISORDER

$6
Sunday Jan 19th
3 pm SHARP!

CBGB
and OMFUG
(212)982-4052

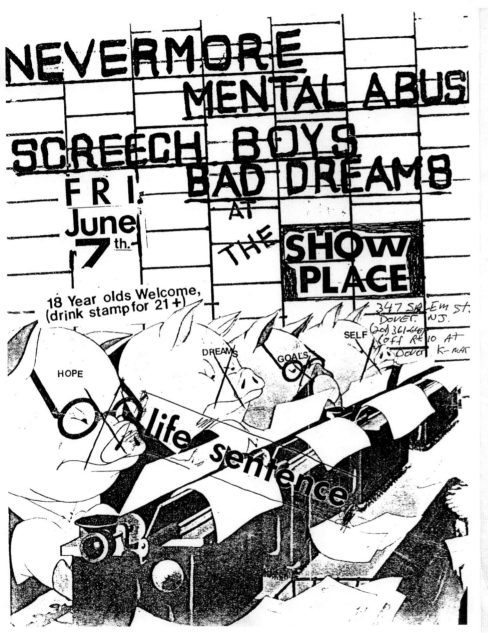

NEVERMORE
MENTAL ABUS
SCREECH BOYS
FRI. BAD DREAM8
June AT
7th. THE SHOW PLACE

18 Year olds Welcome,
(drink stamp for 21 +)

347 SALEM St.
DOVER. NJ.
(201) 361-6467
off Rt 10 At
Dover K-MART

SELF

HOPE  DREAMS  GOALS

life sentence

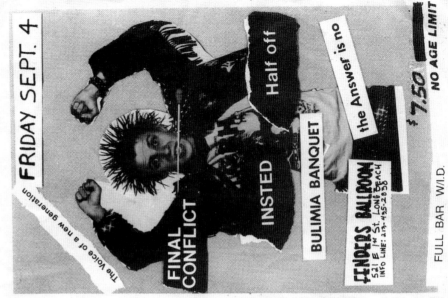

FRIDAY SEPT. 4

The Voice of a new generation

Half off

the Answer is no

$7.50  NO AGE LIMIT

FINAL CONFLICT

INSTED

BULIMIA BANQUET

FENDERS BALLROOM
521 E 1st St. LONG BEACH
INFO LINE: 213-435-2055

FULL BAR W/ID.

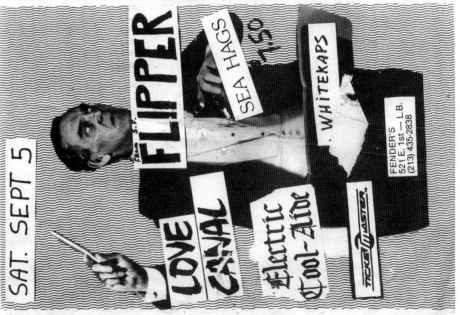

SAT. SEPT 5

From S.F. FLIPPER

SEA HAGS

150

WHITEKAPS

LOVE CANAL

Electric Cool-Aide

FENDER'S
521 E. 1st — L.B.
(213) 435-2838

TICKETMASTER

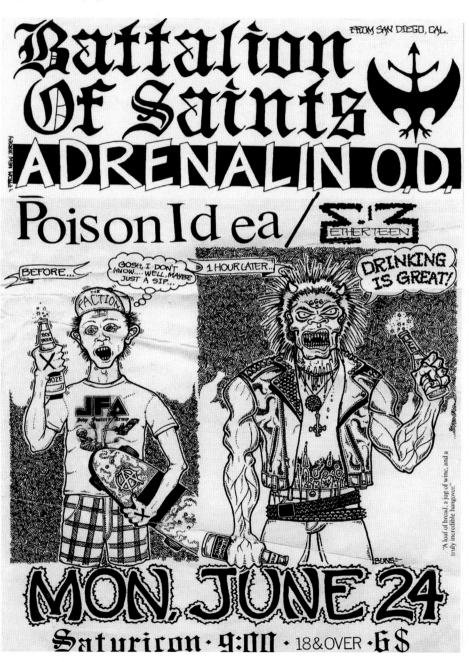

**Battalion Of Saints**
FROM SAN DIEGO, CAL.
**ADRENALIN O.D.**
FROM NEW JERSEY
**Poison Idea** / **Σ·13** ETHERTEEN

BEFORE...
GOSH, I DON'T KNOW... WELL, MAYBE JUST A SIP...
1 HOUR LATER...
DRINKING IS GREAT!
"A loaf of bread, a jug of wine, and a truly incredible hangover."

**MON. JUNE 24**
Saturicon · 9:00 · 18 & OVER · 6$

**KRAUT**
BUTTHOLE SURFERS
RUIN
THE VANDALS
SCORNFLAKES
SUN. SEPT. 9th 4-9 p.m.
**NEW YORK SOUTH**
RT. 130 FLORENCE NJ
for info 609-298-3628
ALL AGES—NO LIQUOR
COMING UP—
SUN. SEPT. 23 - THE REPLACEMENTS
              THE JOHNSONS
SUN. SEPT. 30 - SUICIDAL TENDENCIES
SUN. OCT. 7 - HÜSKER DÜ
       COMING IN OCT. + NOV.—
MARGINAL MAN, S.S. DECONTROL,
76% UNCERTAIN, TSOL, 45 GRAVE,
NASH THE SLASH,
BEASTIE BOYS

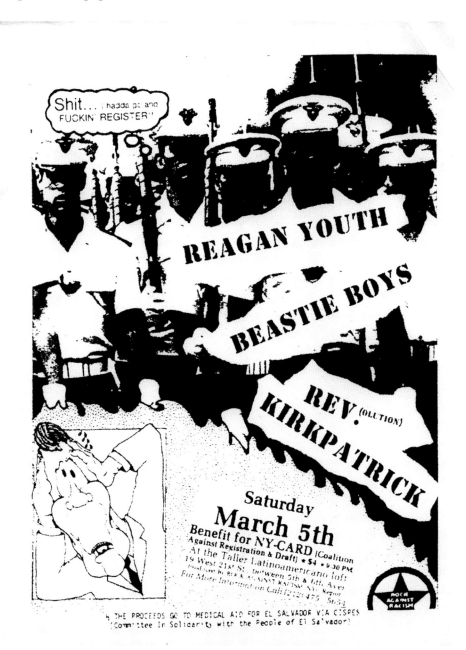

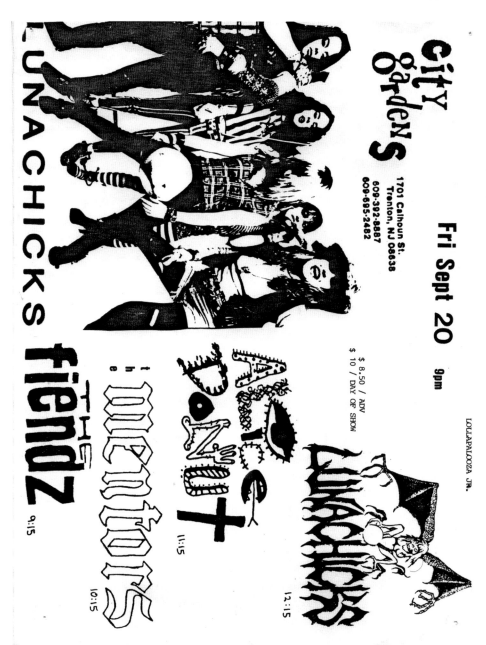

# MEET SLAYER!

## FRIDAY, JUNE 28th 3:30 - 5:00pm
## AT HMV · 1280 LEXINGTON AT 86TH

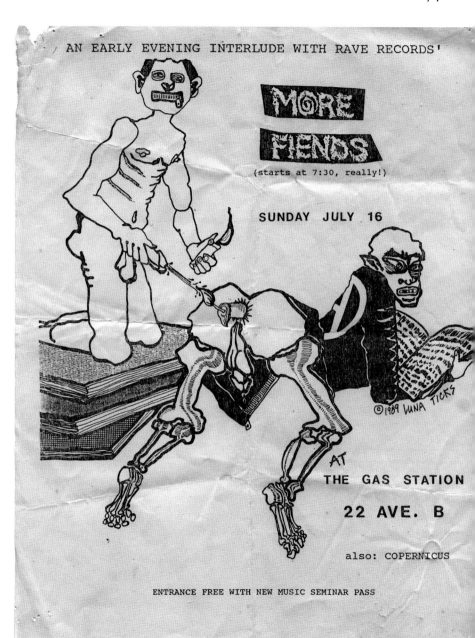

AN EARLY EVENING INTERLUDE WITH RAVE RECORDS'

MORE FIENDS

(starts at 7:30, really!)

SUNDAY JULY 16

©1989 LUNA TICKS

AT
THE GAS STATION

22 AVE. B

also: COPERNICUS

ENTRANCE FREE WITH NEW MUSIC SEMINAR PASS

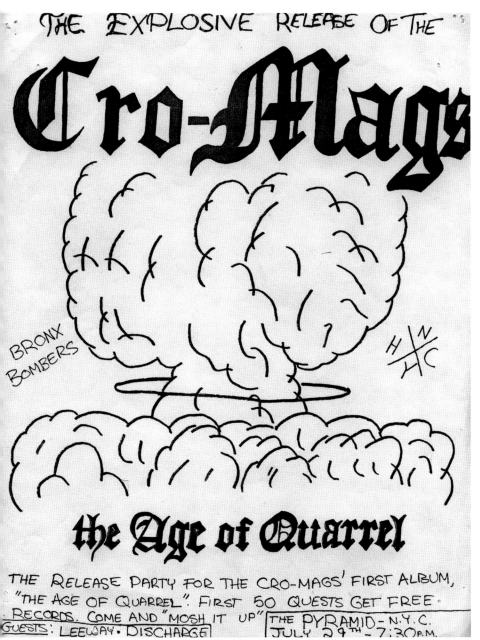

THE EXPLOSIVE RELEASE OF THE

# Cro-Mags

BRONX BOMBERS

H/N/HC

## the Age of Quarrel

THE RELEASE PARTY FOR THE CRO-MAGS' FIRST ALBUM,
"THE AGE OF QUARREL". FIRST 50 QUESTS GET FREE
RECORDS. COME AND "MOSH IT UP" | THE PYRAMID - N.Y.C.
GUESTS: LEEWAY • DISCHARGE | JULY 29TH - 7:30 P.M.

big boys
AUSTIN, TEXAS

YUM YUM

| SAN FRANCISCO | LOS ANGELES |
|---|---|
| MAY 27&28 w/ BLACK FLAG MINUTEMEN AT "ON BRDWY" | JUNE 3 (FRIDAY) w/ CH.3 |
| MAY 30 THRASHER SKATE MAGAZINE SHOW AT "ON BRDWY" —7 BAND SHOW! | AT VEX'S |

BISCUIT '93

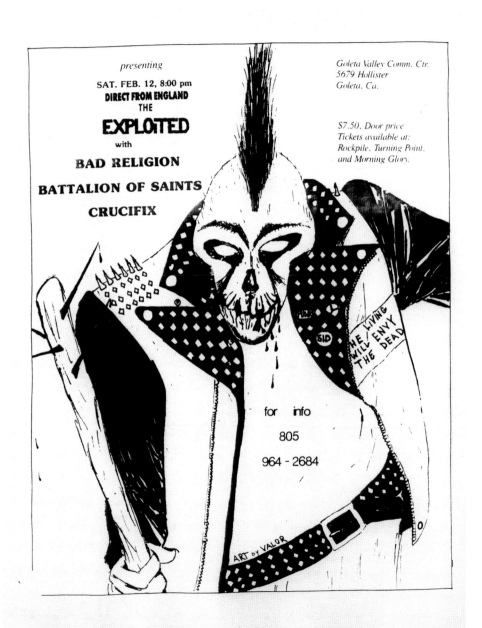

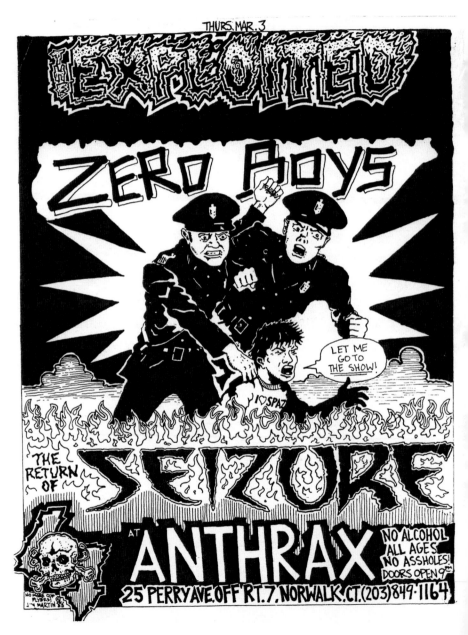

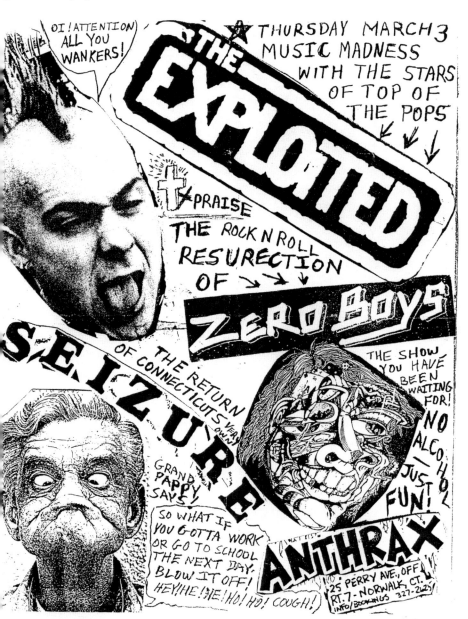

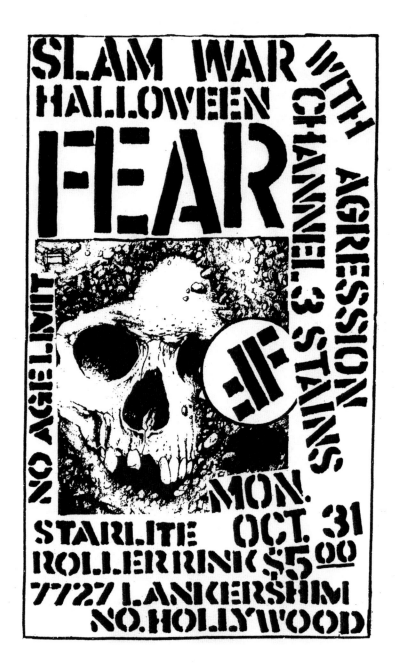

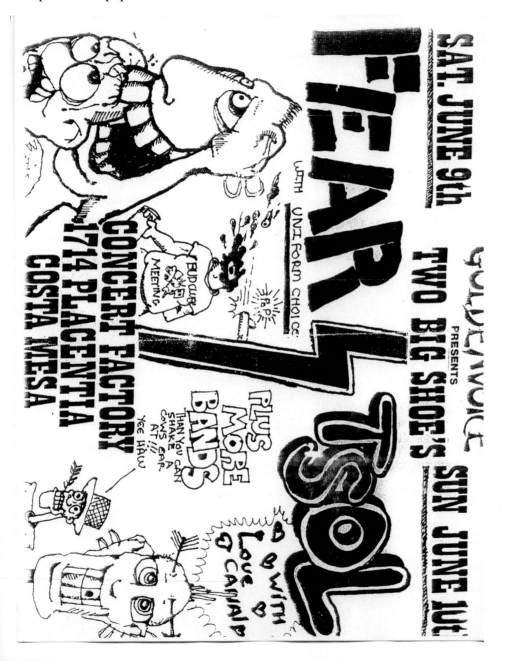

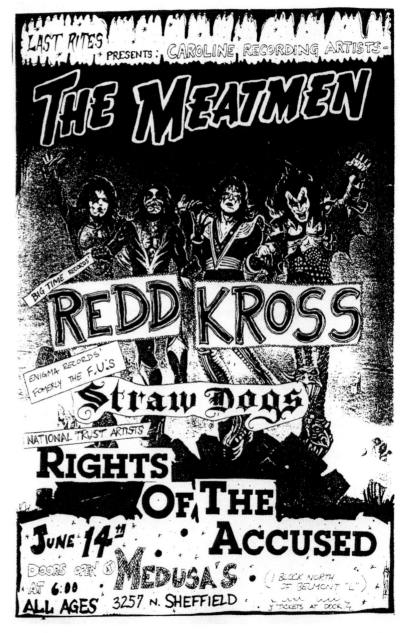

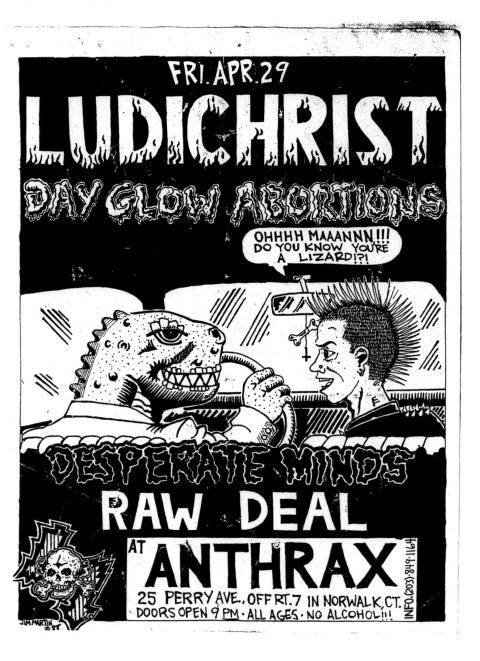

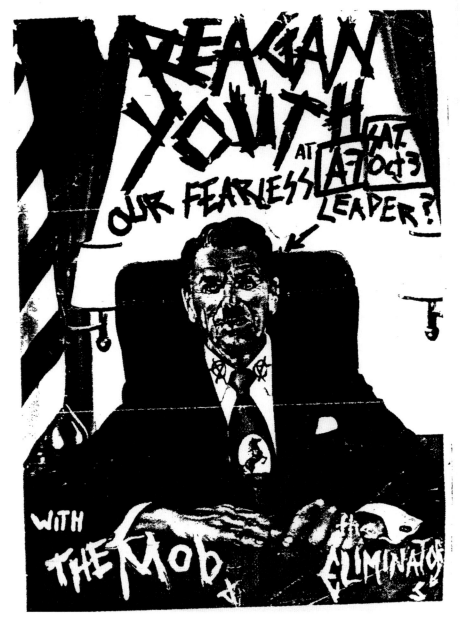

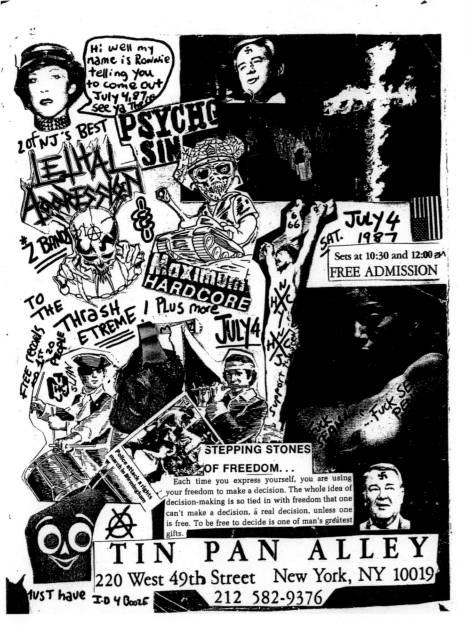

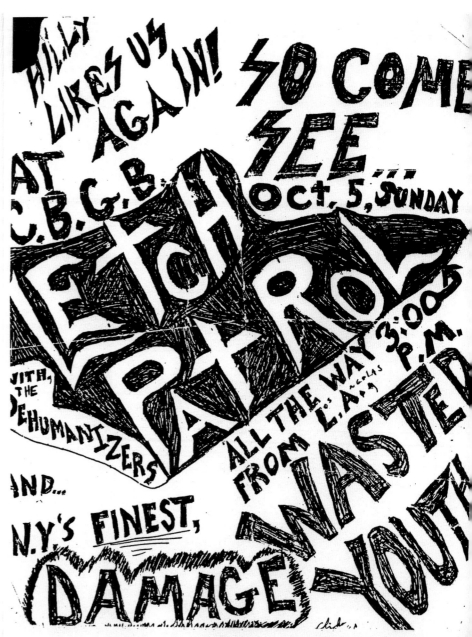

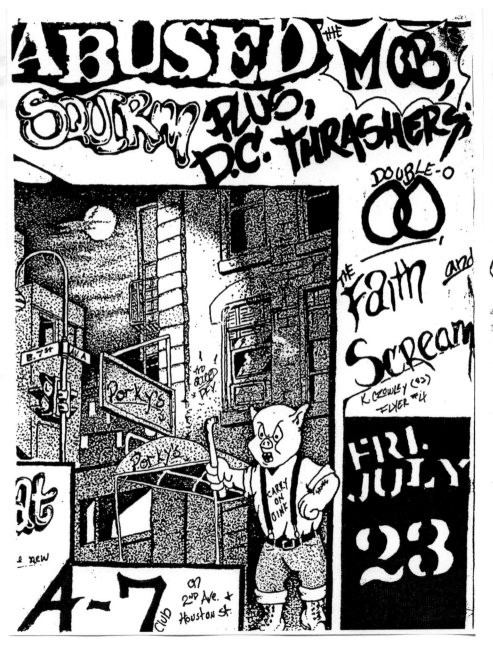

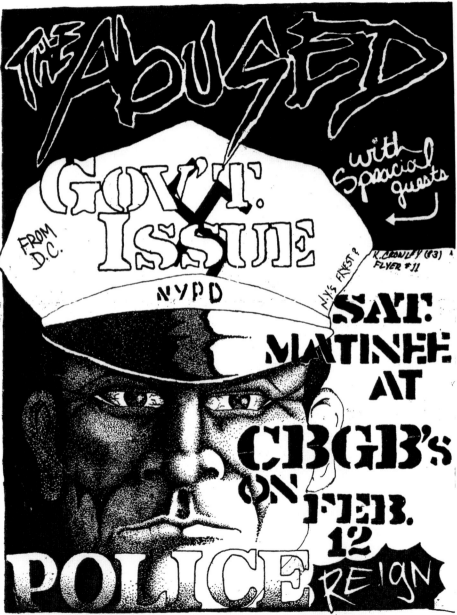

SILVER DOLLAR SALOON presents

Fri March 5
NYC Hardcore

**EVEN WORSE**

N.J. Hardcore

**ADRENALIN O.D.**

Fri March 12
Dangerous Birds (Boston)
Erratic Sensation

Sat. March 6

**KINETICS**
**U.S. PLAINZ**
**UXB**

Sat March 13
V. (Boston)

Coming Native Tongue. Cyclones. Heart Attack. Black Flag

201 483-9052

801 S. 4th St. at PATH station  Harrison N.J.

"Arrive early, doors open 9 PM"

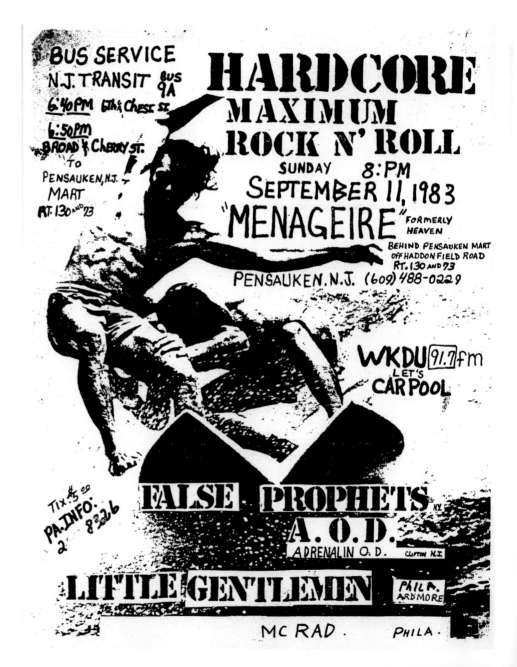

BUS SERVICE
N.J. TRANSIT BUS 9A
6:40 PM 6th & Chest. St.

6:50 PM
BROAD & CHERRY ST.
TO
PENSAUKEN, N.J.
MART
RT. 130 AND 73

# HARDCORE
## MAXIMUM
## ROCK N' ROLL
SUNDAY     8:PM
SEPTEMBER 11, 1983
"MENAGEIRE" FORMERLY HEAVEN

BEHIND PENSAUKEN MART
OFF HADDON FIELD ROAD
RT. 130 AND 73
PENSAUKEN, N.J. (609) 488-0229

WKDU 91.7 fm
LET'S
CAR POOL

Tix $5.00
PA. INFO:
2  8326

**FALSE PROPHETS** N.Y.
**A.O.D.**
ADRENALIN O.D.  CLIFTON N.J.

**LITTLE GENTLEMEN**  PHILA. ARDMORE

MC RAD.          PHILA.

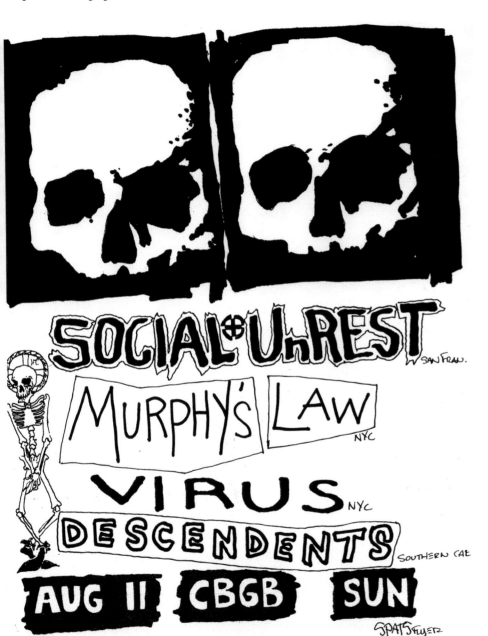

SOCIAL ☩ UnREST SAN FRAN.

MURPHY'S LAW NYC

VIRUS NYC

DESCENDENTS SOUTHERN CAL.

AUG 11    CBGB    SUN

SPATS FLYER

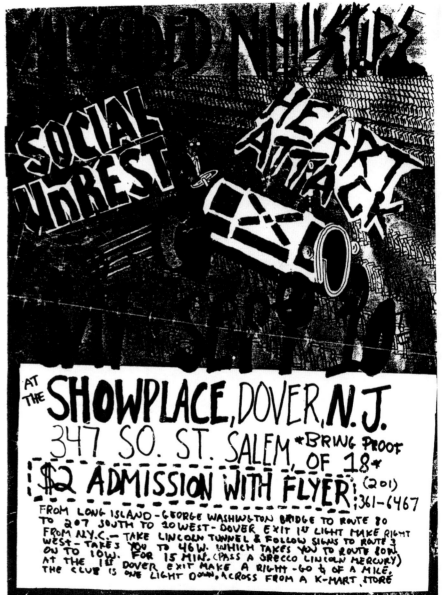

SOCIAL UnREST    HEART ATTACK

AT THE SHOWPLACE, DOVER, N.J.
347 SO. ST. SALEM *BRING PROOF OF 18*
$2 ADMISSION WITH FLYER (201) 361-6467
FROM LONG ISLAND - GEORGE WASHINGTON BRIDGE TO ROUTE 80
TO 207 SOUTH TO 10 WEST - DOVER EXIT 1st LIGHT MAKE RIGHT
FROM N.Y.C. - TAKE LINCOLN TUNNEL & FOLLOW SIGNS TO ROUTE 3
WEST - TAKES YOU TO 46 W. WHICH TAKES YOU TO ROUTE 80N
ON TO 10W. FOR 15 MIN. (PASS A GRECCO LINCOLN MERCURY)
AT THE 1st DOVER EXIT MAKE A RIGHT - GO ⅔ OF A MILE.
THE CLUB IS ONE LIGHT DOWN, ACROSS FROM A K-MART STORE

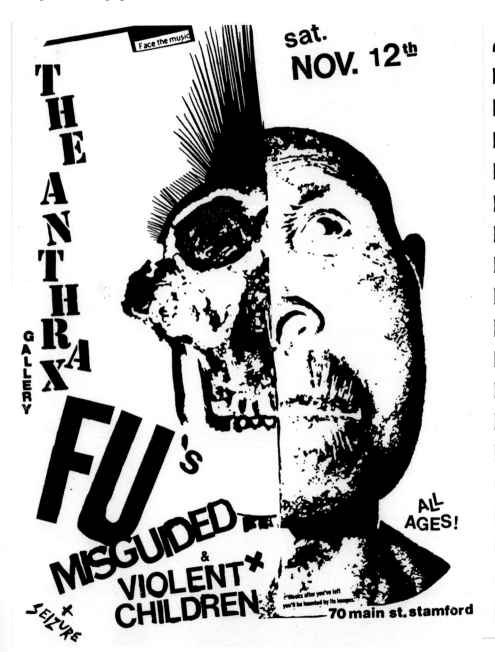

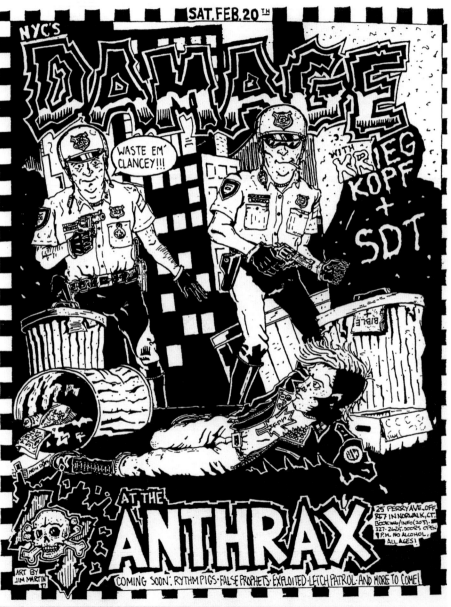

# MISGUIDED
# HOLY TERRORS
PLUS FROM SAN FRANCISCO: **SOCIAL UnREST**

HOME SWEET HOME

SAT. SEPT 3RD
CBGB'S
3:00
$3

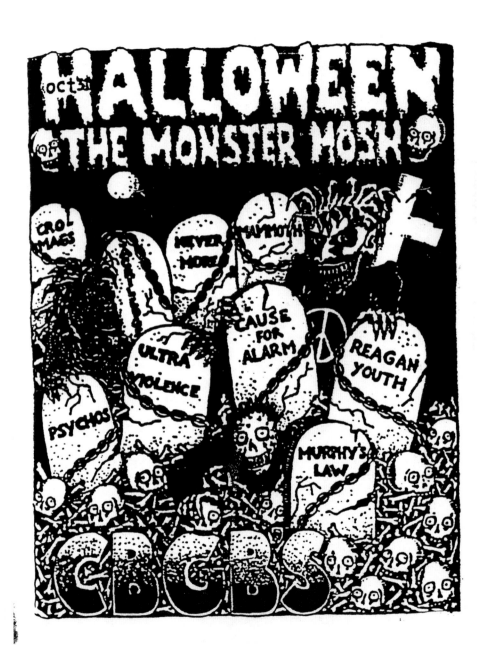

OCT 31 HALLOWEEN
THE MONSTER MOSH

CRO-MAGS
NEVER MORE
MAMMOTH
CAUSE FOR ALARM
REAGAN YOUTH
ULTRA VIOLENCE
PSYCHOS
MURPHY'S LAW

CBGB

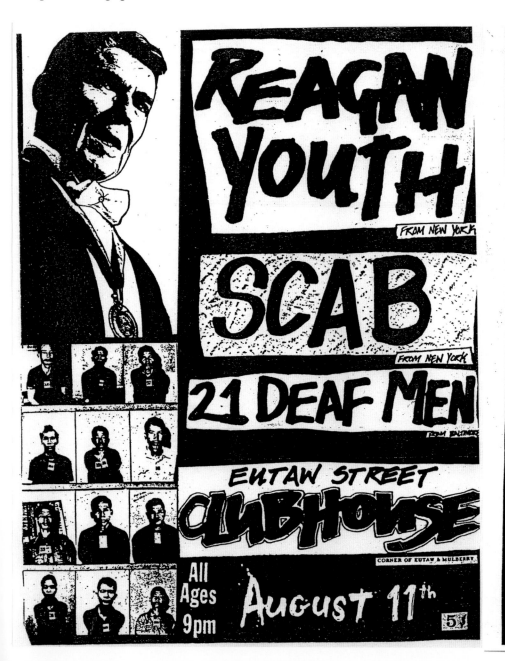

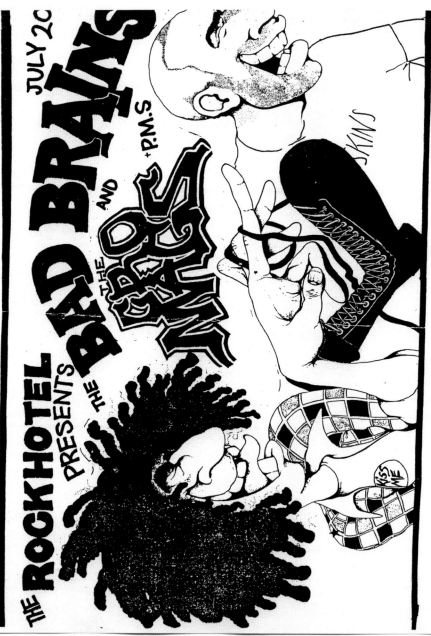

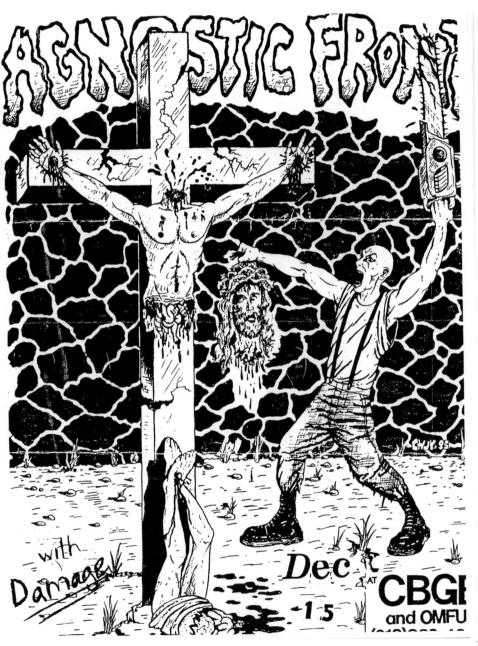

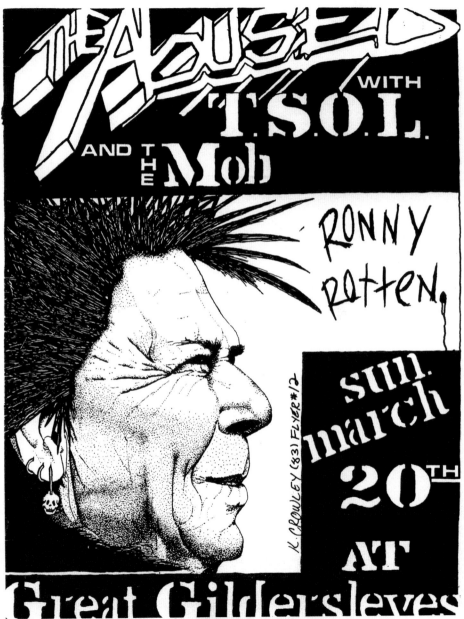

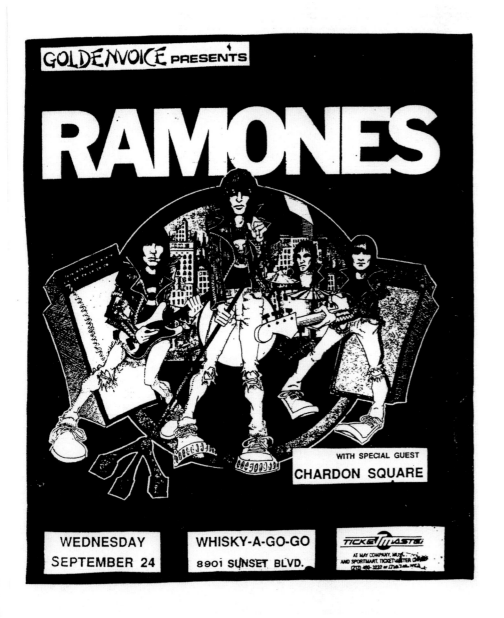

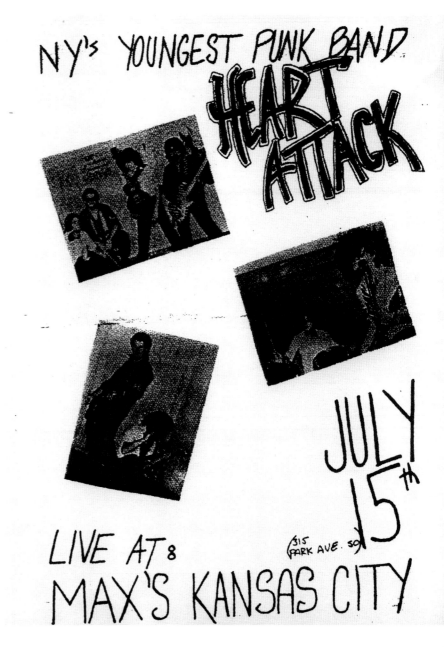

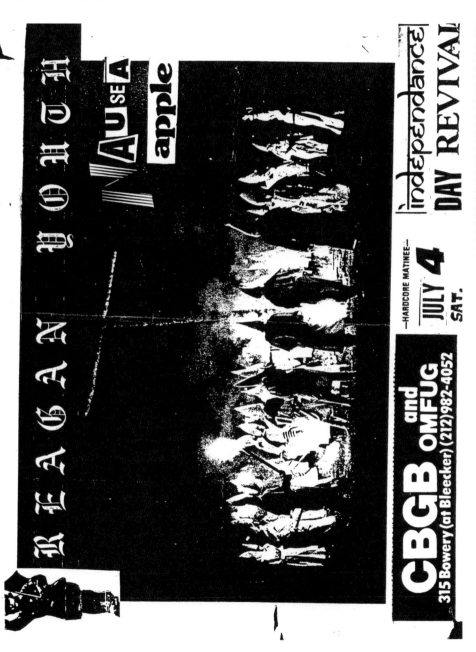

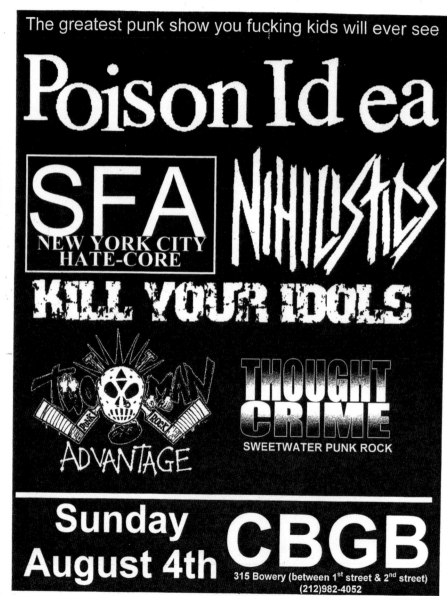

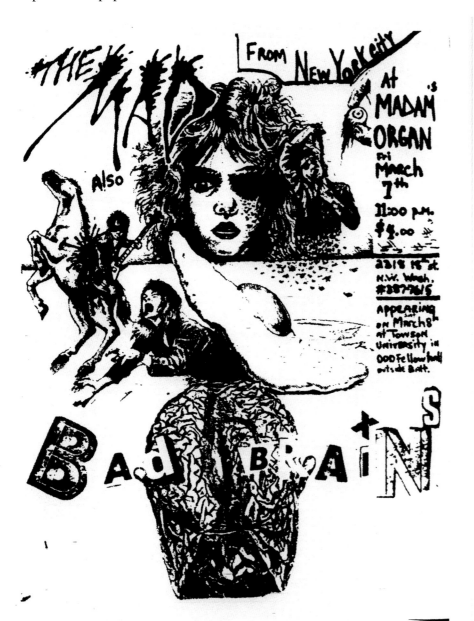

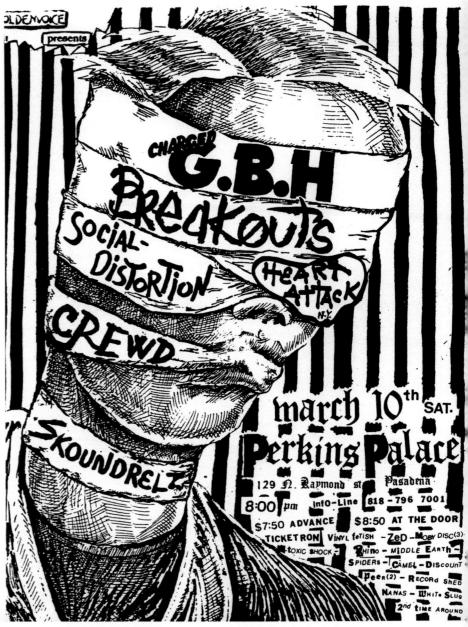

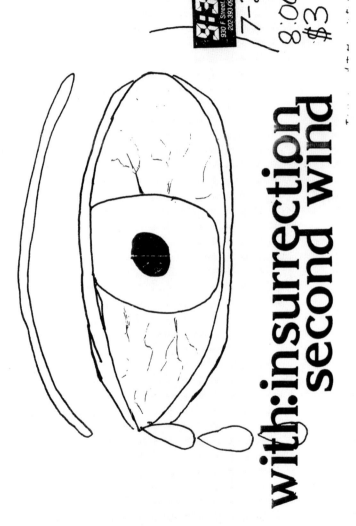

MARGINAL MAN

with: insurrection
second wind

9:30
930 F Street, N.W.
202.393.0930
7-24
8:00P
$3

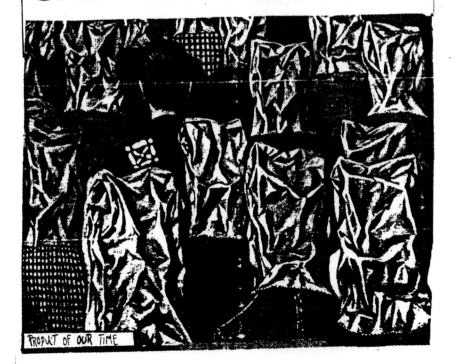

MISGUIDED PLUS FROM BOSTON: F.U.'S
JERRY'S KIDS / 3:00
JAN. 29 CBGB'S
SAT. MATINEE

PRODUCT OF OUR TIME

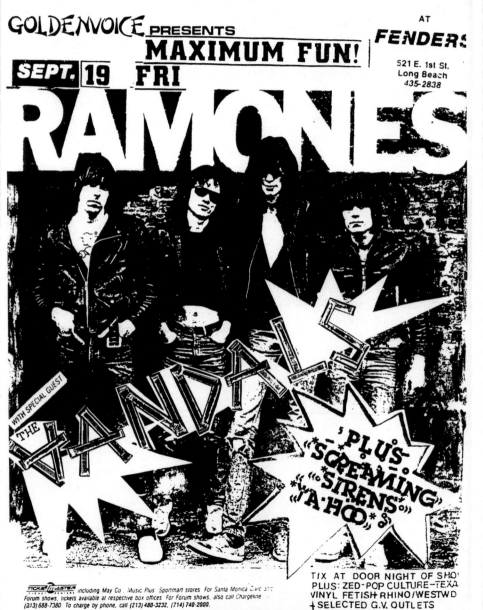

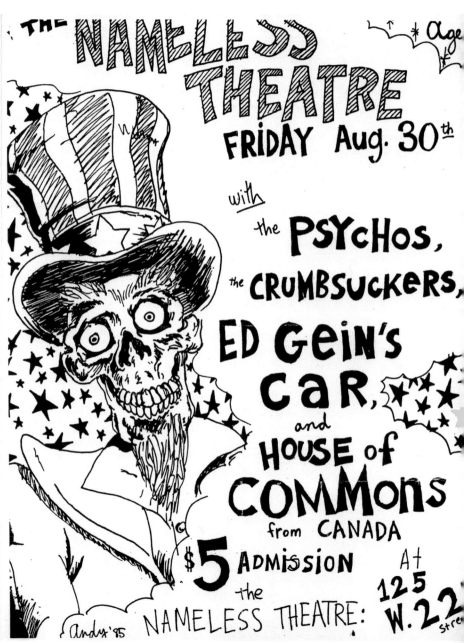

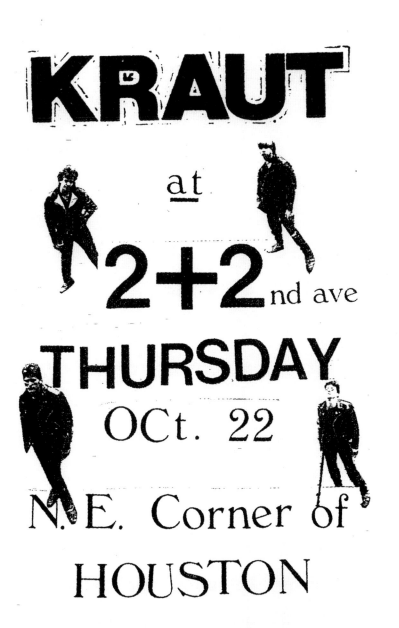

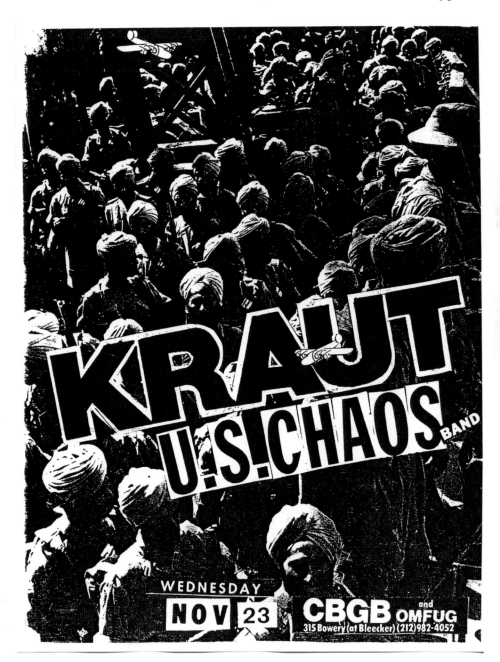

Everyone involved in this book grew up in Northern New Jersey, so you could say this book is geographically biased. I grew up near a club called the Showplace, which was a lot like any other dark, dirty, loud punk place. The Showplace did have an actual pit though. The pit was about 6 inches recessed into the floor, near the stage. I am not sure if this is how the term "pit" was derived, I'm not sure if other clubs had these. The Showplace did and that is all that mattered to me at that time.

My friend Steve Burns got me into the club even though I was under age. I think he looked after me mainly because he wanted to get with my older sister. He would have no idea the effect these shows would have on me through the years

I visited the Showplace in 2005. It is now a strip bar. I wouldn't have it any other way.

Black Flag played there in 1985.

Lee

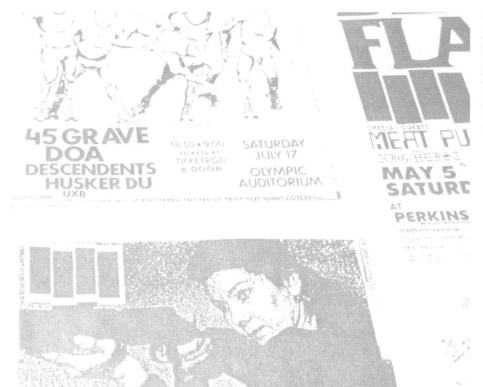

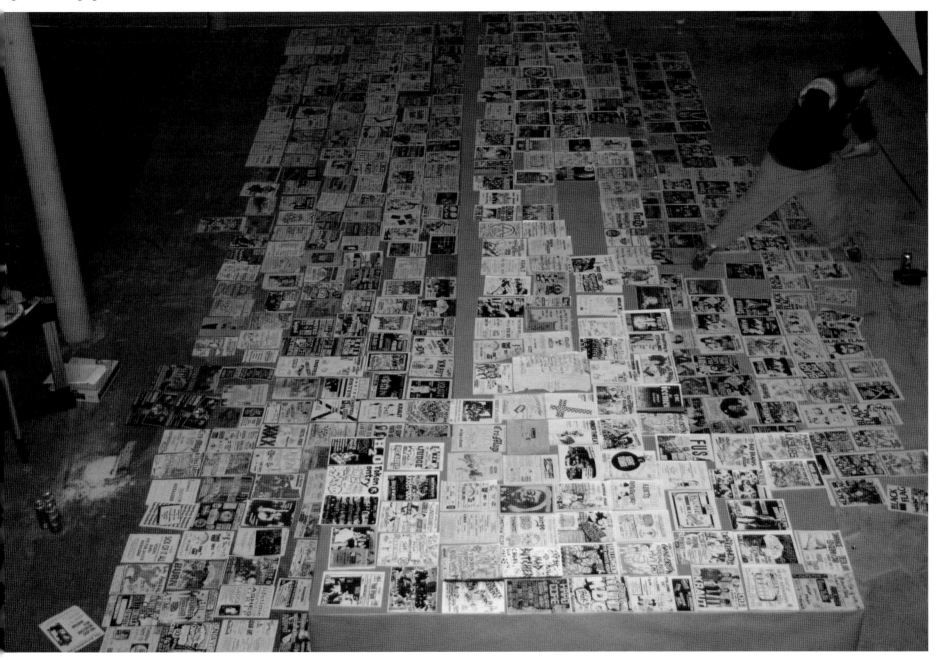

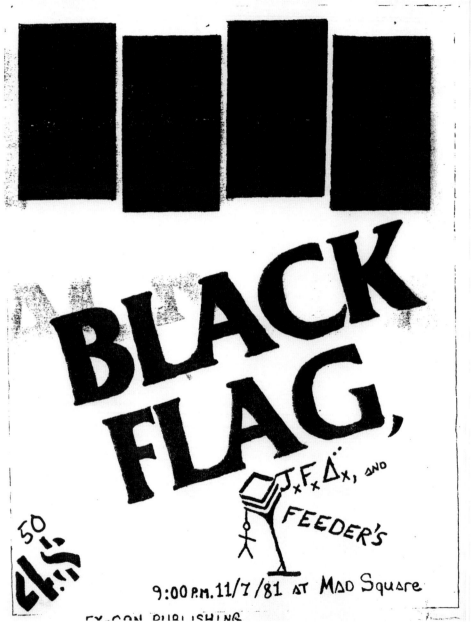

BLACK FLAG,

$J_xF_x\Delta_x$, and

FEEDER'S

50¢

9:00 P.M. 11/7/81 AT MAD Square

EX-CON PUBLISHING

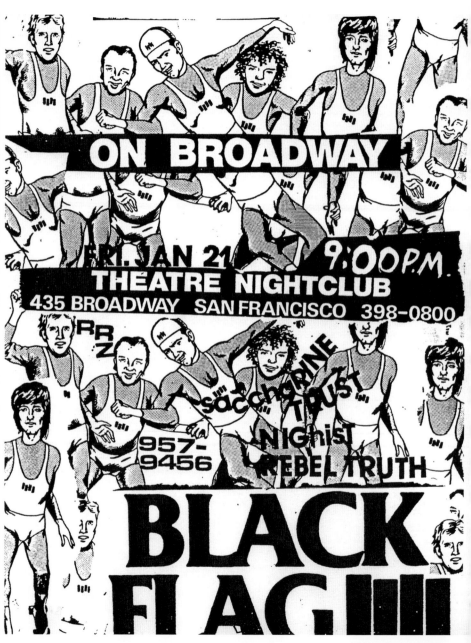

ON BROADWAY

FRI. JAN 21     9:00 P.M.
THEATRE NIGHTCLUB
435 BROADWAY   SAN FRANCISCO   398-0800

RRZ

957-9456

Saccharine Trust

NIGhiST
REBEL TRUTH

BLACK FLAG

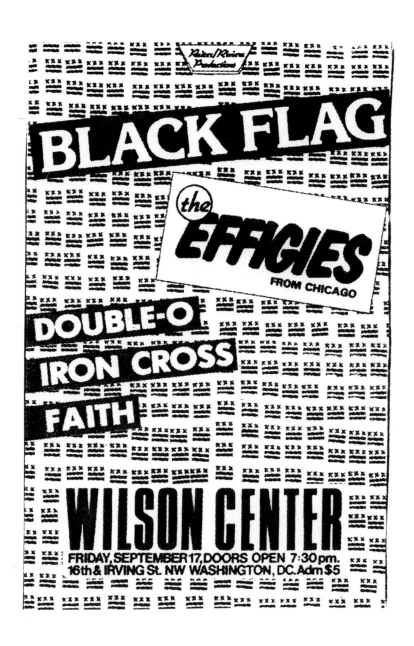

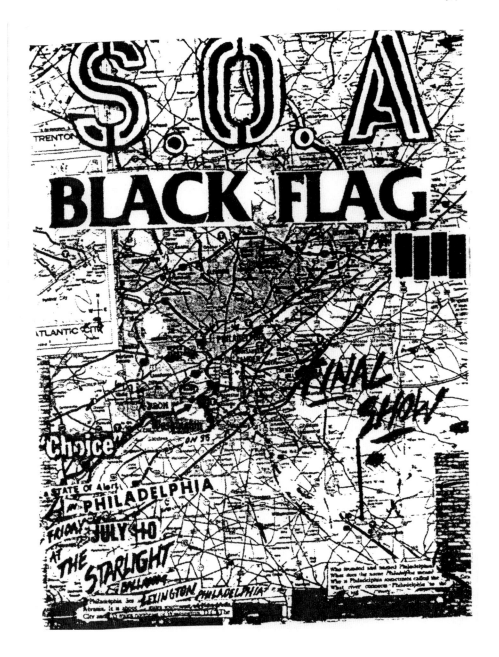

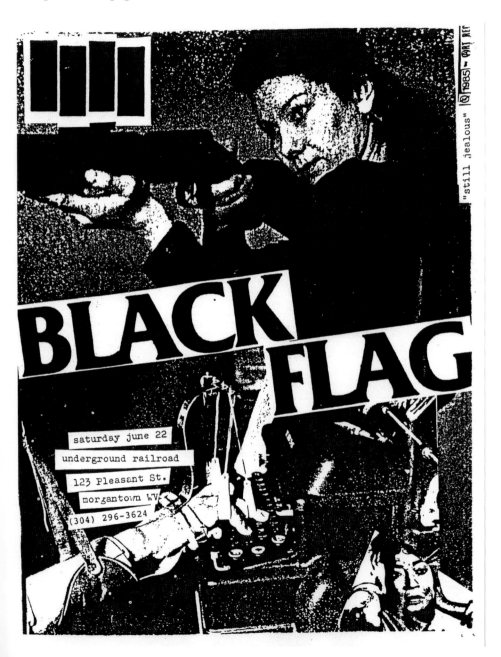

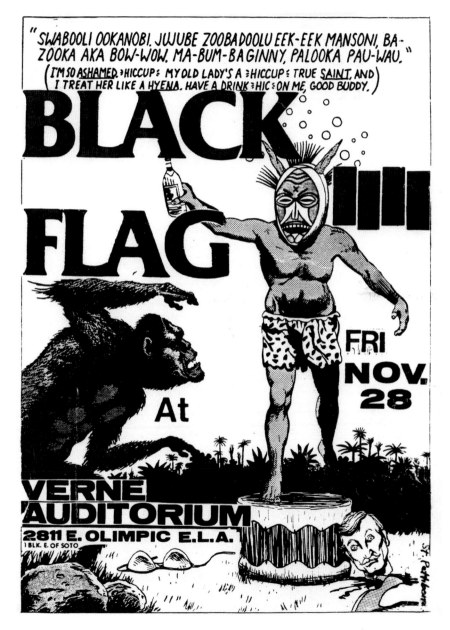

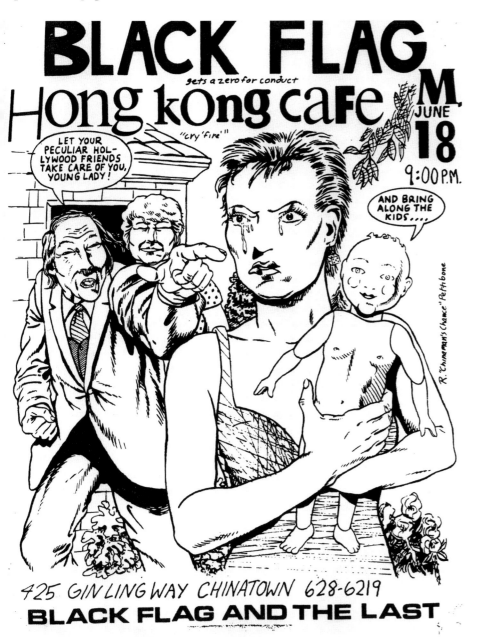

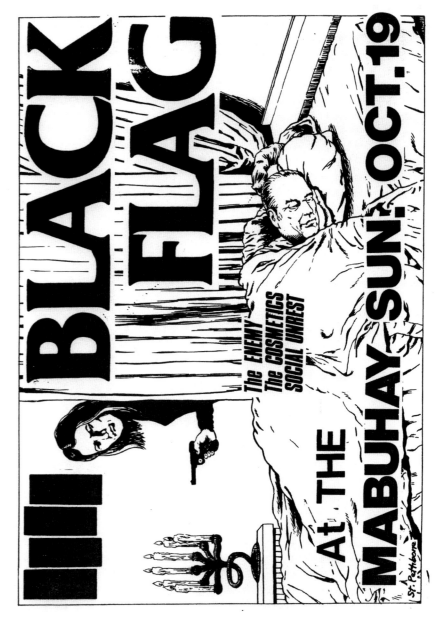

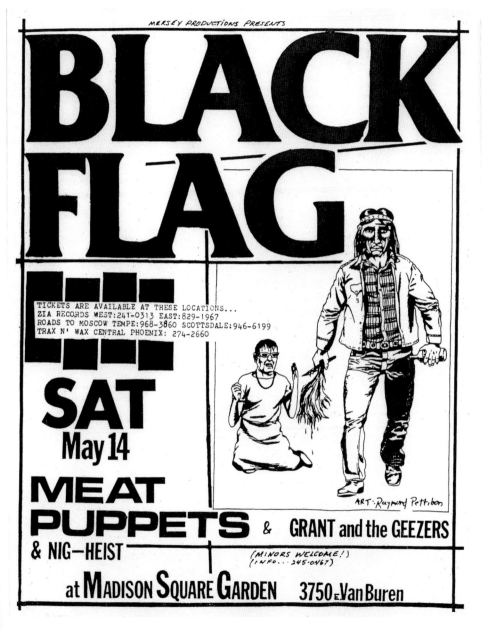

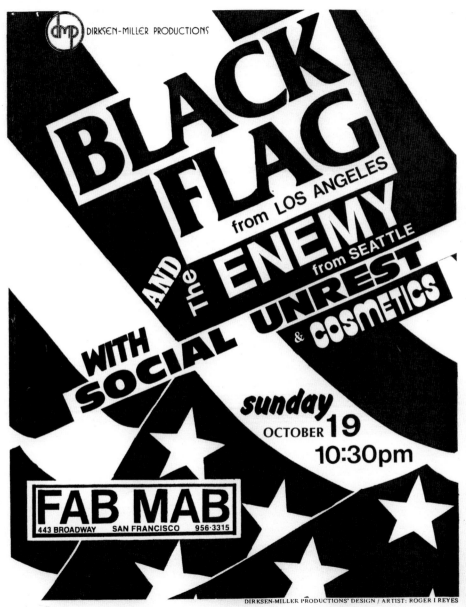

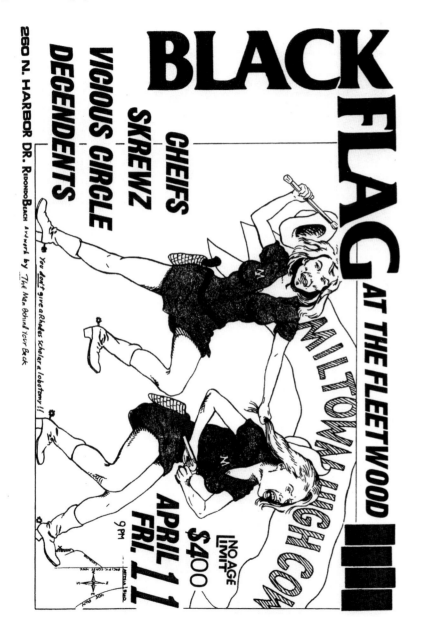

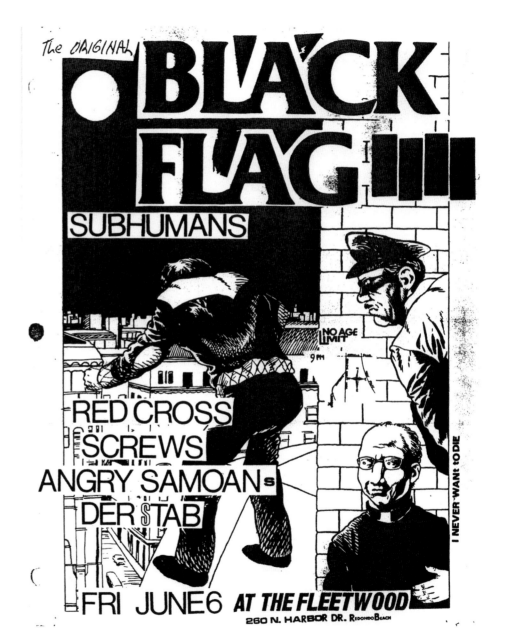

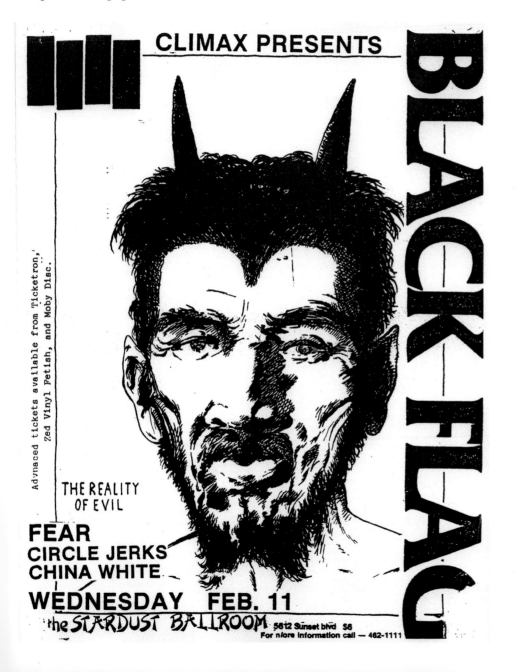

CLIMAX PRESENTS

BLACK FLAG

Advnaced tickets available from 'Ticketron,' Zed Vinyl Fetish, and Moby Disc.

THE REALITY
OF EVIL

FEAR
CIRCLE JERKS
CHINA WHITE

WEDNESDAY   FEB. 11

the STARDUST BALLROOM   5612 Sunset blvd  $6
For more information call — 462-1111

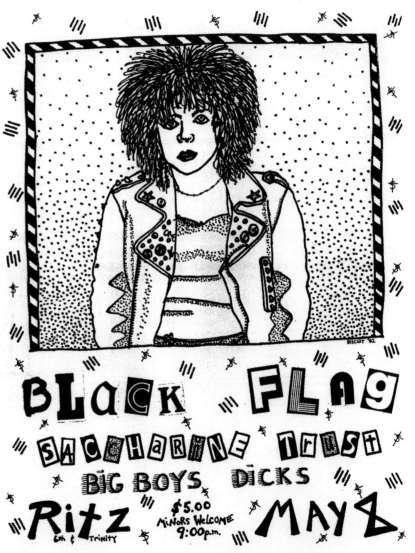

BLACK FLAG
SACCHARINE TRUST
BIG BOYS   DICKS
RITZ   $5.00   MAY 2
6th & Trinity   MINORS WELCOME
9:00 p.m.

**BLACK FLAG**

DEC 31
NEW YEAR'S EVE
$7.00

GALAXY
FULLERTON
121 N. GILBERT

REDD KROSS
HÜSKER DÜ

DEATH OF A GREMMIE

fine art by Raymond Pettibon

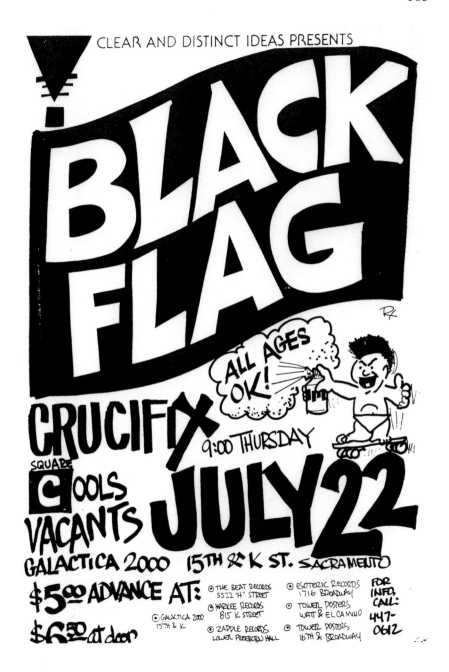

CLEAR AND DISTINCT IDEAS PRESENTS

**BLACK FLAG**

CRUCIFIX
ALL AGES OK!
9:00 THURSDAY
SQUARE COOLS
VACANTS
JULY 22
GALACTICA 2000   15TH & K ST. SACRAMENTO

$5.00 ADVANCE AT:
$6.50 at door

THE BEAT RECORDS
5522 "H" STREET
HARLEE RECORDS
815 K STREET
ZAPPLE RECORDS
LOWER FREEBORN HALL
GALACTICA 2000
15TH & K

ESOTERIC RECORDS
1716 BROADWAY
TOWER POSTERS
WATT & EL CAMINO
TOWER POSTERS
16TH & BROADWAY

FOR INFO CALL:
447-0612

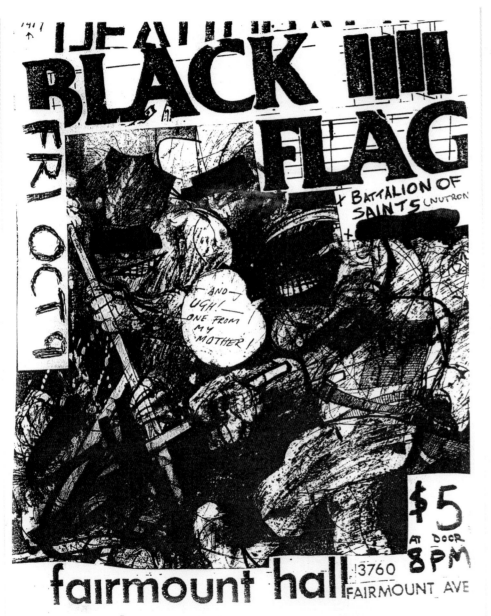

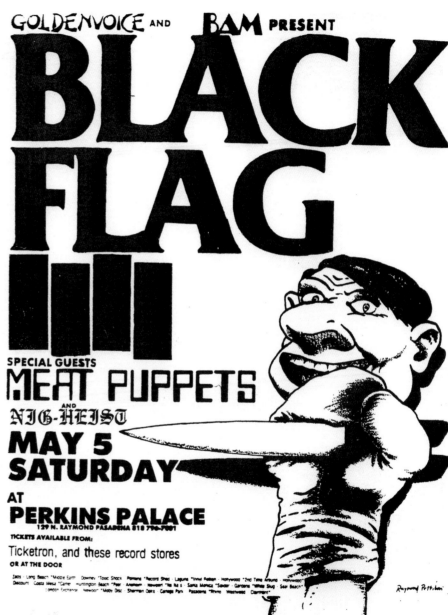

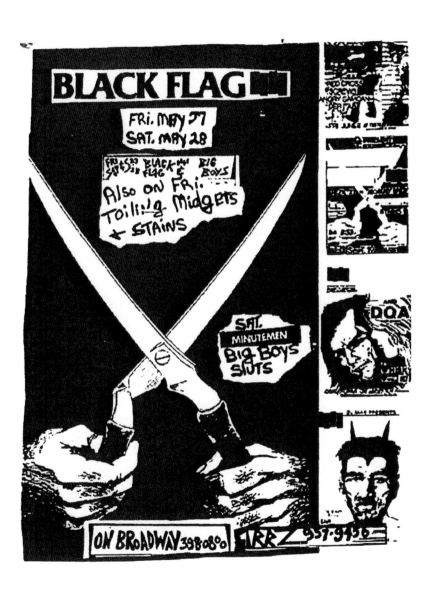

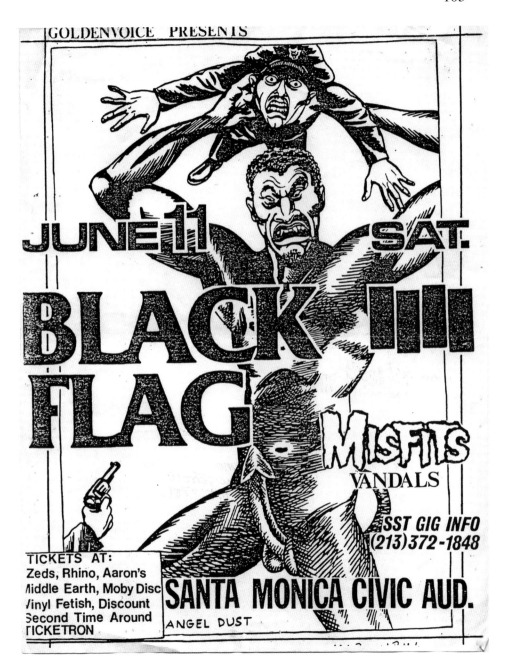

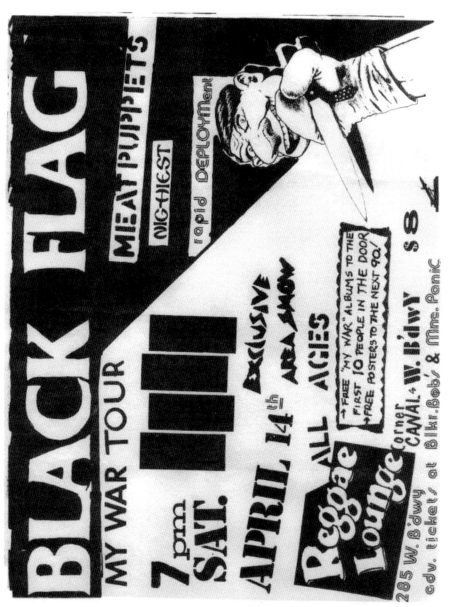

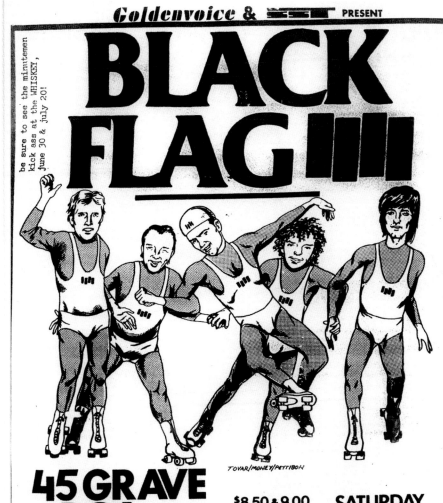

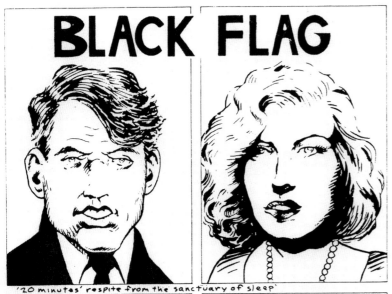

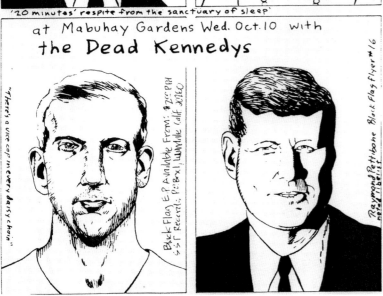

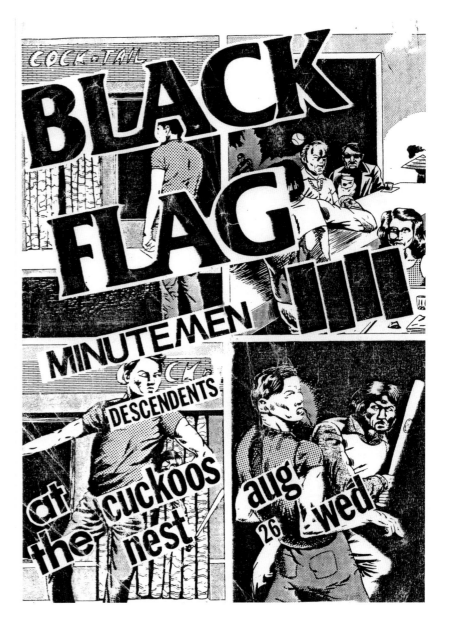

# BLACK ▐▐▐▐ FLAG

$4.00

**RED CROSS**

**DESCENDENTS**

AT THE STATION 9:00 P.M.

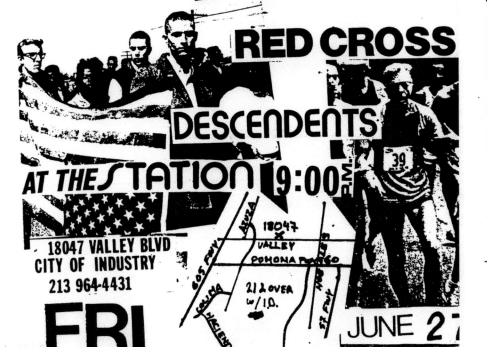

18047 VALLEY BLVD
CITY OF INDUSTRY
213 964-4431

**FRI**

18047 X VALLEY POMONA FRWY

21 & OVER W/ID.

JUNE 27

# BLACK ▐▐▐▐ FLAG

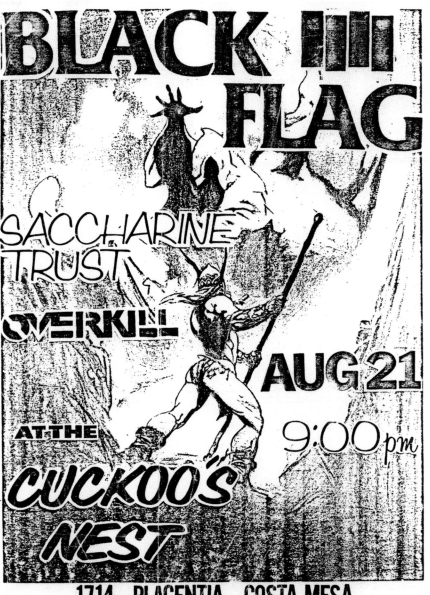

SACCHARINE TRUST

OVERKILL

AUG 21

AT THE

9:00 pm

CUCKOO'S NEST

1714 PLACENTIA, COSTA MESA

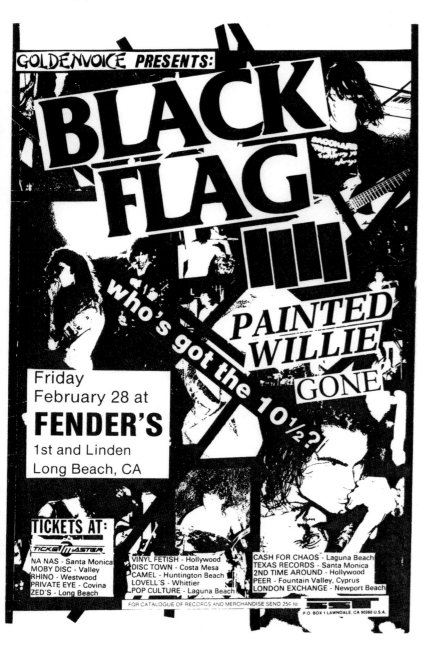

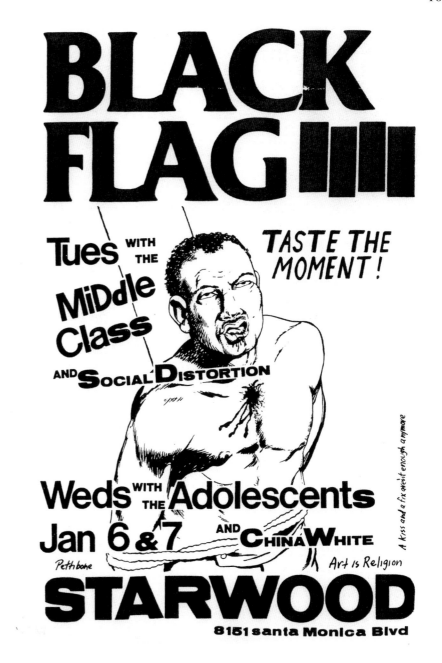

missed seeing the Misfits by less than one year.
I never would have even known who they were if my
cousin Rich didn't introduce me to hardcore back in 1984.
I was 14. He took me to see my first show, the Cro-mags and
Malignant Tumor, at the Rainbow Nite Club in Passaic N.J.
Jim Murphy was there skating. No stage, just a small
sweaty room. Lots of skinheads and skaters. Everybody
knew each other, it felt like a party. I was welcomed in.
Then it started.  BOOM!  The music was intense. Like
nothing I had ever heard or seen before. Everybody went
nuts and my hardcore days began.

My first experience with anything Misfits related hap -
pened a little while later. Rich used to talk about the
Misfits all the time, like they were this super group. They
had broken up and the records were hard to find, so I just
listened to other stuff. Little did I know the influence they
would have on just about everything I would do.

Rich called one day and said he just got the new record
from the singer of the Misfits. When I got there and
first looked at the cover, three white guys completely
drenched in blood with the name Samhain on the top,
I remember thinking, "What is this"? We used to hang
out in his basement, which was pretty dark and dreary
to begin with, so, when the first song came on it literally
scared the shit out of me. After about a minute the music
kicked in and it hit me like a rock.  I soon realized this
band was different, special,  like nothing I had seen or
heard before. I got into the Misfits after I heard Samhain.

The Misfits broke up before I even knew they existed.
I borrowed "Walk Among Us" and couldn't stop listening
to it.  I started collecting the records and got hooked.

But, not completely. That didn't happen until I saw Sam-
hain at the Ritz in 86, at their last show. It was the New
Music Seminar with DOA, MDC, Celtic Frost, Rogues
Gallery and the Cheetah Chrome Motherfuckers. With
that line up and all I remember was Samhain. They
sounded incredible. To me that was their peak and also
a defining moment in my hardcore youth. I became
obsessed. I started to grow my hair long in front, dress
in black and collect everything I could find. I knew all the
words, still do, and occasionally would travel to the Lodi
Post Office and hopefully run into Glenn,  I never did.
I waited for the next Samhain show but it never came.
They were supposed to play at City Gardens on Hallow-
een in 87' but never did. Bad Brains played instead, which
was a nice replacement.

Hardcore was changing and not for the better. Everybody
started to sound and look the same. Stupid violence
would ruin the shows. Clubs built walls between the
bands and the crowds to prevent diving, but all they did
was make it more dangerous. Bands just fell apart.
The fun ended.

The set list in this book came from the first Danzig
show at City Gardens. It was a good show but as a
devoted Misfits/Samhain fan when the devilocks and
music disappeared, so did I.

Art

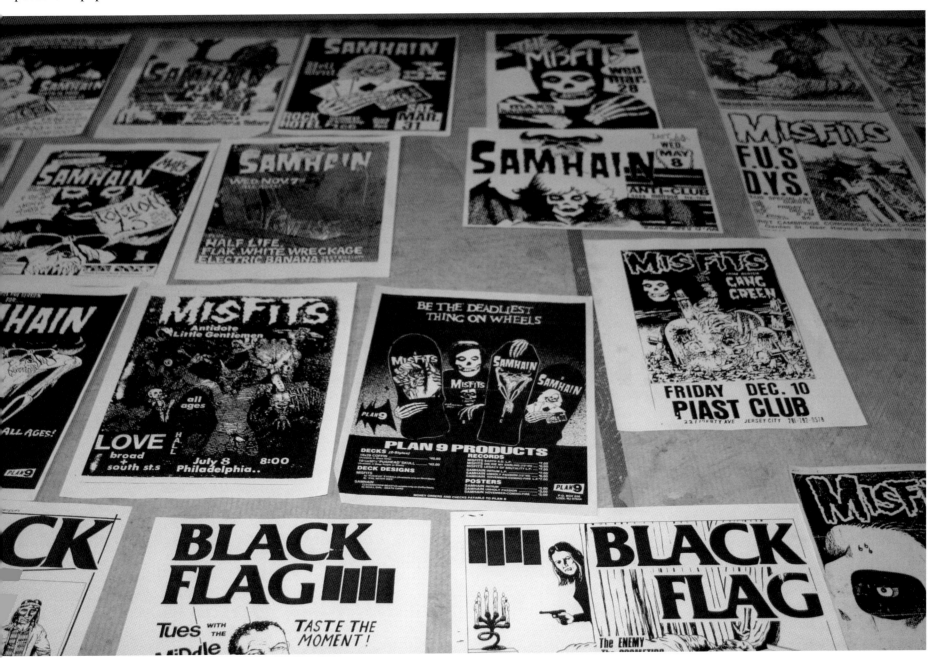

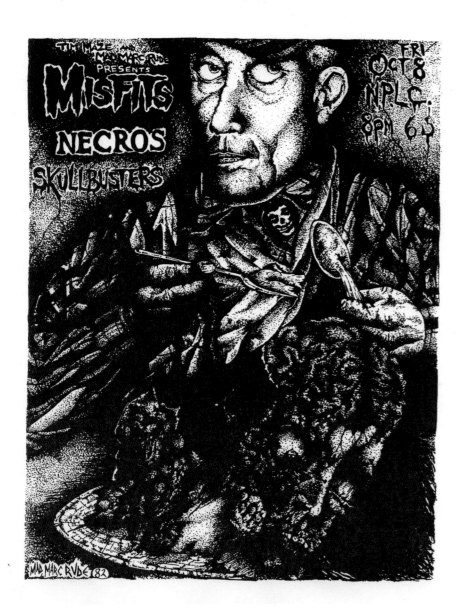

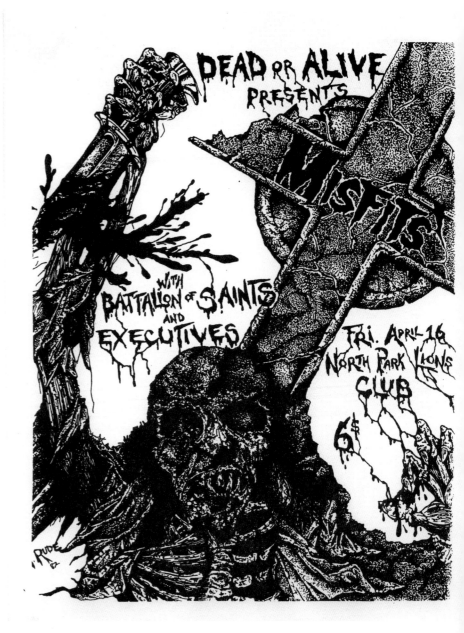

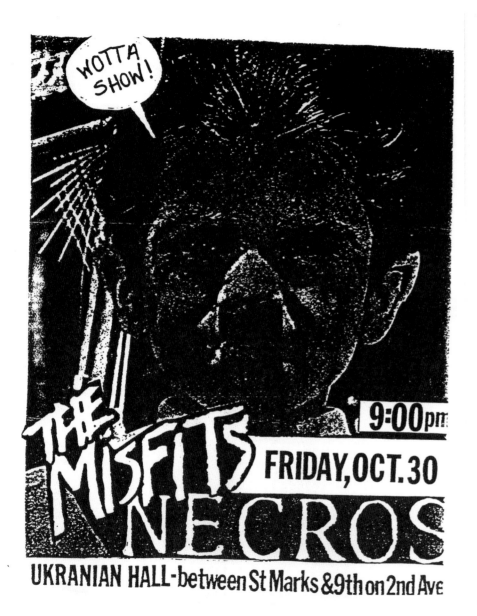

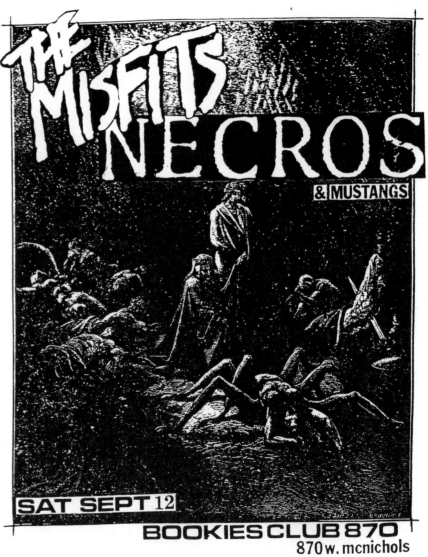

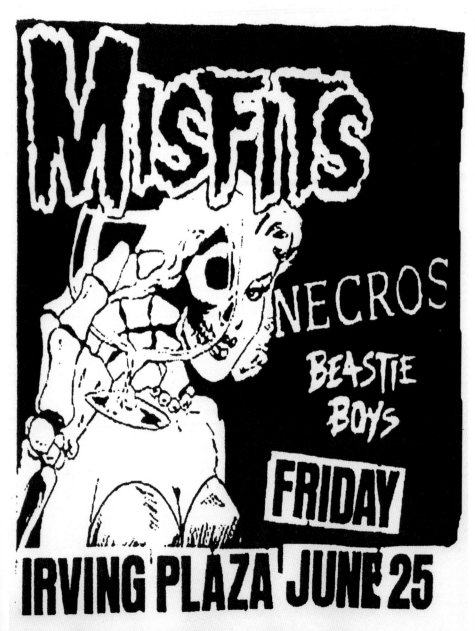

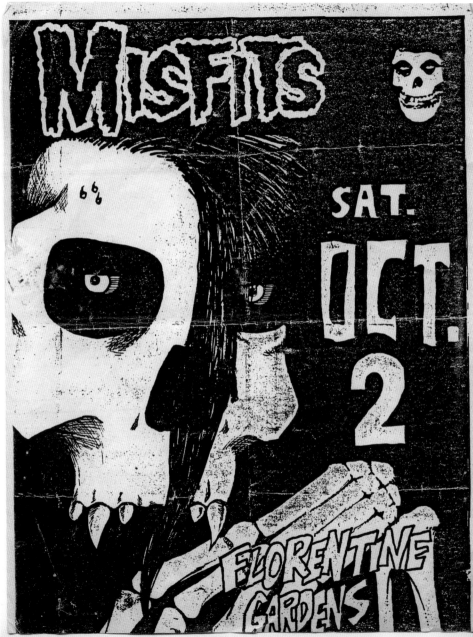

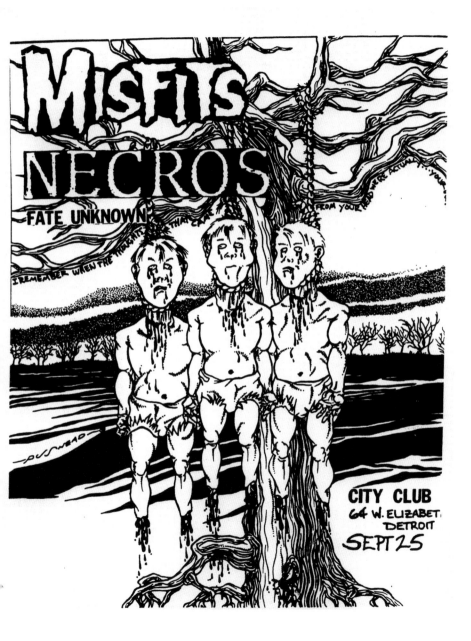

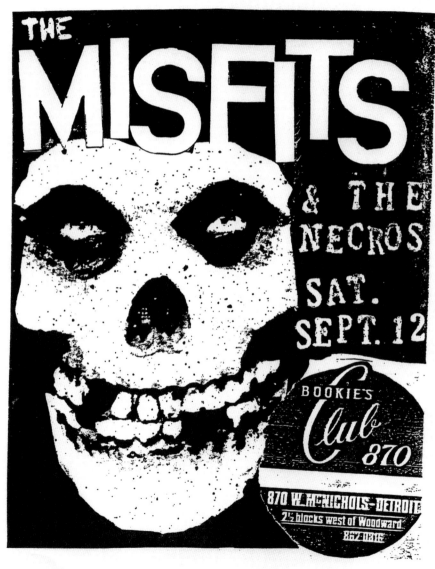

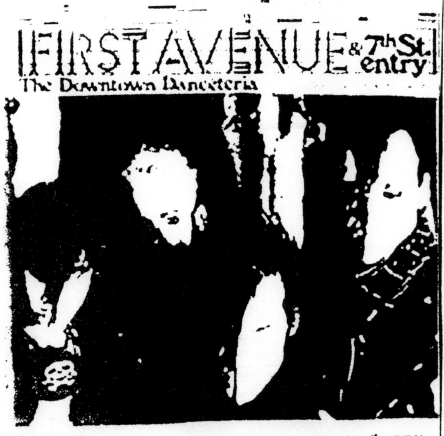

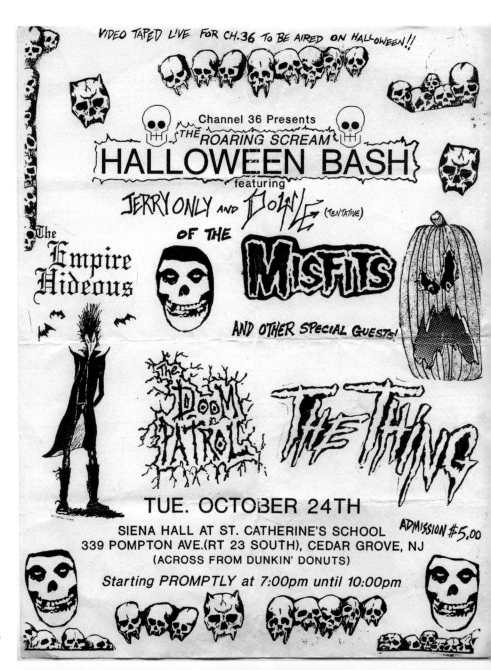

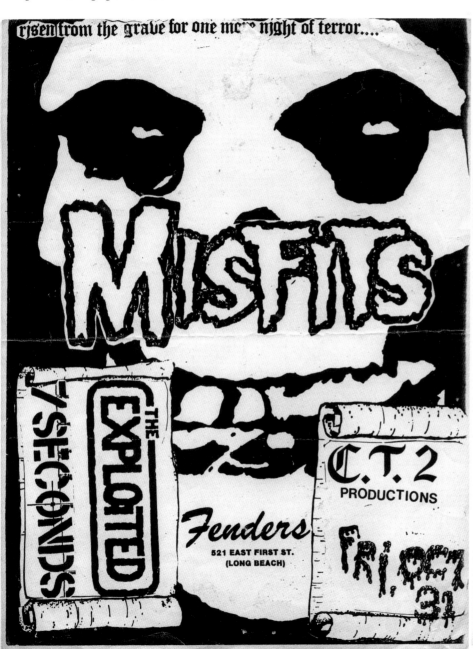

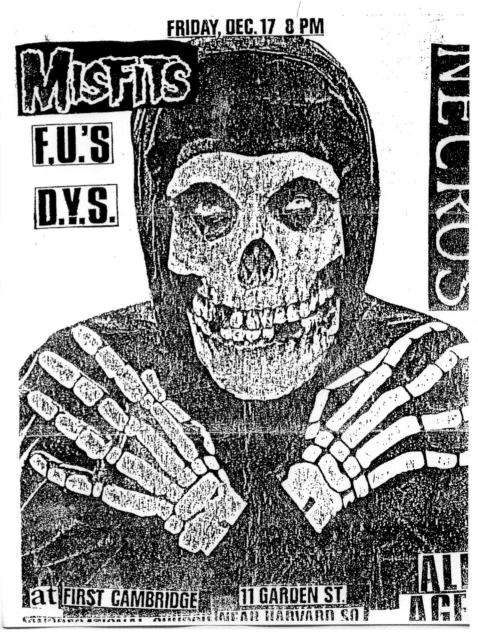

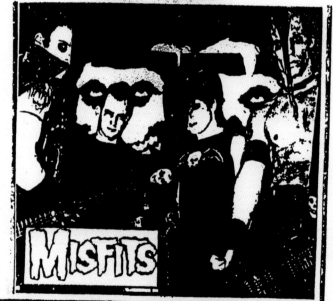

$6 ALL AGES

SATURDAY
APRIL 23
9:00

UNION BALLROOM
530 S. STATE    ANN ARBOR

MISFITS

NEGATIVE APPROACH

ground zero STATE

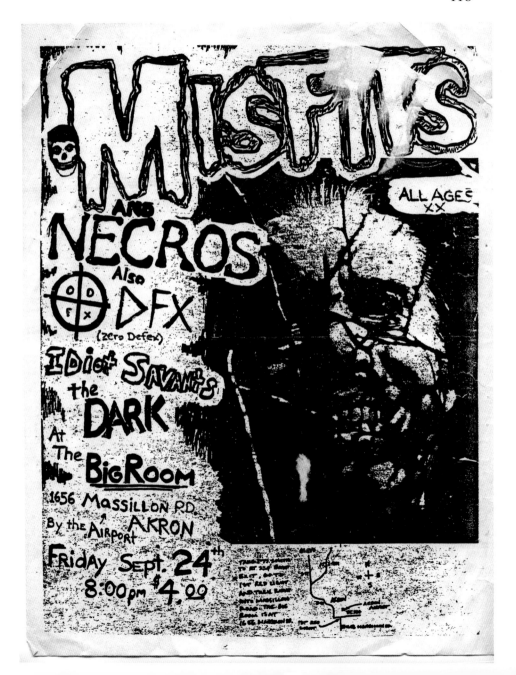

MISFITS
AND
NECROS
ALSO
ODFX
(Zero Defex)
Idiot Savants
the DARK
At The BigRoom
1656 Massillon Rd.
By the Airport  AKRON
Friday Sept. 24th
8:00pm $4.00

ALL AGES XX

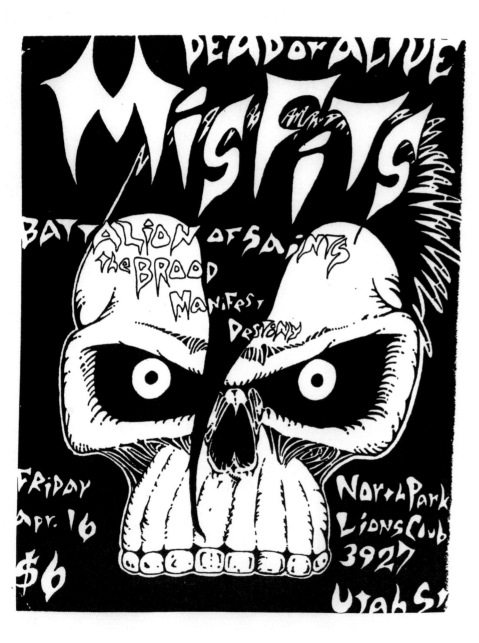

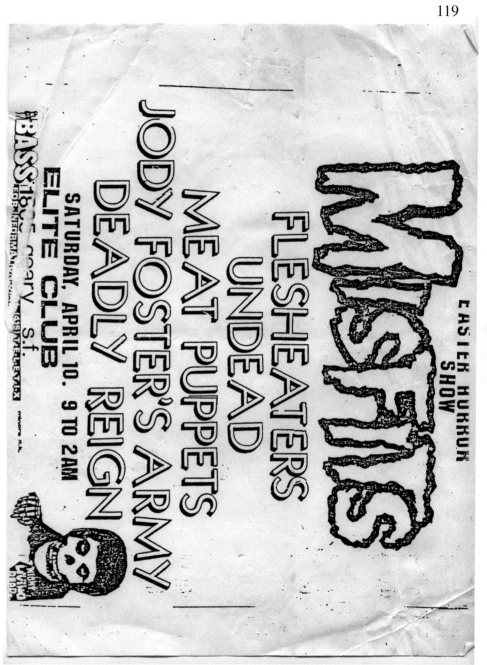

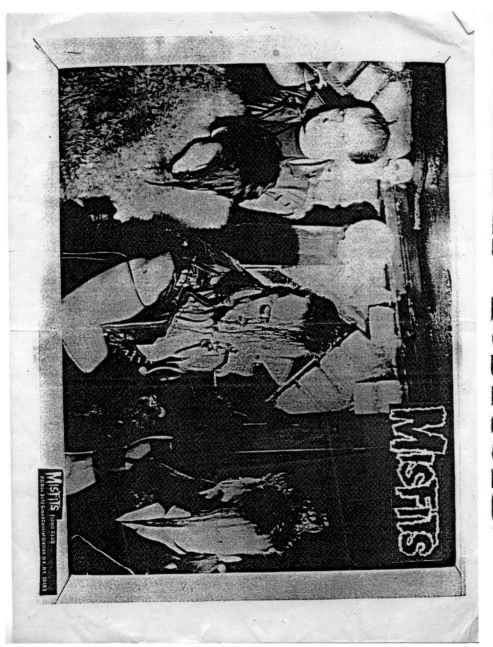

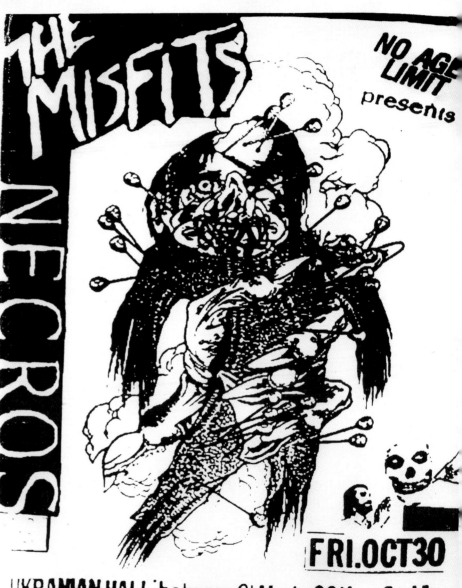

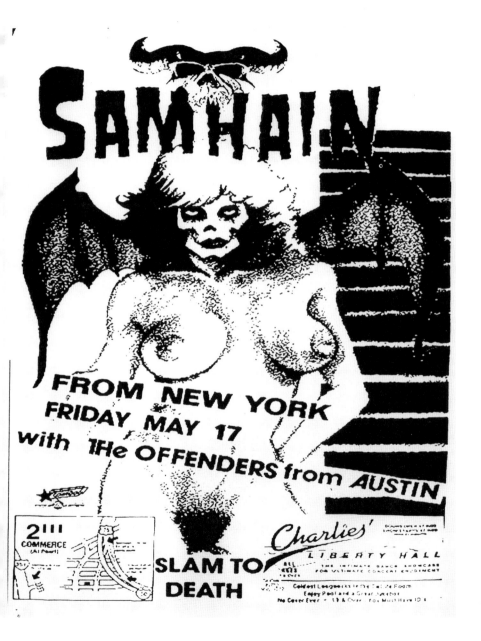

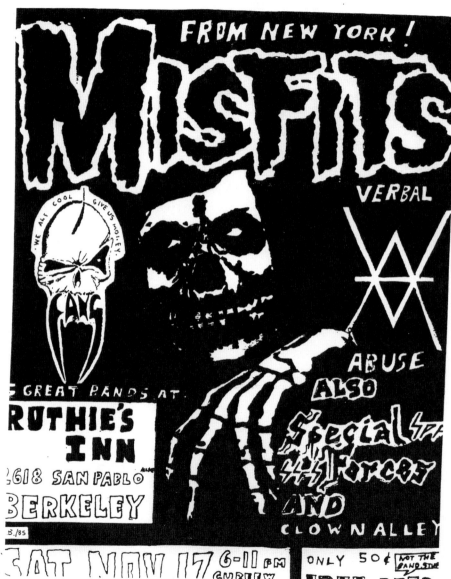

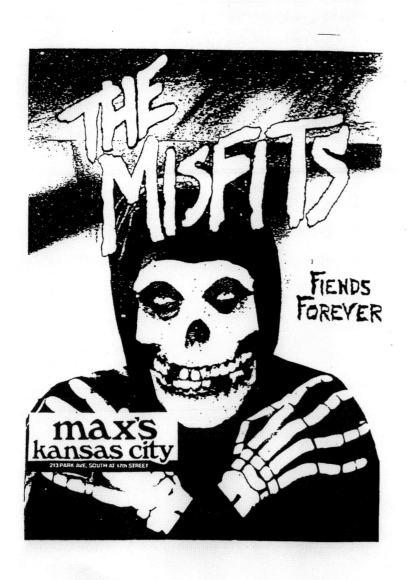

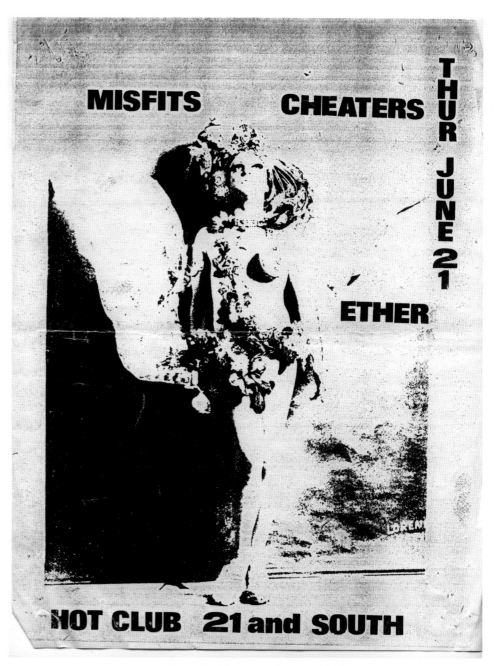

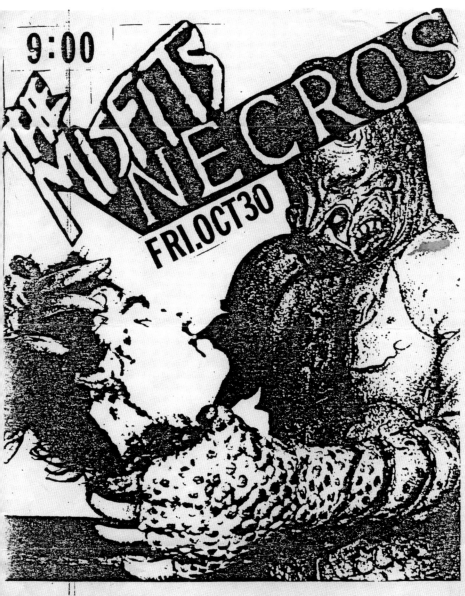

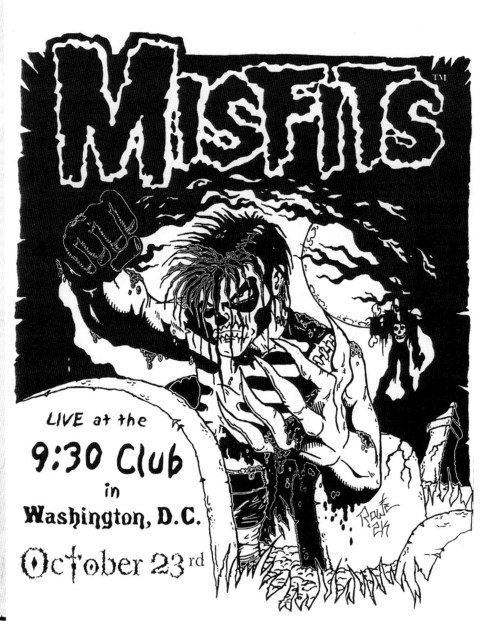

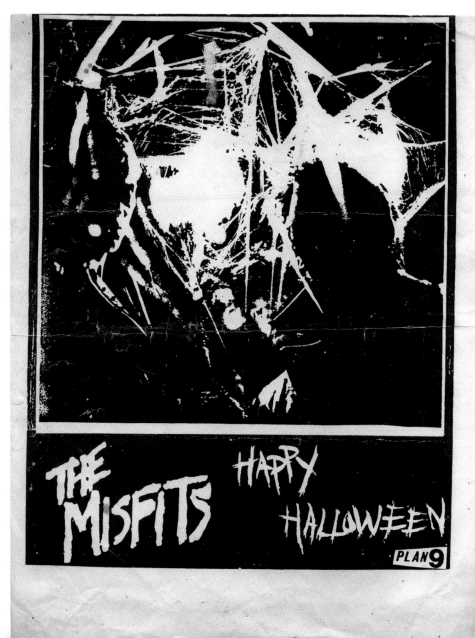

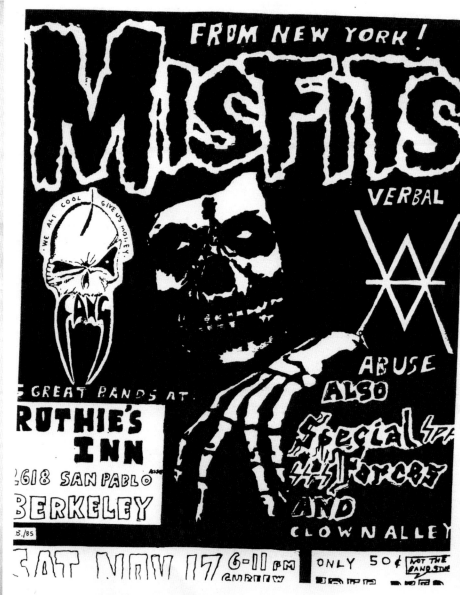

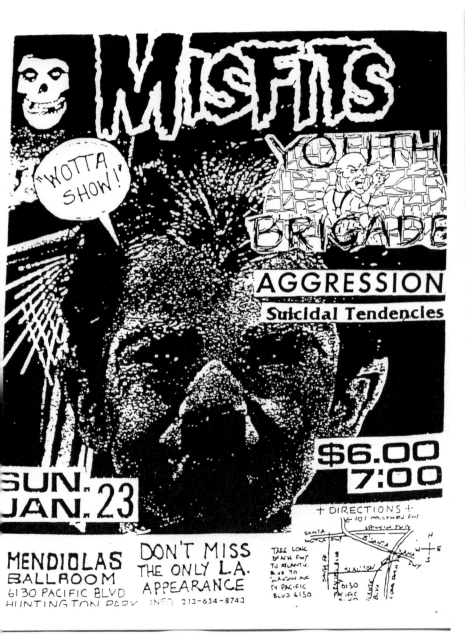

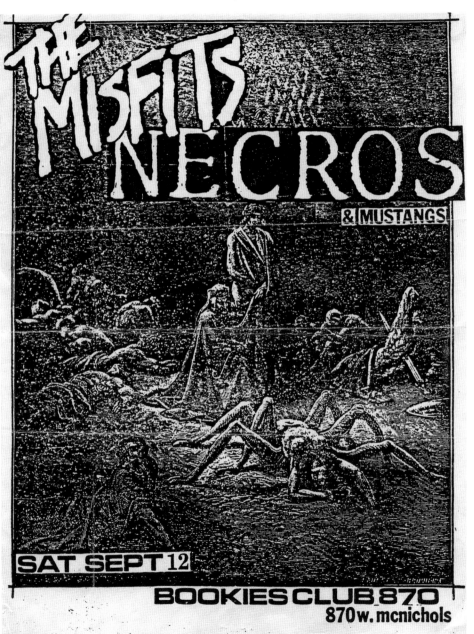

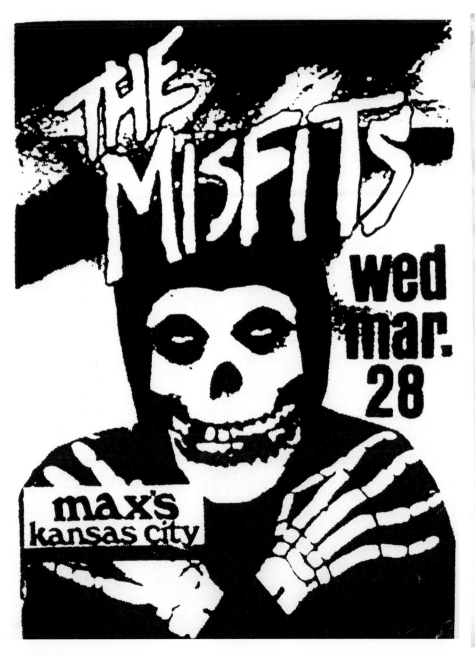

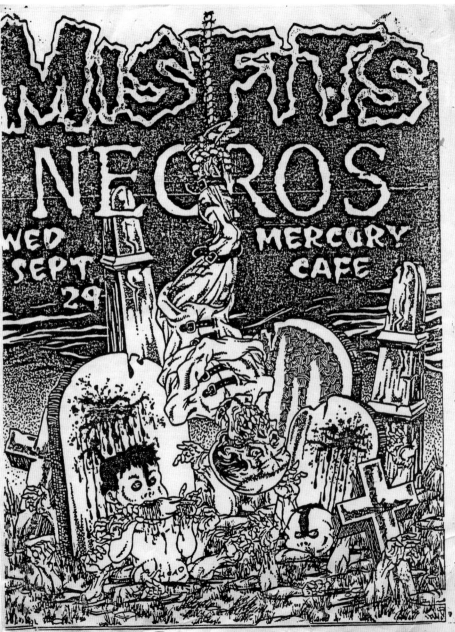

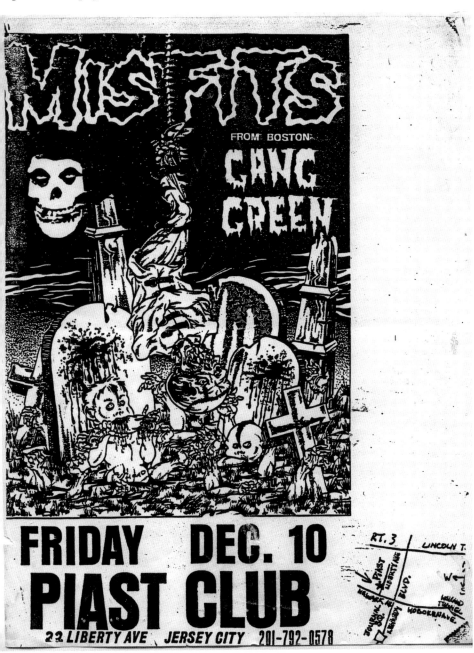

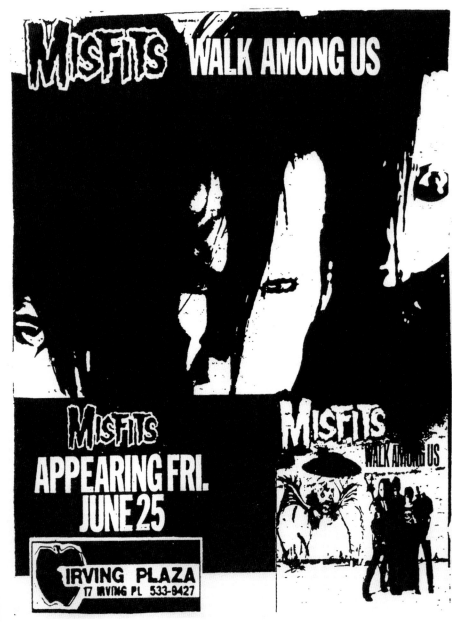

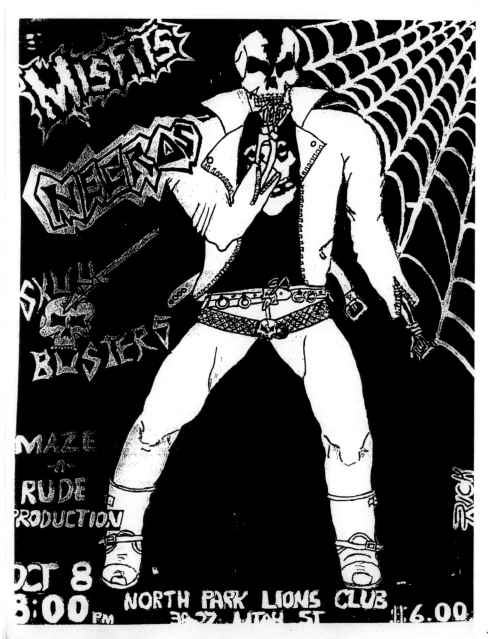

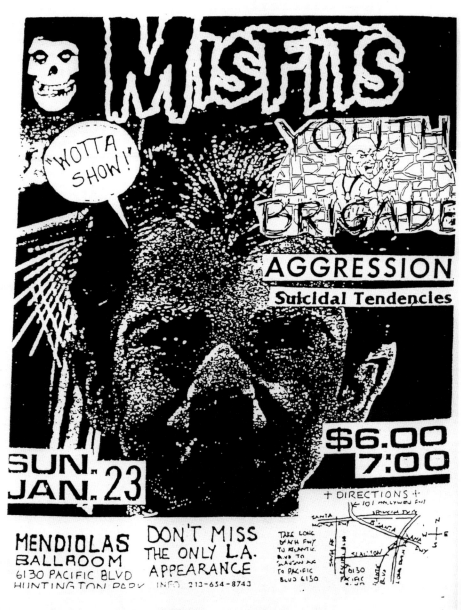

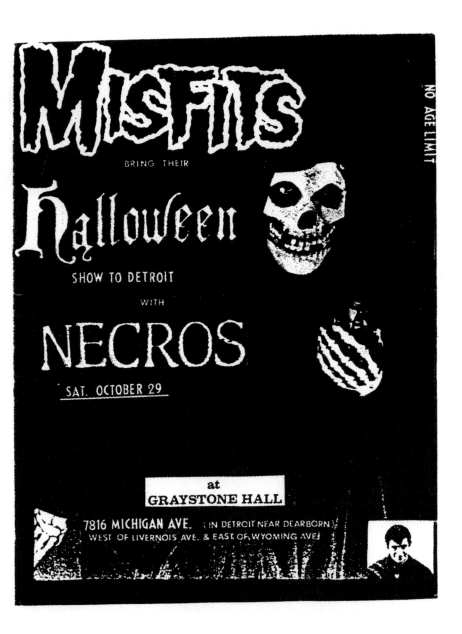

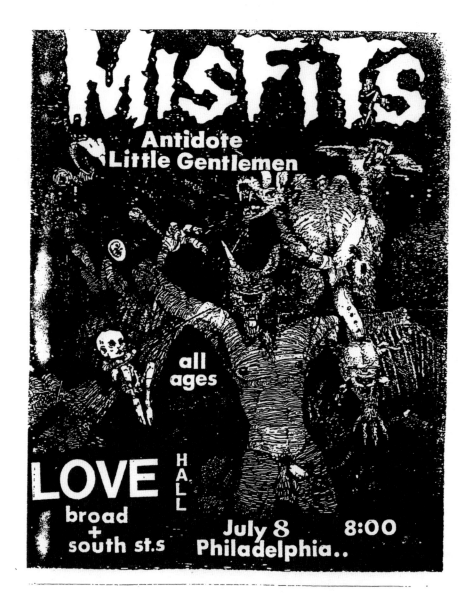

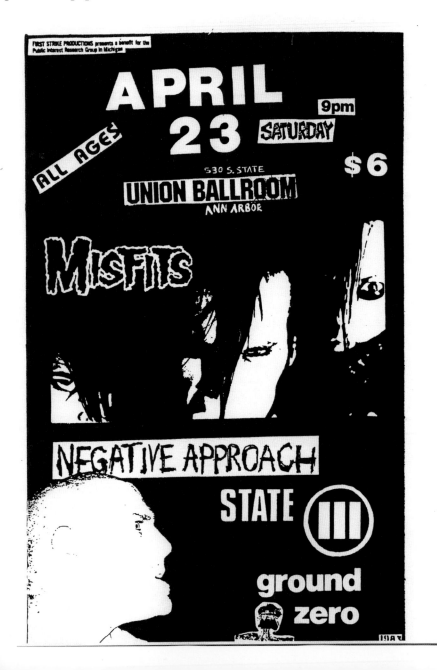

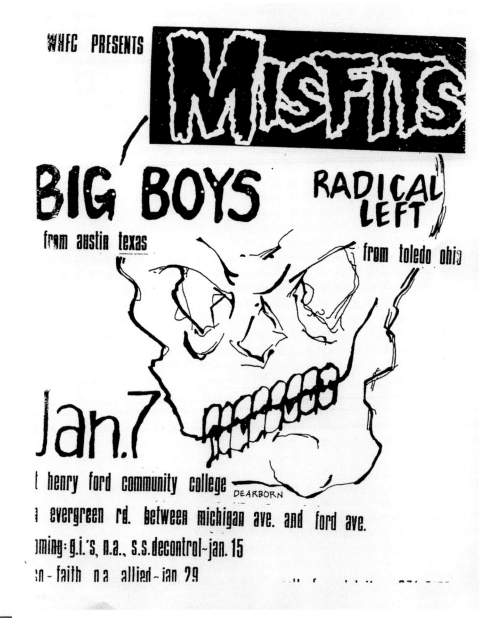

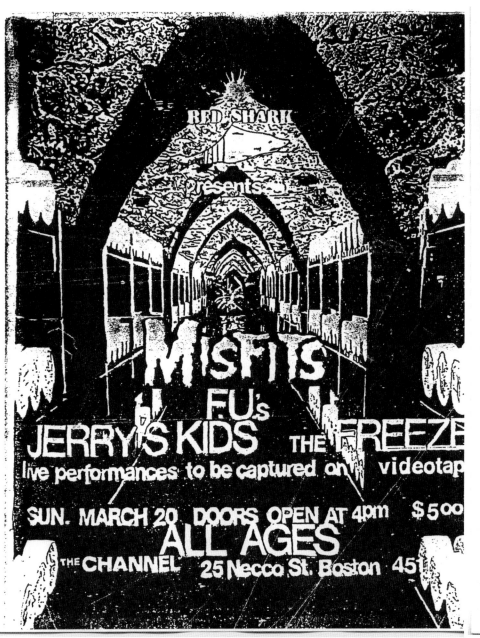

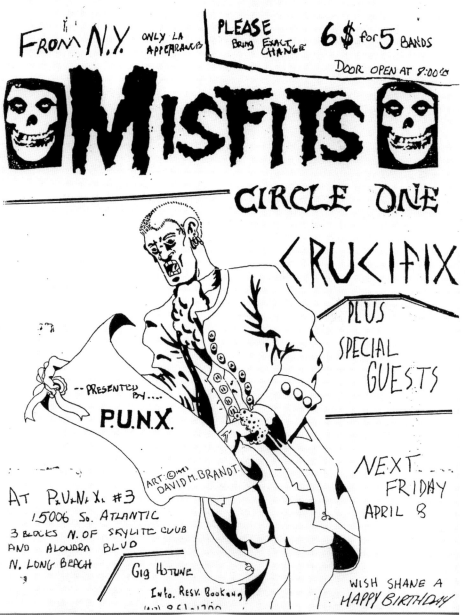

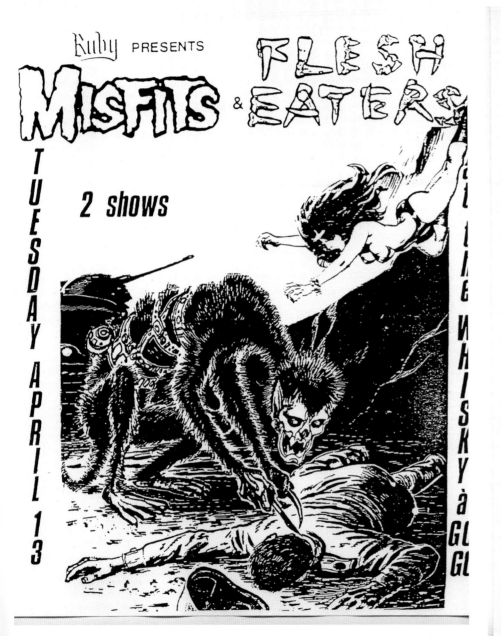

Ruby PRESENTS

**MISFITS** & **FLESH EATERS**

2 shows

TUESDAY APRIL 13

at the Whisky à Go Go

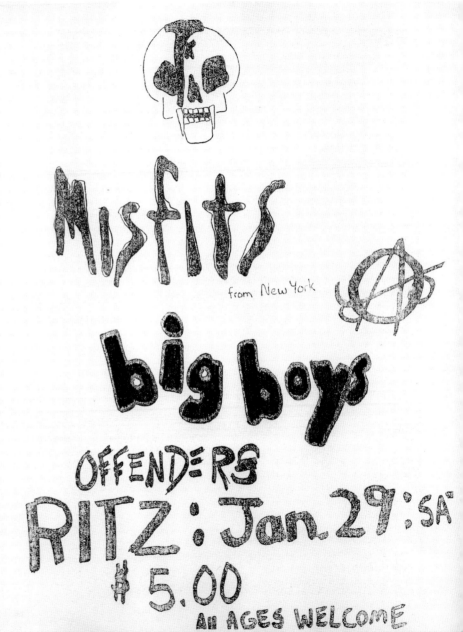

**Misfits**

from New York

**big boys**

OFFENDERS

RITZ: Jan. 29: SA

$5.00

All AGES WELCOME

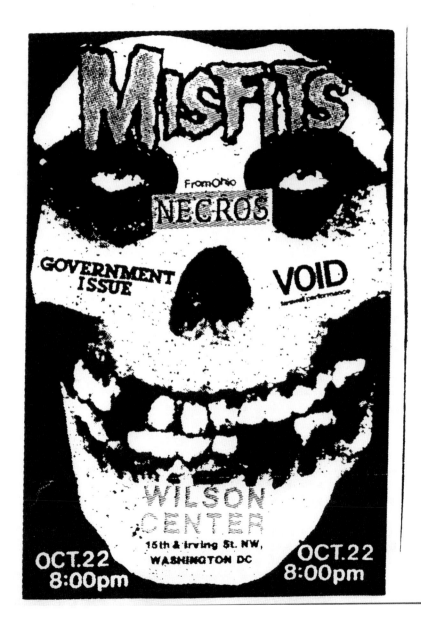

MISFITS
FROM OHIO
NECROS
GOVERNMENT ISSUE    VOID
benefit performance
WILSON CENTER
15th & Irving St. NW,
WASHINGTON DC
OCT.22
8:00pm    OCT.22
8:00pm

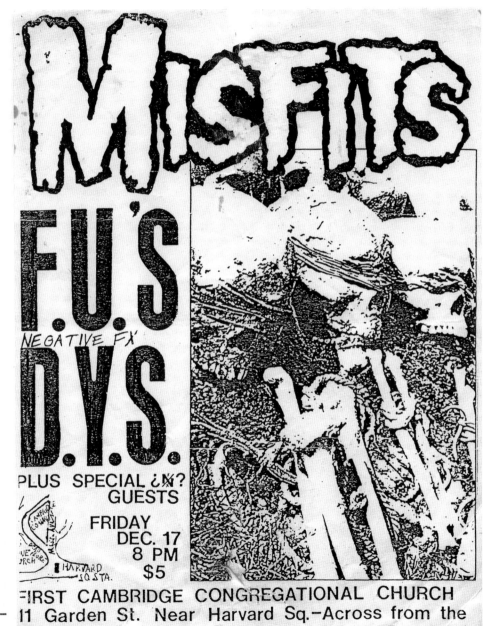

MISFITS
F.U.'S
NEGATIVE FX
D.Y.S.
PLUS SPECIAL ¿N? GUESTS
FRIDAY
DEC. 17
8 PM
$5
FIRST CAMBRIDGE CONGREGATIONAL CHURCH
11 Garden St. Near Harvard Sq.–Across from the Common.

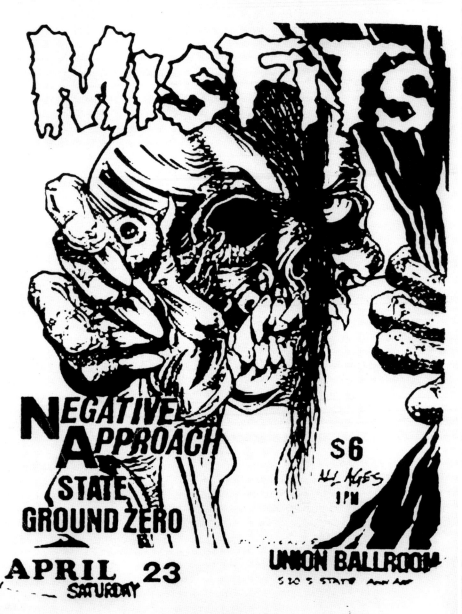

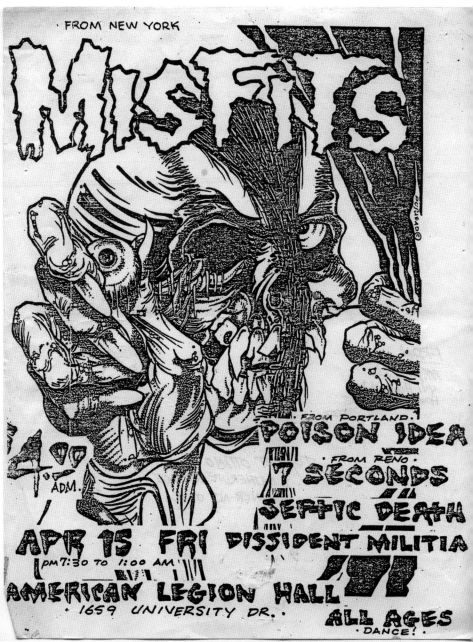

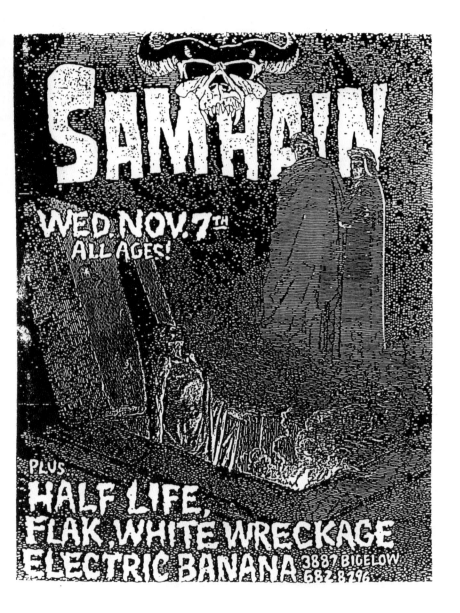

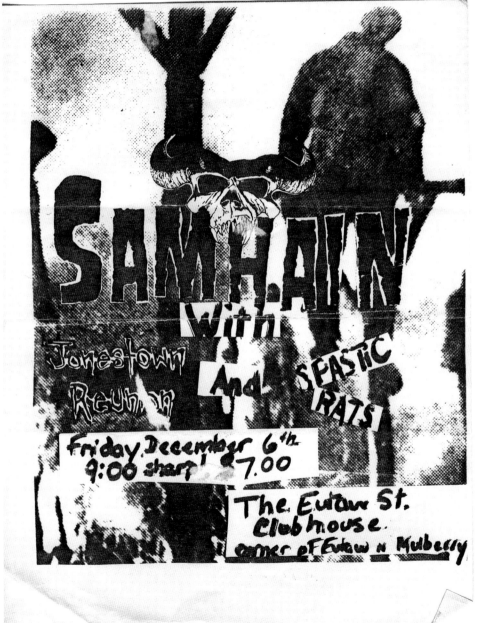

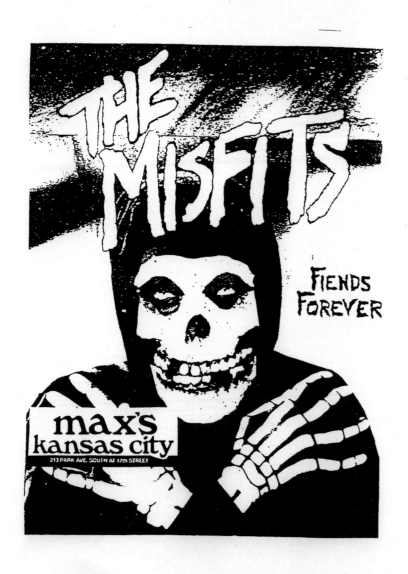

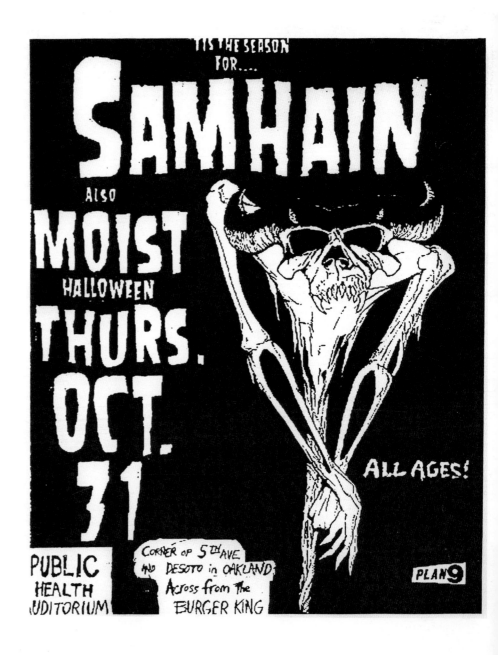

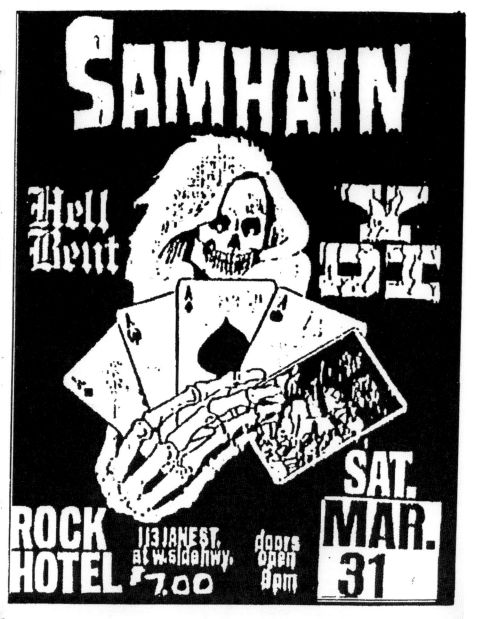

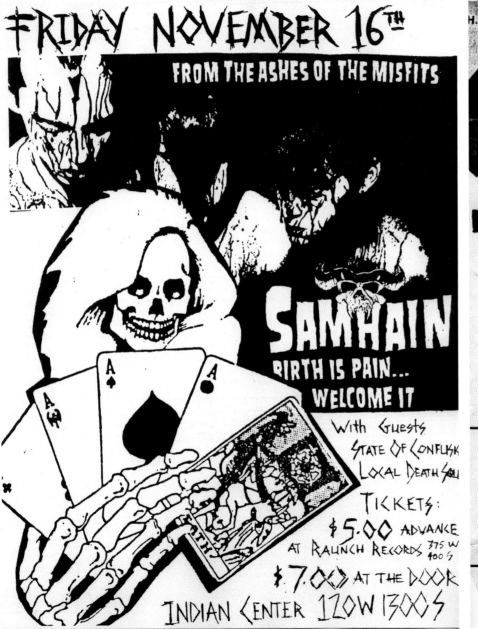

FRIDAY NOVEMBER 16TH

FROM THE ASHES OF THE MISFITS

SAMHAIN

BIRTH IS PAIN...
WELCOME IT

With Guests
State Of Conflkk
Loxal Death Squ

TICKETS:
$5.00 ADVANCE
AT RAUNCH RECORDS 375 W 400 S
$7.00 AT THE DOOR
INDIAN CENTER 120 W 1300 S

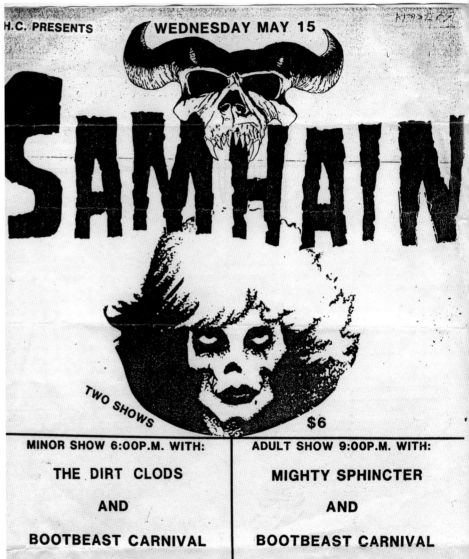

H.C. PRESENTS        WEDNESDAY MAY 15

SAMHAIN

TWO SHOWS                          $6

| MINOR SHOW 6:00 P.M. WITH: | ADULT SHOW 9:00 P.M. WITH: |
| --- | --- |
| THE DIRT CLODS | MIGHTY SPHINCTER |
| AND | AND |
| BOOTBEAST CARNIVAL | BOOTBEAST CARNIVAL |

IMPULSE 2326 E. INDIAN SCHOOL RD.

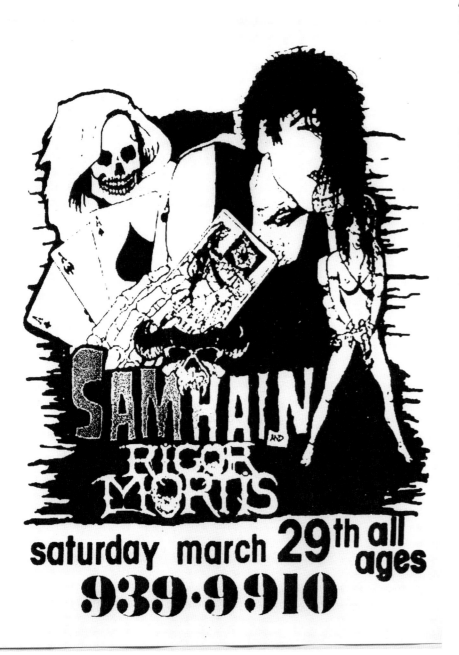

**SAMHAIN** AND
**RIGOR MORTIS**
saturday march **29**th all ages
**939·9910**

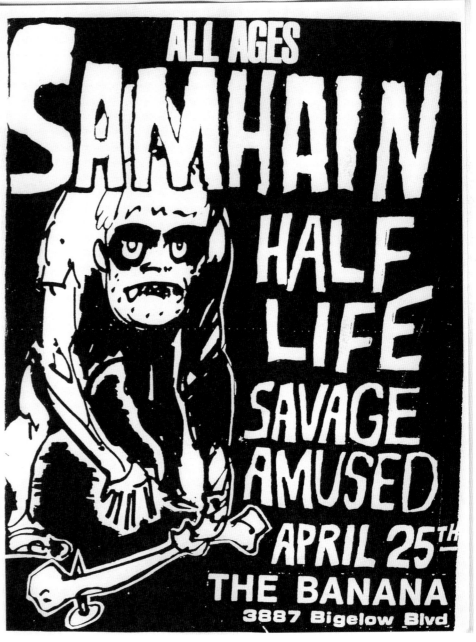

ALL AGES
**SAMHAIN**
**HALF LIFE**
**SAVAGE AMUSED**
**APRIL 25**th
**THE BANANA**
3887 Bigelow Blvd

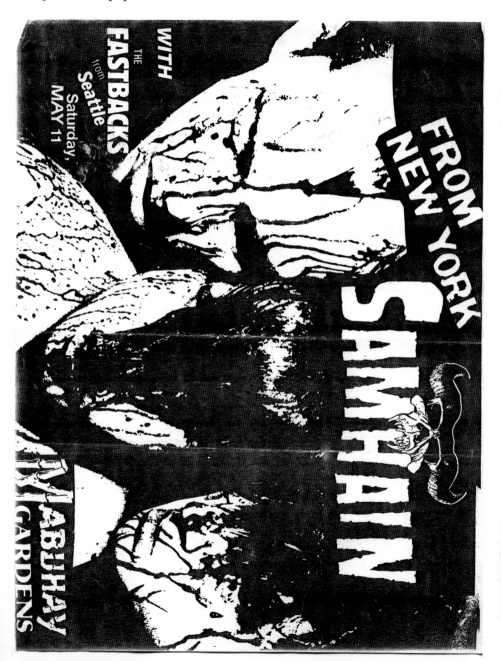

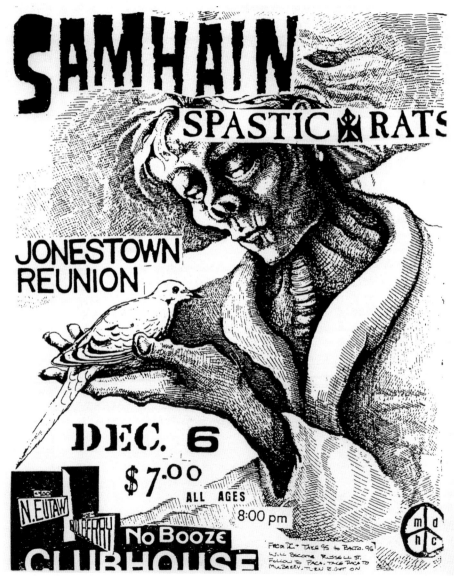

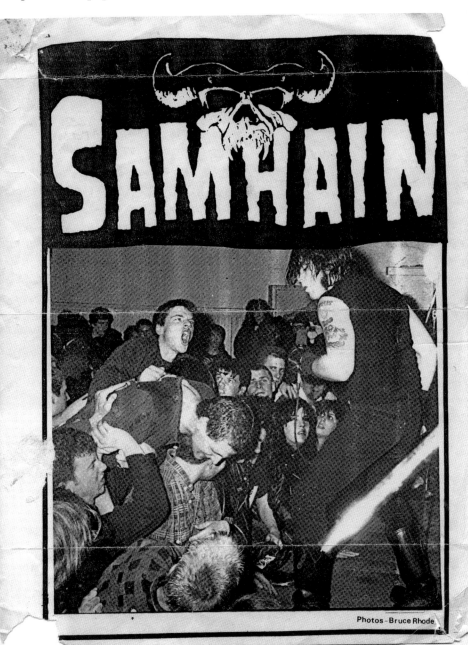

Photos - Bruce Rhode

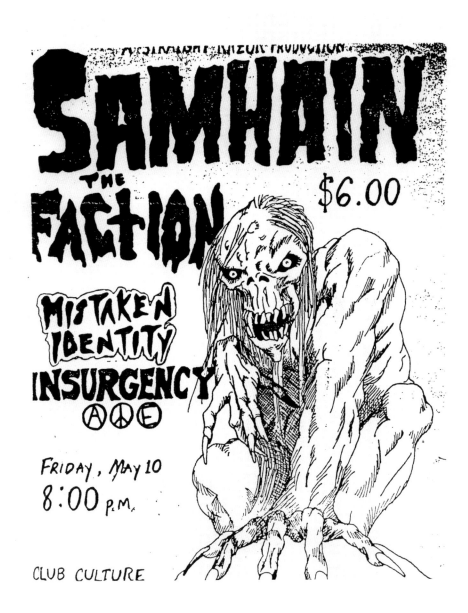

SAMHAIN
THE FACTION
MISTAKEN IDENTITY
INSURGENCY

$6.00

FRIDAY, MAY 10
8:00 P.M.

CLUB CULTURE

**SAMHAIN**

FRI. NOV. 30 THE TWILITE ROOM 2111 COMMERCE

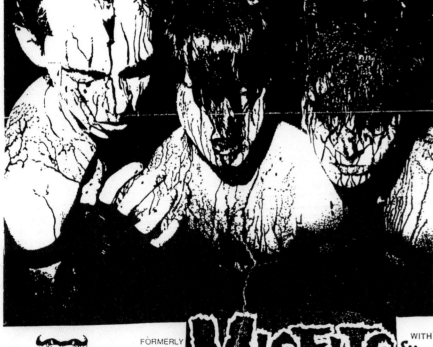

**SAMHAIN** FORMERLY THE **MISFITS** WITH SKETCH

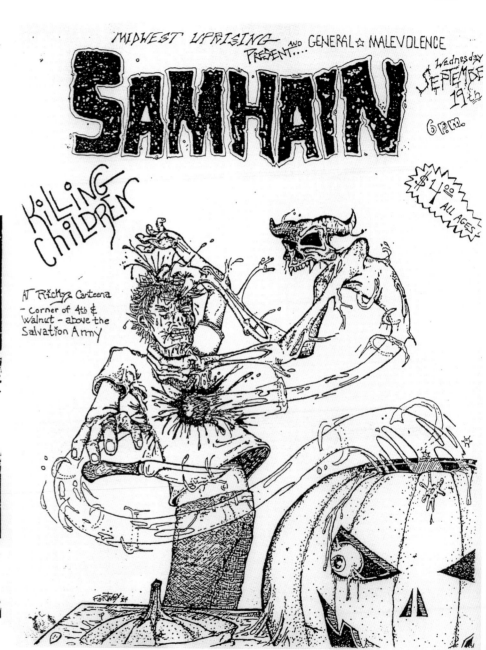

MIDWEST UPRISING PRESENT.... AND GENERAL ☆ MALEVOLENCE

**SAMHAIN**

Wednesday SEPTEMBER 19th 6 p.m.

$1°° ALL AGES

KILLING CHILDREN

AT Ricky's Canteena
- corner of 4th &
Walnut - above the
Salvation Army

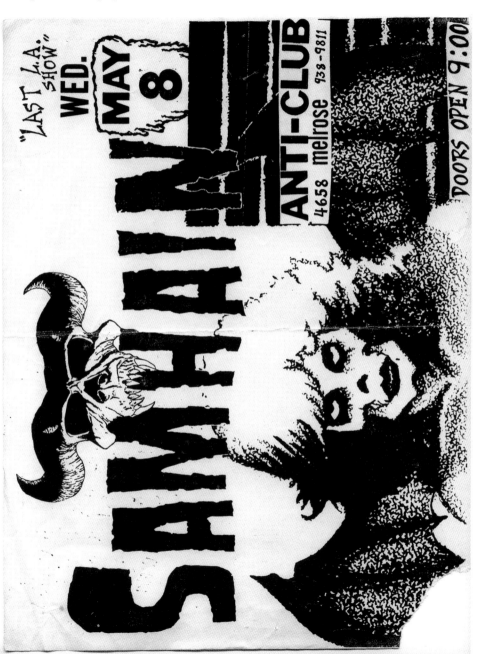

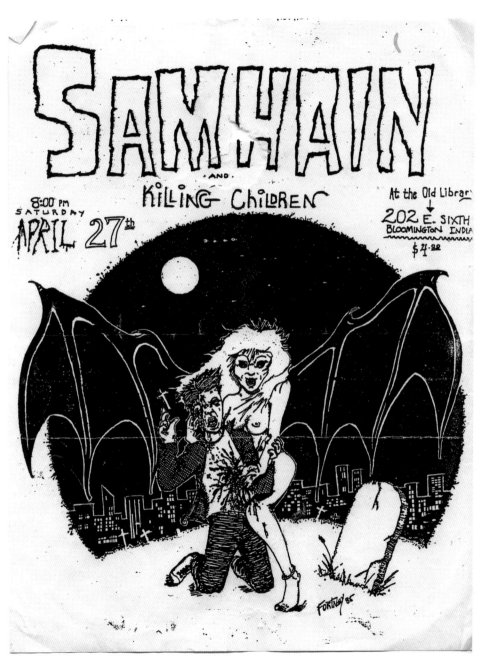

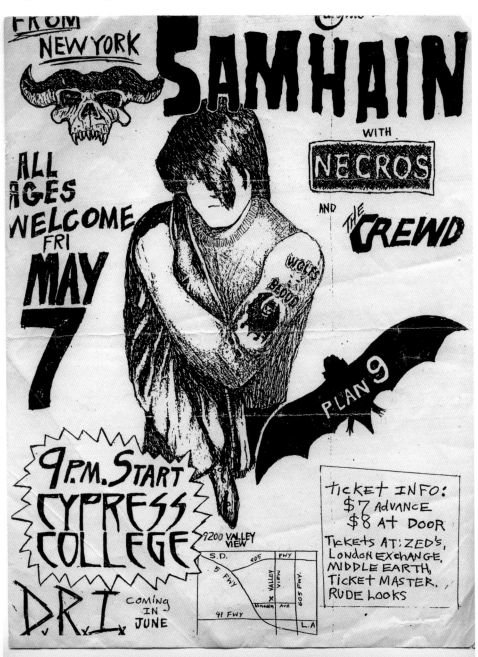

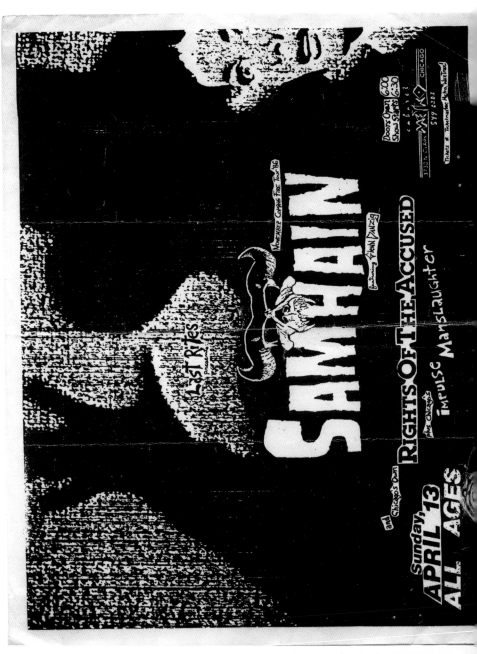

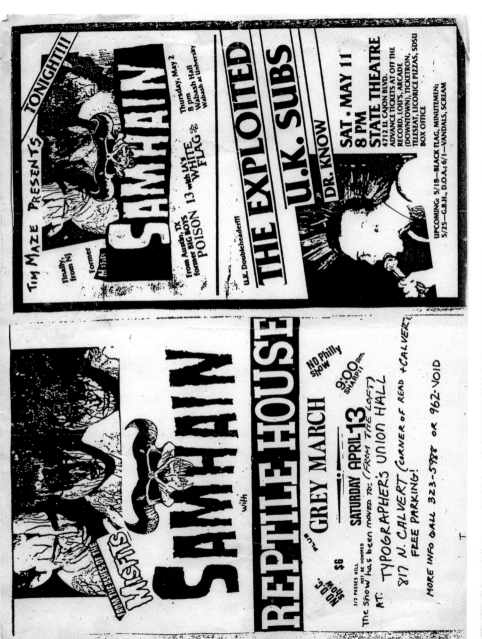

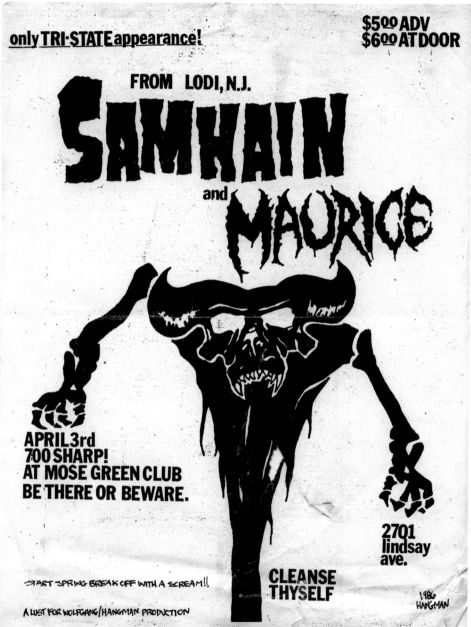

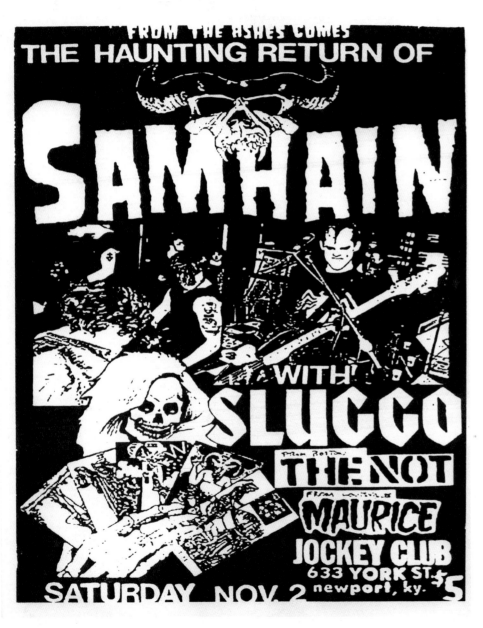

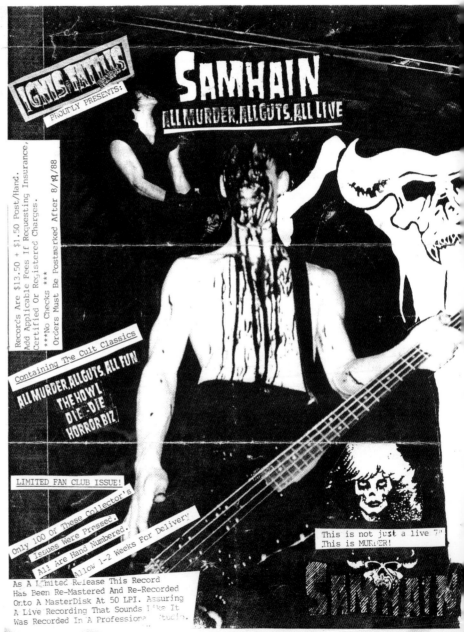

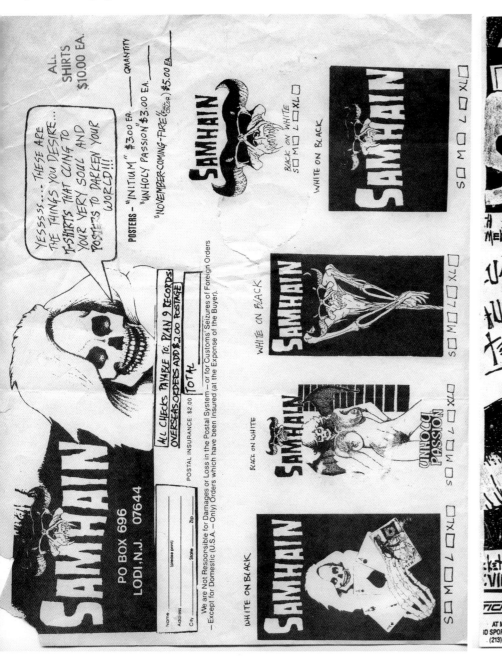

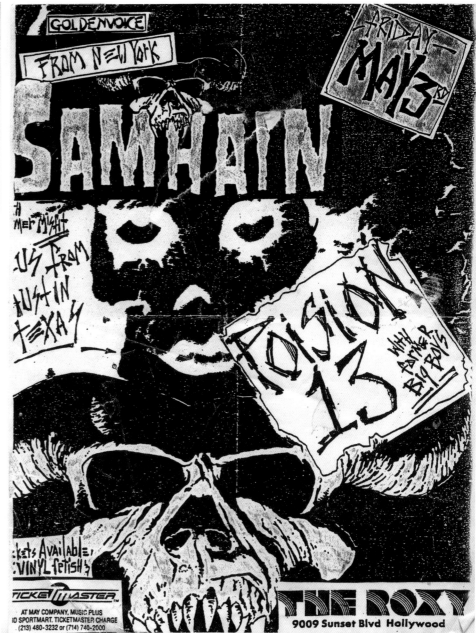

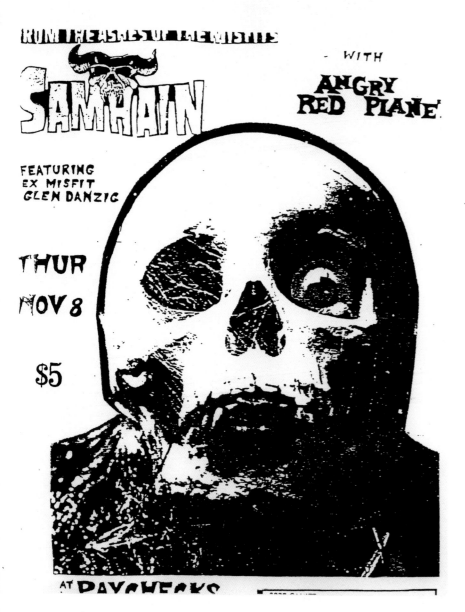

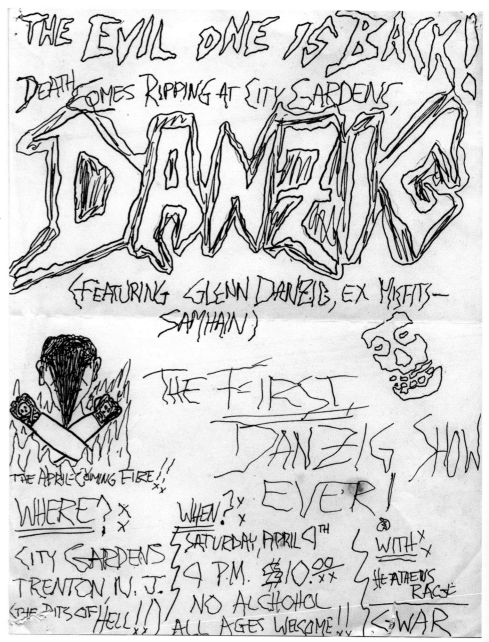

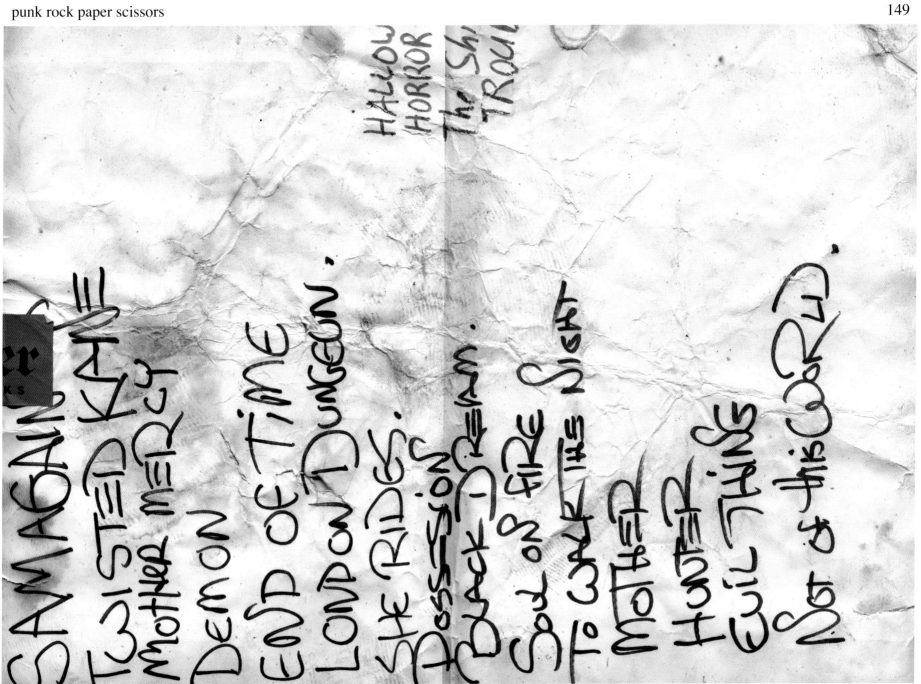

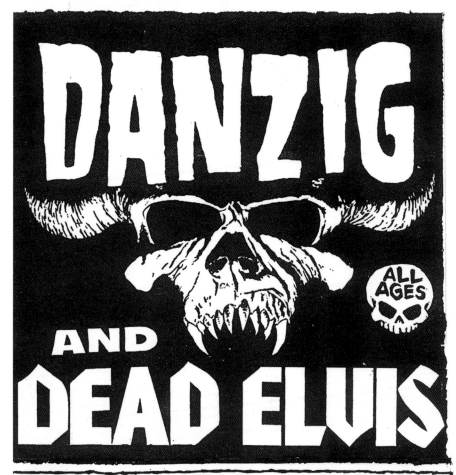

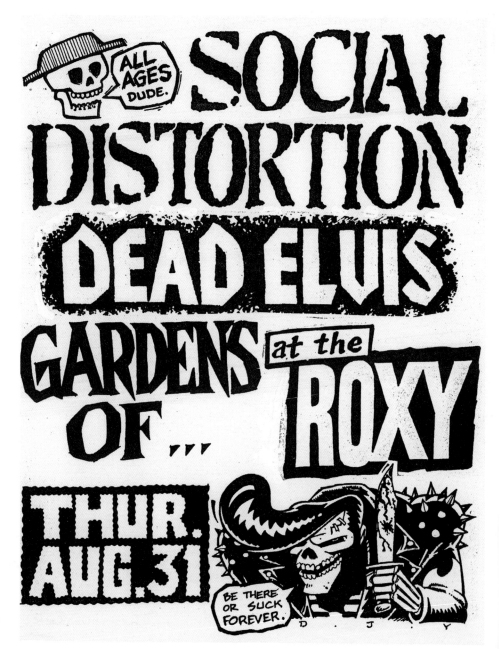

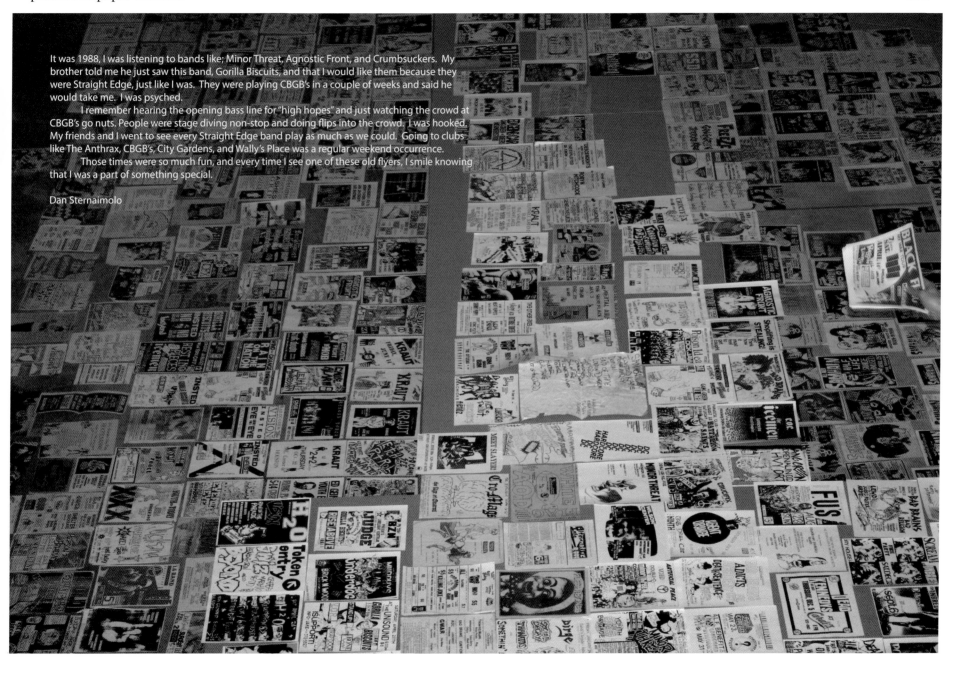

It was 1988, I was listening to bands like; Minor Threat, Agnostic Front, and Crumbsuckers. My brother told me he just saw this band, Gorilla Biscuits, and that I would like them because they were Straight Edge, just like I was. They were playing CBGB's in a couple of weeks and said he would take me. I was psyched.

I remember hearing the opening bass line for "high hopes" and just watching the crowd at CBGB's go nuts. People were stage diving non-stop and doing flips into the crowd. I was hooked. My friends and I went to see every Straight Edge band play as much as we could. Going to clubs like The Anthrax, CBGB's, City Gardens, and Wally's Place was a regular weekend occurrence.

Those times were so much fun, and every time I see one of these old flyers, I smile knowing that I was a part of something special.

Dan Sternaimolo

CBGB

L. Williamson presents

SAT JUNE 7

LEEWAY

CRUMBSUCKERS

AGNOSTIC FRONT

New York's Only ROCK HOTEL AT THE RITZ

11th St. bet. 3rd & 4th Avenues

INFO 279-1984 254-2800

Doors Open 9 PM · Show starts 11PM · $10. ADV

ROCK HOTEL PRESENTS

THE RETURN OF THE

# Cro-Mags

H/N/C/Y

THE SKINHEADS
ARE BACK! SEE
THE FIRST N.Y.
SHOW OF THEIR
NEW TOUR!

SKINHEAD!

## WITH GUESTS:

## LEEWAY · CARNIVORE
## DAMAGE

# CRO MAGS    L'AMOUR

FRI
NOV 13

1546 62ND ST., BAYRIDGE, BROOKLYN
718-232-1616
"THE ROCK CAPITOL
OF BROOKLYN"

L'AMOUR IS NOW OPEN TO ANYONE 16 & OVER
ALCOHOL SERVED TO 21 YEARS & OLDER
WITH I.D.

# Murphy's Law

AT PIZAZZ
MARGARET +ORTHODOX
EL STOP
ALL AGES
8-12:30
FRI,
OCT. 2

# SERIAL KILLERS   $8.00
AT THE DOOR

E.A.B.    NOT DEAD YET    RETRIBUTOIN

FLYER BY
BRUCE BOYD
FRANK PHOBIA ©

## CLUB PIZAZZ   FRANKFORD Y OXFORD AVES
FILTHADELPHIA, 215 387 0789

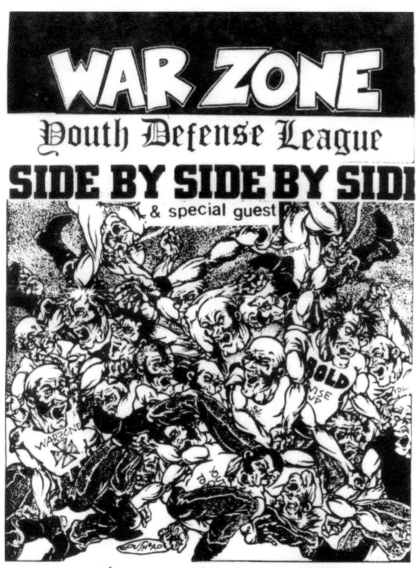

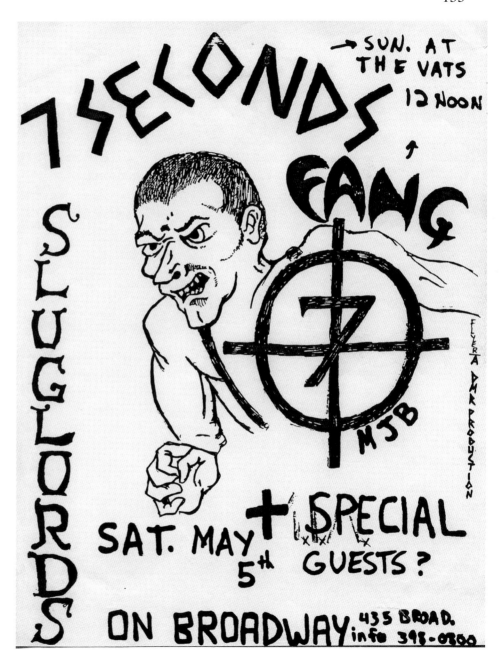

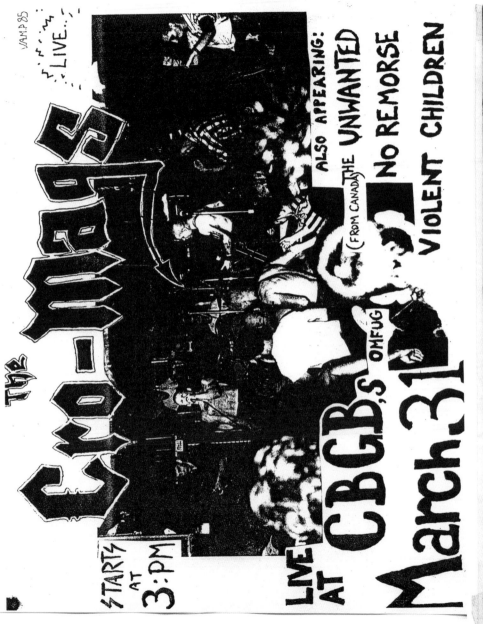

JAM.P 85

..LIVE..;

The CRO-MAGS

ALSO APPEARING:
THE UNWANTED (FROM CANADA)
NO REMORSE
VIOLENT CHILDREN

LIVE AT CBGB'S OMFUG March 31

STARTS AT 3:PM

FRIDAY, JANUARY 12TH
NEW YORK CITY'S
DOORS OPEN AT 9:30PM
ALL AGES!

REST IN PIECES

"...FOR YOU MUST MAKE A FRIEND OF HORROR... HORROR AND MORAL TERROR..."

the icemen

WITH
CT.'S POWERSURGE

AT: THE ANTHRAX
INFO: (203) 849-1160
25 PERRY AVE. NORWALK, CT.

CJD 90

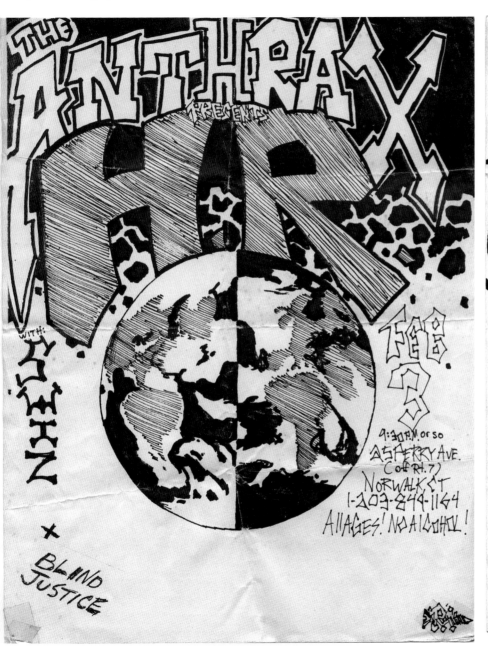

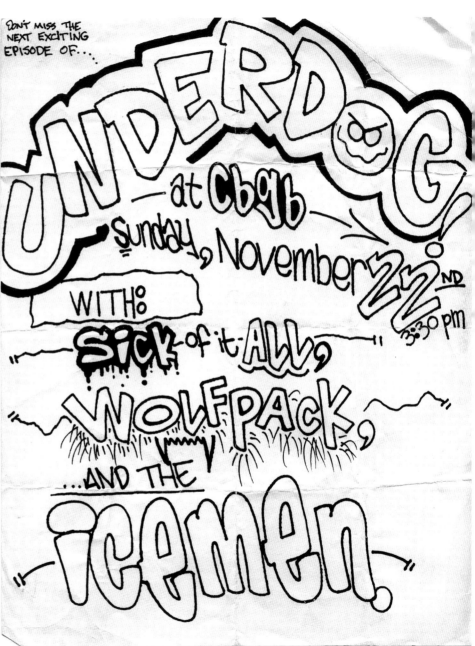

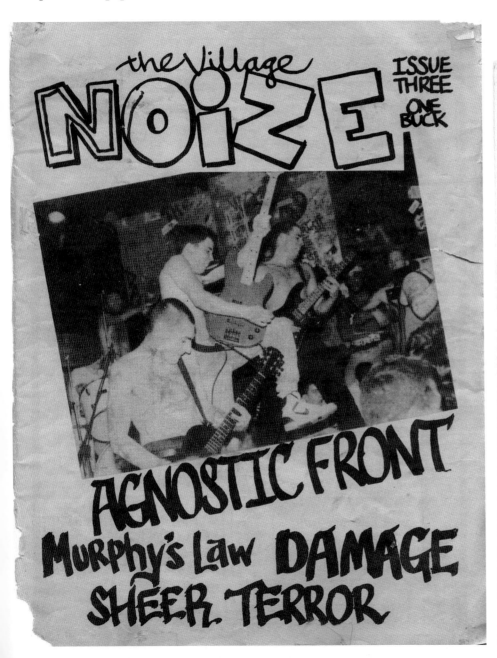

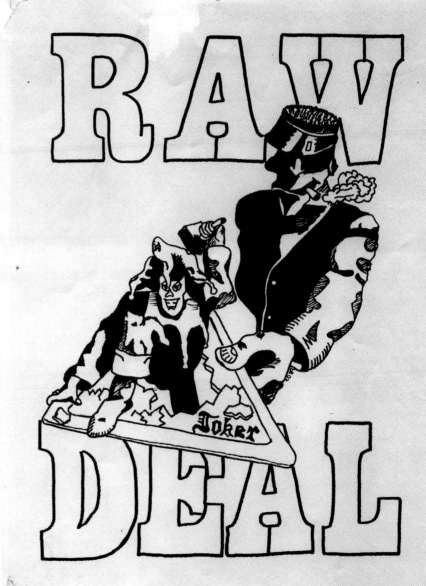

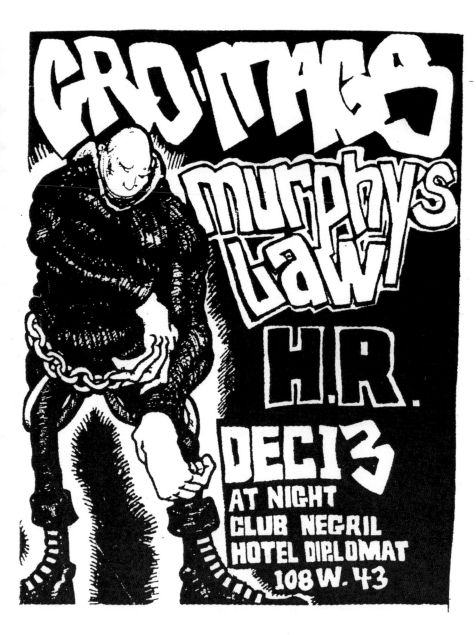

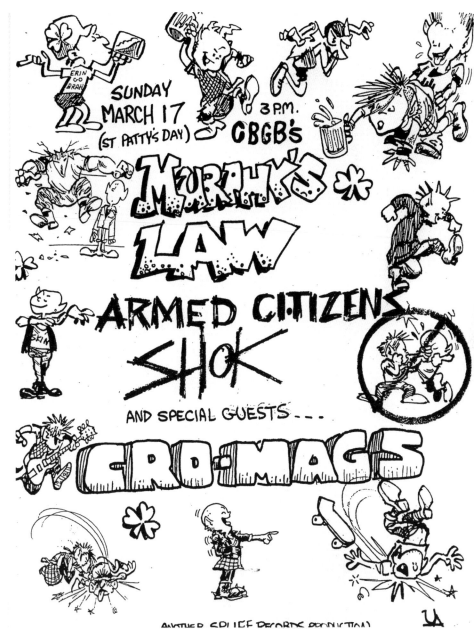

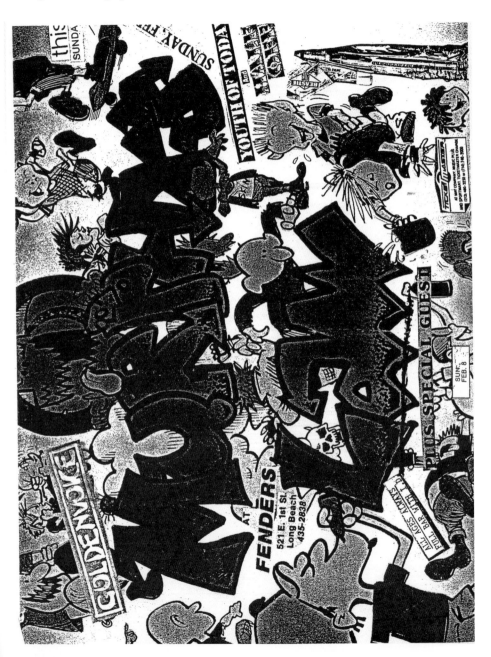

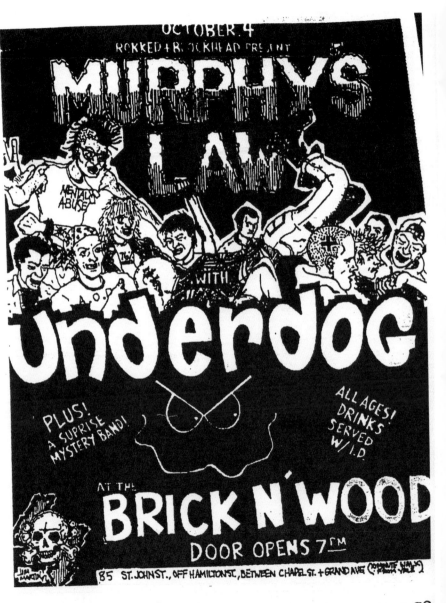

and whether this is a go

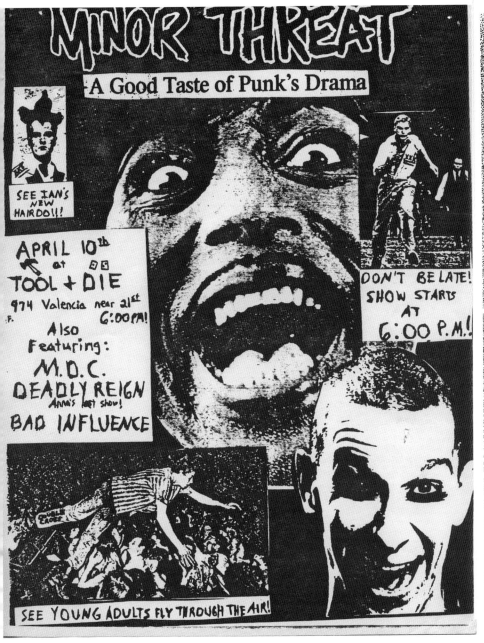

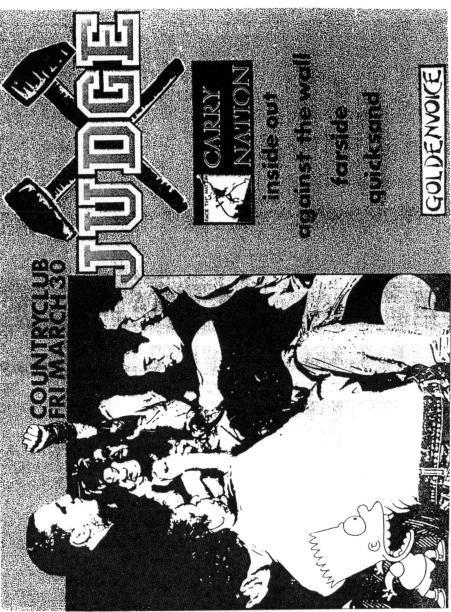

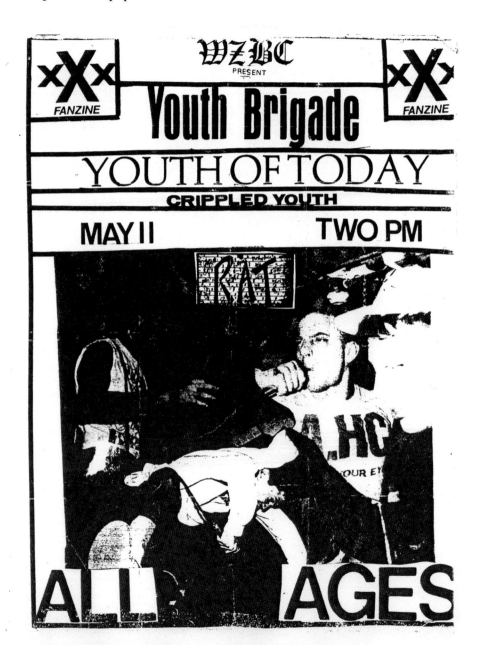

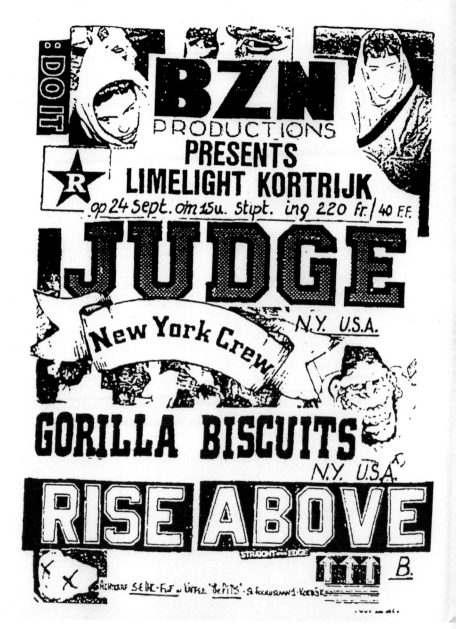

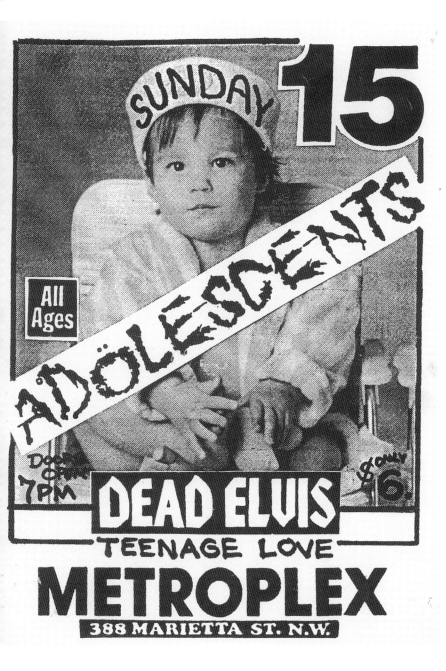

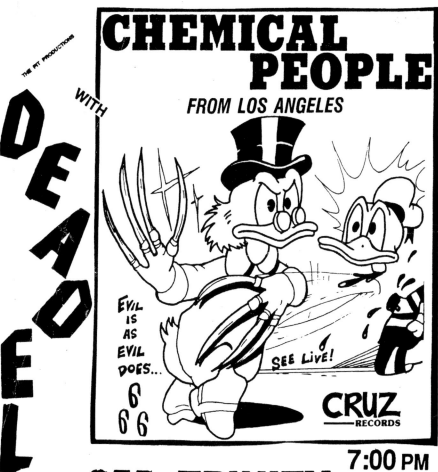

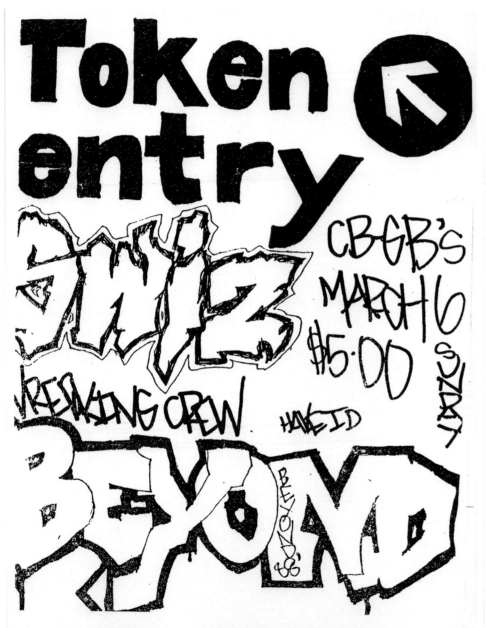

# Token entry

SWIZ

WRECKING CREW

BEYOND

CBGB's
MARCH 6
$5.00
SUNDAY
HAVE ID

SATURDAY, APRIL 28TH
AT THE UNISOUND 6:00PM $8

THE INCREDIBLE

GORILLA BISCUITS

GORILLA BISCUITS

STAND UP↑

THE BONE SHAKERS

VOR
Voice Of Reason

TRAP DOOR
FORMERLY FOUNDATION X

!SUPPORT!
INFO-JAKE-(215) 372-5827

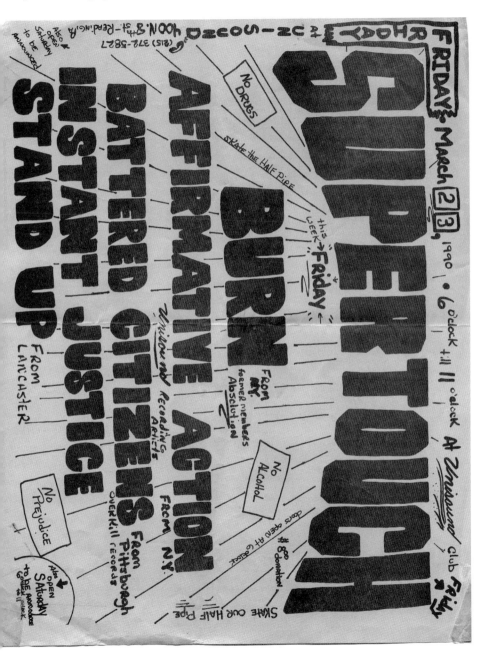

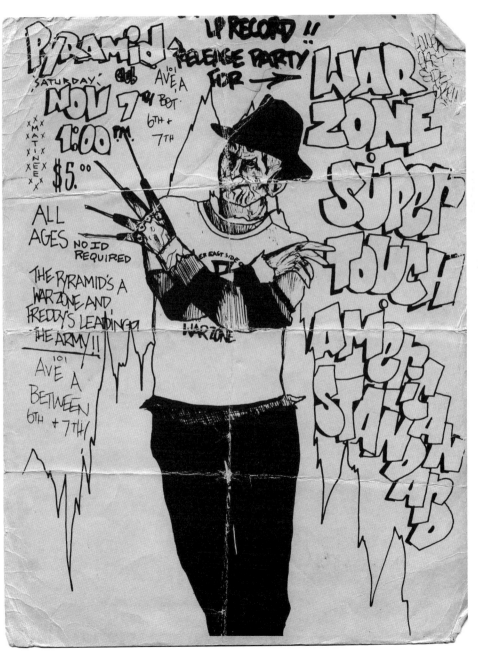

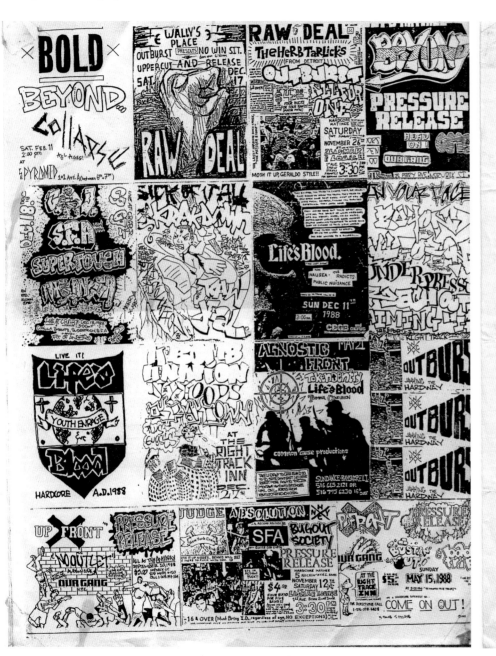

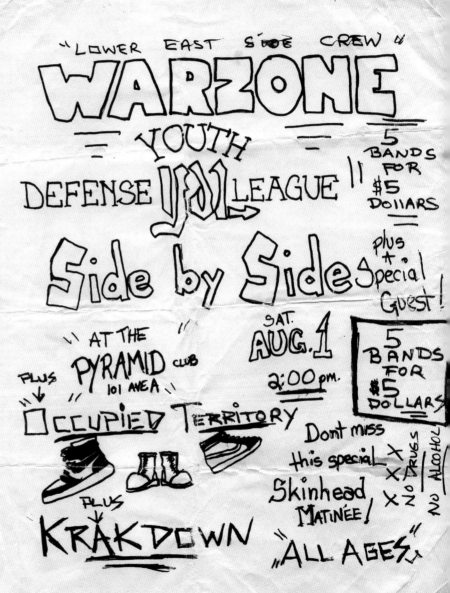

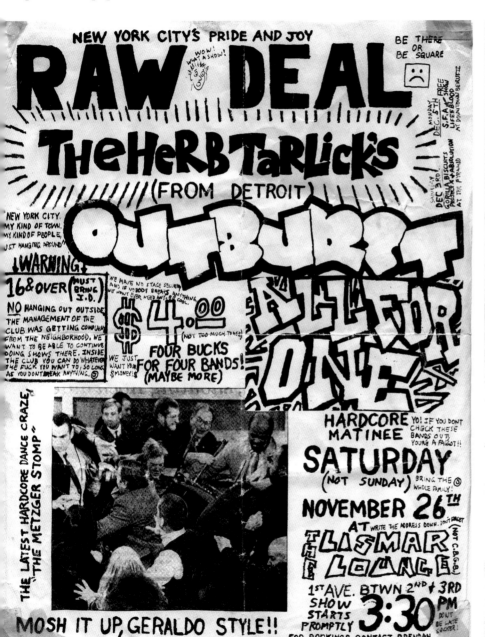

**NEW YORK CITY'S PRIDE AND JOY**

WOW! WHAT A SHOW!

BE THERE OR BE SQUARE

# RAW DEAL

## The HeRB TaRLick's

(FROM DETROIT)

NEW YORK CITY, MY KIND OF TOWN. MY KIND OF PEOPLE. JUST HANGING AROUND!

MONDAY DEC. 5TH S.F.A. FREE SHOW LIFE'S BLOOD GORILLA BISCUITS PROJECT X + ABOLUTION AT THE PYRAMID

SATURDAY DEC. 3RD. AT DOWNTOWN BEIRUT II

## OUTBURST

**WARNING**

16 & OVER (MUST BRING I.D.)

NO HANGING OUT OUTSIDE. THE MANAGEMENT OF THE CLUB WAS GETTING COMPLAINTS FROM THE NEIGHBORHOOD. WE WANT TO BE ABLE TO CONTINUE DOING SHOWS THERE. INSIDE THE CLUB YOU CAN DO WHATEVER THE FUCK YOU WANT TO, SO LONG AS YOU DON'T BREAK ANYTHING.

WE HAVE NO STAGE SECURITY AND IF NOBODY BREAKS ANYTHING WE WON'T EVER NEED ANY. SO COOL.

$$ $4.00 $$

(NOT TOO MUCH TO ASK)

FOUR BUCKS FOR FOUR BANDS! (MAYBE MORE)

WE JUST WANT YOUR $MONEY!$

## ALL FOR ONE

**HARDCORE MATINEE**

YO! IF YOU DON'T CHECK THESE BANDS OUT, YOU'RE A FAGGOT!!

## SATURDAY

(NOT SUNDAY)

BRING THE WHOLE FAMILY!

## NOVEMBER 26TH

AT WRITE THE ADDRESS DOWN. DON'T FORGET (NOT C.B.G.B.)

## THE PLASMAR LOUNGE

1ST AVE. BTWN 2ND + 3RD

SHOW STARTS PROMPTLY **3:30 PM**

DON'T BE LATE SUCKER!

FOR BOOKINGS CONTACT BRENDAN

THE LATEST HARDCORE DANCE CRAZE, "THE METZGER STOMP"

**MOSH IT UP, GERALDO STYLE!!**

---

## PREPARE YOURSELVES FOR

# BIGGER THOMAS

(FORMERLY PANIC!)

## APPEARING

**FRIDAY, FEBRUARY 16**
GREEN PARROT
SPECIAL VIDEO SHOOT
NEPTUNE, NJ
(201) 775-1991

**FRIDAY, FEBRUARY 23**
CLUB BENE
WITH JAH LOVE AND THE SURVIVORS
SOUTH AMBOY, NJ
(201) 727-3000

**SATURDAY, FEBRUARY 24**
CBGB
WITH THE TOASTERS & N.Y. CITIZENS
NYC, NY
(212) 982-4052

**THURSDAY, MARCH 1**
MAXWELL'S
HOBOKEN, NJ
(201) 656-9632

**MONDAY, MARCH 26**
CAT CLUB
SPECIAL VIDEO SHOOT WITH THE TOASTERS & THE N.Y. CITIZENS
NYC, NY
(212) 505-0090

BIGGER THOMAS info: 218 RUTGERS ST., NEW BRUNSWICK, NJ 08901
(201) 249-8274

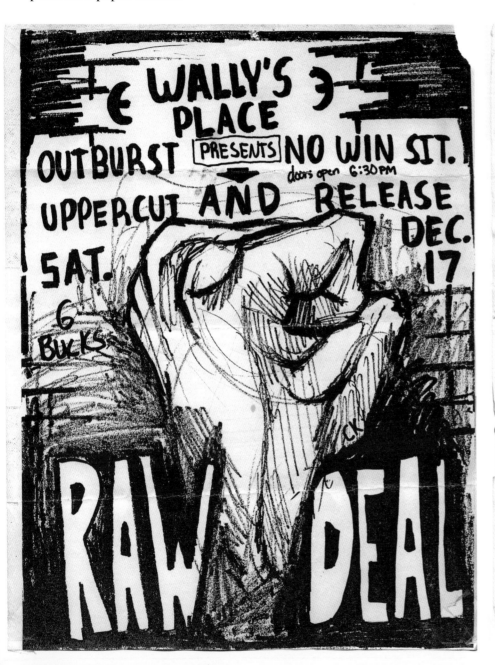

WALLY'S PLACE

PRESENTS

OUTBURST NO WIN SIT.

doors open 6:30 PM

UPPERCUT AND RELEASE

SAT. DEC. 17

6 BUCKS

RAW DEAL

24-7 Spyz and FRIED X the icemen

friday night July:28

at sundance

bay shore long island

MCMLXXXVIIII

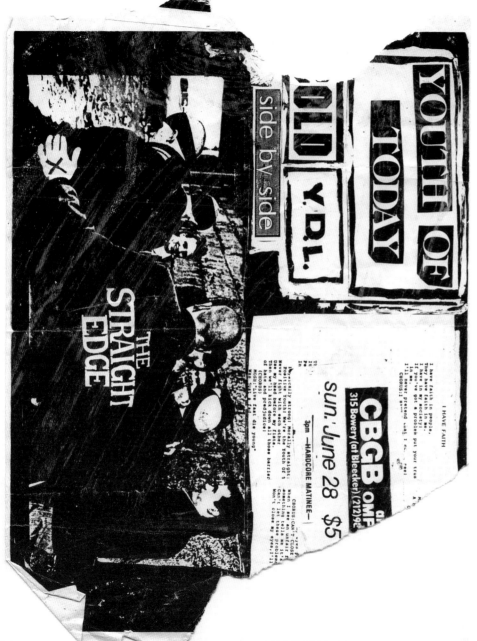

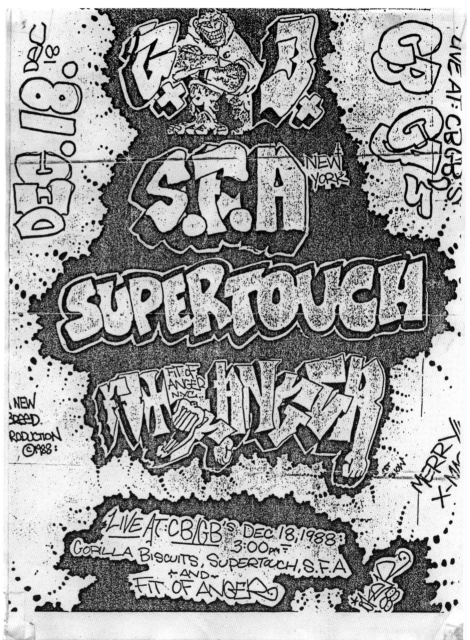

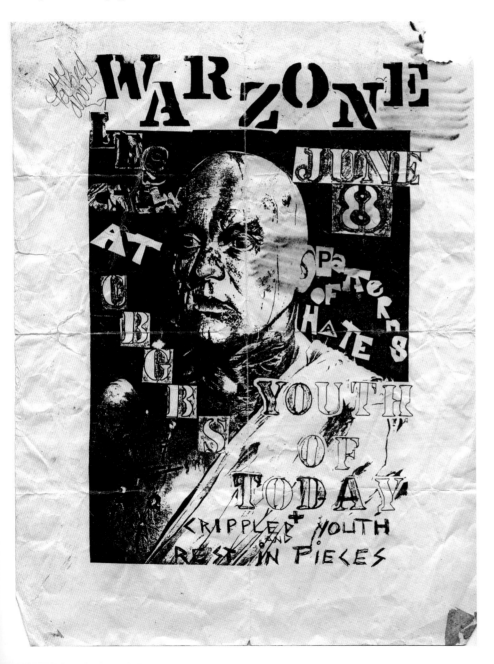

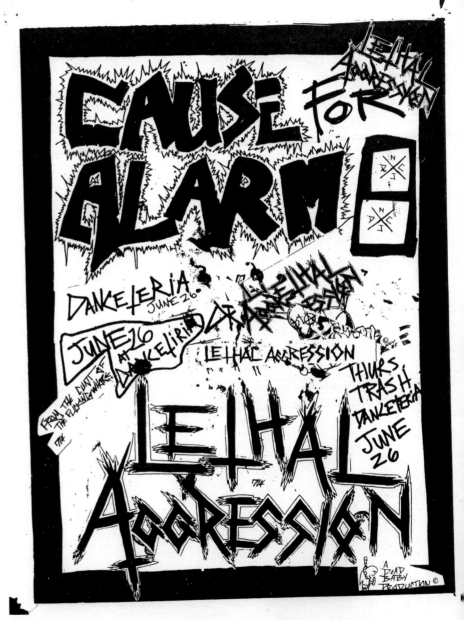

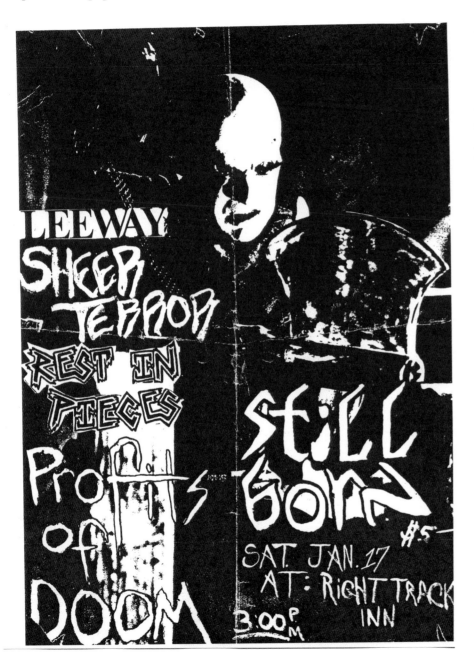

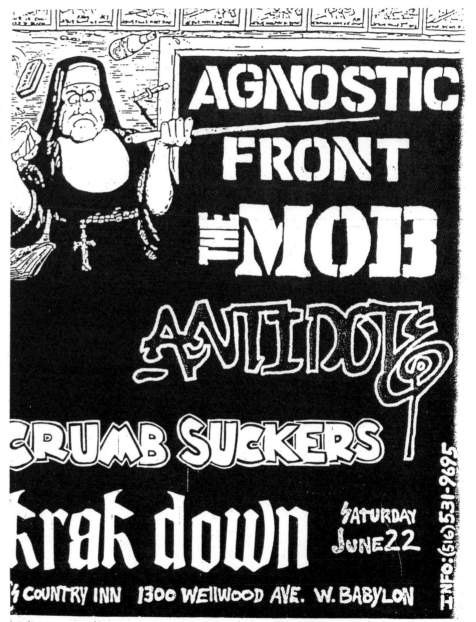

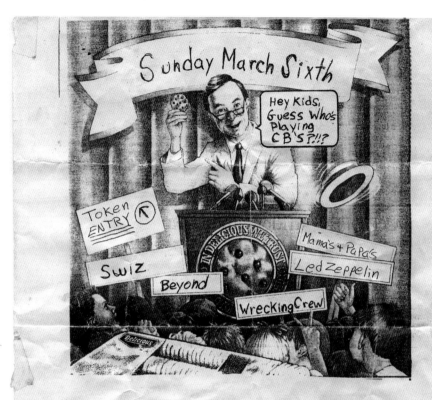

Sunday March Sixth

Hey Kids, Guess Who's Playing CB'S ?!!?

Token ENTRY ®

Swiz

Beyond

Mama's + Papa's

Led Zeppelin

Wrecking Crew

TOKEN ENTRY

with special guests

MARCH 6th

★ Swiz

★ Wrecking Crew

CB-GB's Bring I.D.

★ Beyond

Publishers Note: we are sorry to inform you that the Mama's + the Papa's, and Led Zeppelin will not be Performing  Thank you

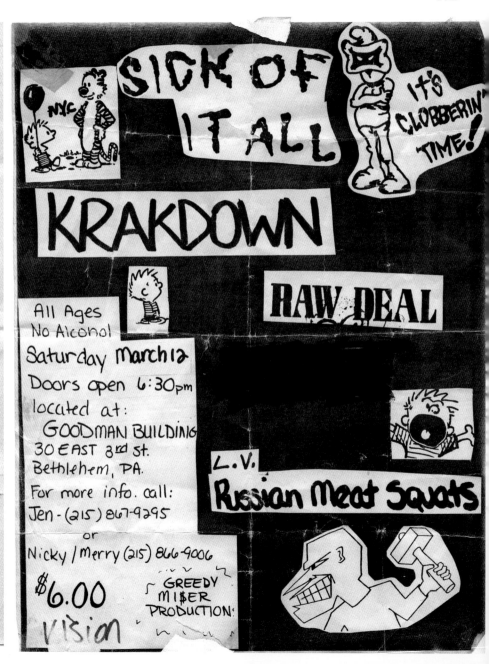

SICK OF IT ALL

NYC

IT'S CLOBBERIN' TIME!

KRAKDOWN

RAW DEAL

All Ages
No Alcohol

Saturday March 12

Doors open 6:30 pm

located at:
GOODMAN BUILDING
30 EAST 3rd St.
Bethlehem, PA.

For more info. call:
Jen - (215) 867-9295
or
Nicky/Merry (215) 866-9006

$6.00

GREEDY MI$ER PRODUCTION

VISION

L.V.
Russian Meat Squats

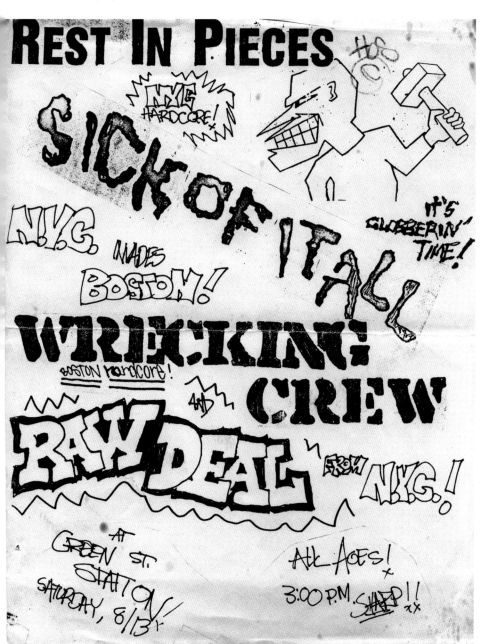

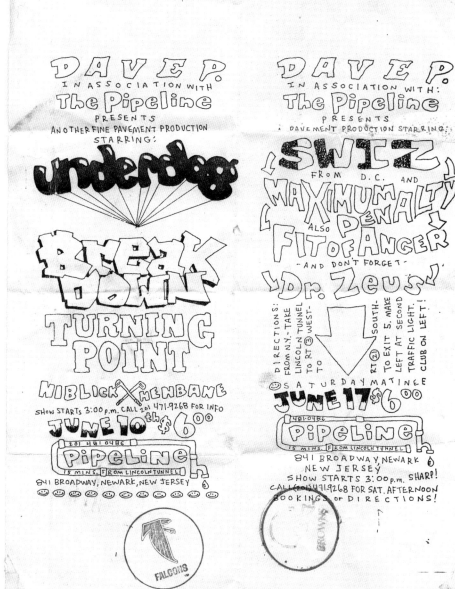

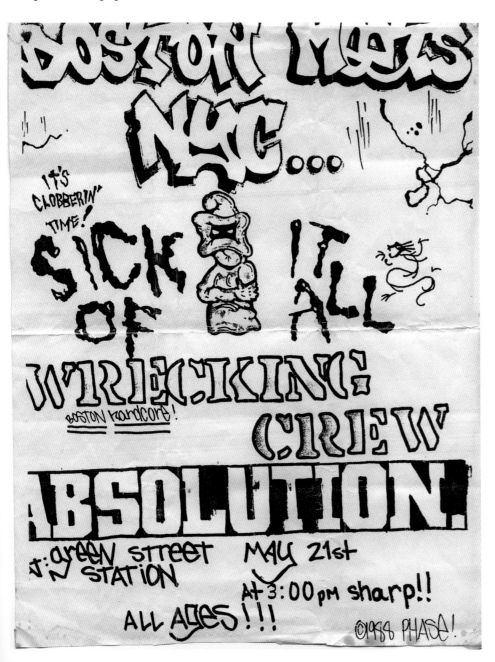

BOSSON Meets

NYC...

IT'S CLOBBERIN' TIME!

SICK OF

IT ALL

WRECKING

BOSTON hardcore!

CREW

ABSOLUTION!

J: GREEN STREET STATION    MAY 21st

At 3:00 pm sharp!!

ALL AGES !!!

©1988 PHASE!

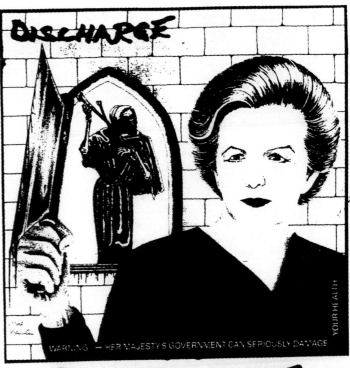

DISCHARGE

WARNING — HER MAJESTY'S GOVERNMENT CAN SERIOUSLY DAMAGE YOUR HEALTH

DISCHARGE

FROM ENGLAND
NEW YEAR'S EVE
ROCK HOTEL
113 JANE STREET
(CORNER OF WEST ST.)

9:00 O'CLOCK     $10.00 ADMISSION

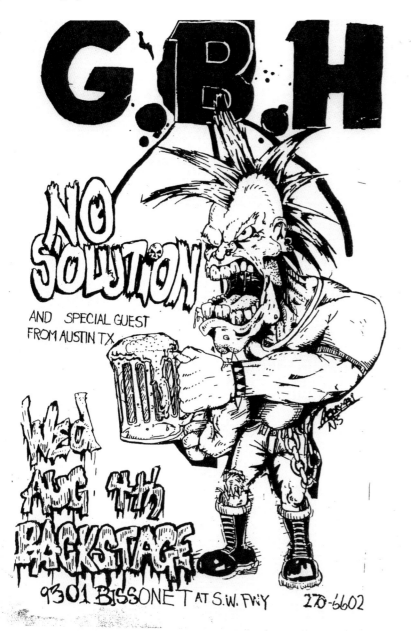

# G.B.H

NO SOLUTION

AND SPECIAL GUEST FROM AUSTIN TX

WED AUG 4th/2 BACKSTAGE

9301 BISSONET AT S.W. FWY

270-6602

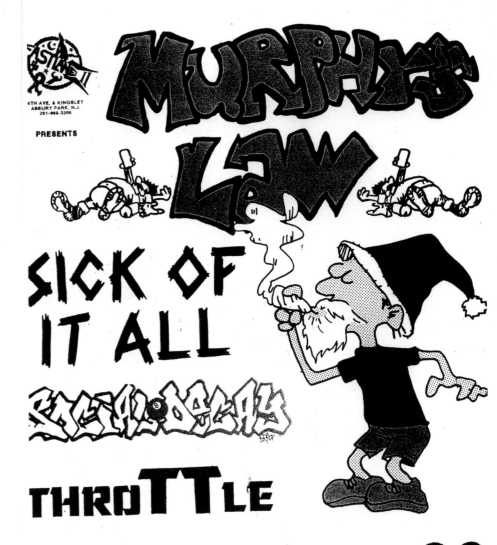

4TH AVE. & KINGSLEY
ASBURY PARK, N.J.
201-988-3205

PRESENTS

# MURPHYS LAW

## SICK OF IT ALL

SOCIAL DECAY

THROTTLE

MENTAL FLOSS

SUNDAY DECEMBER 23

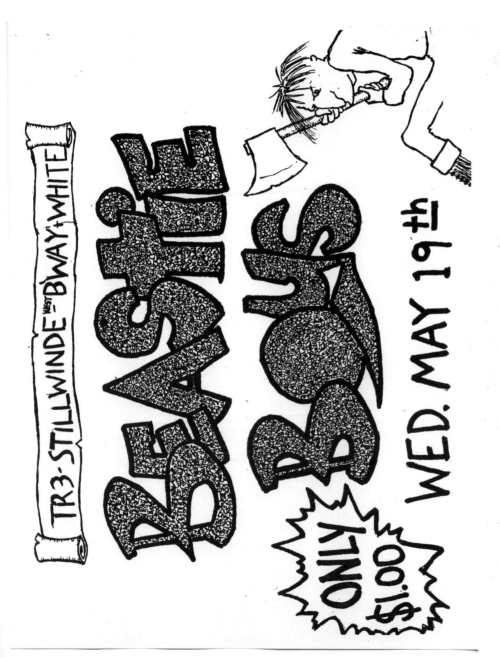

TR3 - STILLWINDE 1st BWAY/WHITE

ONLY $1.00

WED. MAY 19th

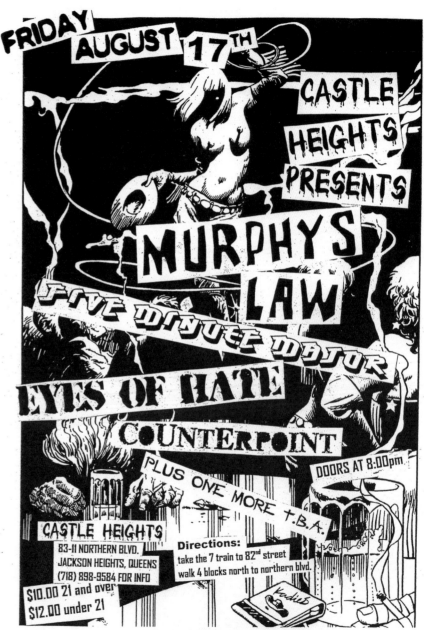

FRIDAY AUGUST 17th

CASTLE HEIGHTS PRESENTS

MURPHYS LAW

FIVE MINUTE MAJOR

EYES OF HATE

COUNTERPOINT

PLUS ONE MORE T.B.A.

DOORS AT 8:00pm

CASTLE HEIGHTS
83-11 NORTHERN BLVD.
JACKSON HEIGHTS, QUEENS
(718) 898-9584 FOR INFO
$10.00 21 and over
$12.00 under 21

Directions:
take the 7 train to 82nd street
walk 4 blocks north to northern blvd.

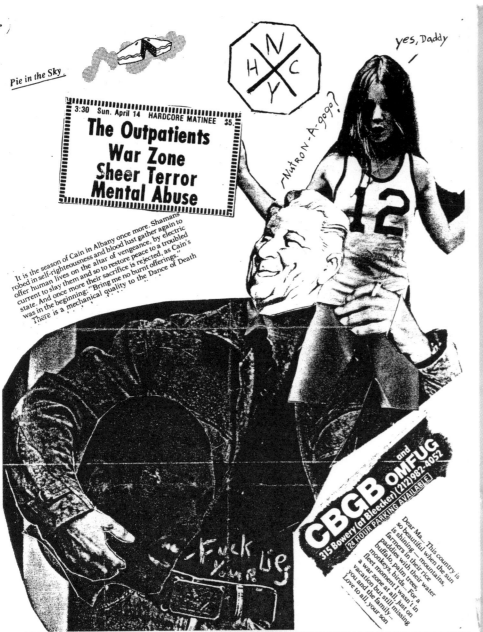

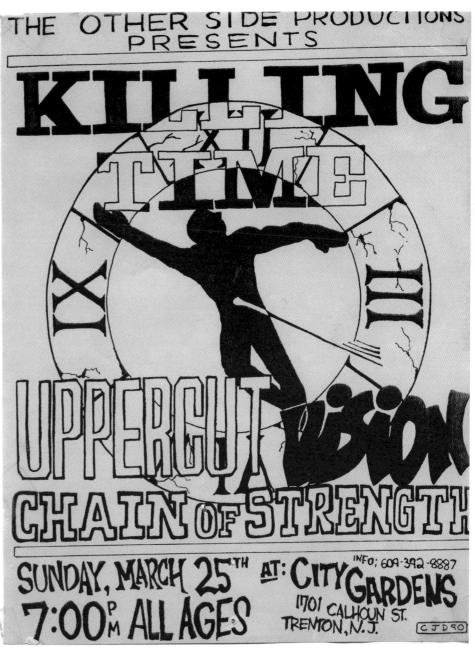

WCSB
CLEVELAND'S FM ALTERNATIVE

STATIC PRODUCTIONS

WRUW 91.1 FM

PRESENT

# Sonic Youth

with special guest:

SQUIRREL BAIT

## MON. JULY 21

**JESUS IS THE ANSWER**

### ALL AGES

9pm

$6.50 adv.

TICKETS AVAILABLE AT:
CHRIS'WARPED RECORDS
3385 Madison Ave.
RECORD REVOLUTION/ COVENTRY
SPLATTERPUSS RECORDS
79 EAST 185th 531-6743
MUSIC AND MORE/PARMATOWN
WAX STAX 2254 Lee Rd.
and PEABODY'S BOX OFFICE

Peabody's down under
CLEVELAND FLATS

1059 OLD RIVER RD. 241 - 0792

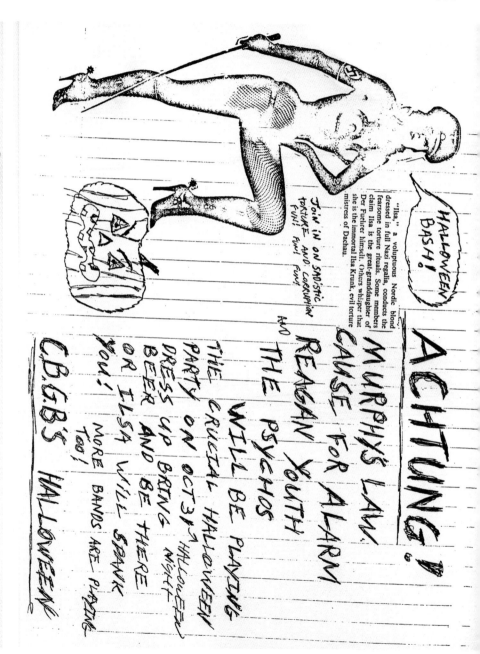

"Ilsa," a voluptuous Nordic blond dressed in full Nazi regalia, conducts the fearsome torture rituals. Some members claim Ilsa is the great-granddaughter of Der Fuehrer himself. Others whisper that she is the immortal Ilsa Krunk, evil torture mistress of Dachau.

HALLOWEEN BASH!

ACHTUNG!

Join in on SADISTIC torture AND CORRUPTION FUN! FUN! FUN!

CAUSE FOR ALARM

REAGAN YOUTH!

AND THE PSYCHOS

MURPHY'S LAW.

WILL BE PLAYING

THE CRUCIAL HALLOWEEN PARTY ON OCT 31st HALLOWEEN NIGHT

DRESS UP BRING BEER AND BE THERE OR ILSA WILL SPANK YOU!

MORE BANDS ARE PLAYING

C.B.G.B's HALLOWEEN!

THE OTHER SIDE
PRESENTS:

City gardens

1701 Calhoun St.
Trenton, NJ 08638
609-392-8887
609-895-2482

SKA

17 & up to enter    21- Lounge

**FRI JULY 14**

the Toasters

PANIC!     **$5** 9pm

**FRI JULY 21**

BAD MANNERS    **BIM** **$5** 9pm
SKALA
BIM

LAUREL AITKEN

**FRI AUG 4**    **THE CITIZENS** $5 9pm

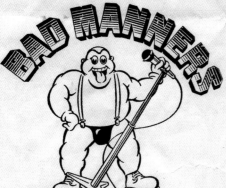

---

THE OTHER SIDE PRODUCTIONS
PRESENTS AT:
City Gardens
1701 CALHOUN ST., TRENTON, N.J. 609-392-8887

$6    9PM    FRI SEPT 4    18&UP    21 & UP/ALCOHOL

**NAKED RAYGUN / Dick Destiny** AND THE HIGHWAY KINGS

90¢    9PM    SAT SEPT 5    18&UP    21 & UP/ALCOHOL

**BEST OF THE OLD WAVE DANCE PARTY**
With d.rettman & r.now

SEX PISTOLS / BUZZCOCKS / THOMPSON TWINS / WALL OF VOODOO / ELVIS COSTELLO /
SQUEEZE / DEPECHE MODE / NEW ORDER / GENERATION XX / GET THE PICTURE?

$10    5:30-10PM    SUN SEPT 6    17 & UP    NO ALCOHOL

# GBH
# DAG NASTY
**Verbal Abuse   The Accused**

SATURDAY SEPT 26    9PM    18&UP    21&UP ALCOHOL

$10/ADV.    $12/DAY OF SHOW

# HOO DOO GURUS
**GUTBANK**

$10 6-10PM    SUNDAY SEPT 27    17 & UP    NO ALCOHOL

**CELTIC FROST**

**FLOTSAM AND JETSAM**

COMING    FRI OCT 2 - ABBIE HOFFMAN
FRI OCT 9 - CELIBATE RIFLES / NO TREND / ANGRY RED PLANET

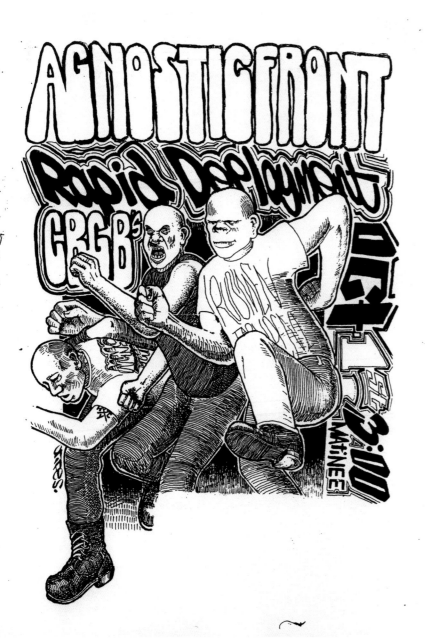

ED GEIN'S CAR
YOUTH BRIGADE

IRVING PLAZA SAT 5-10
17 IRVING PLACE AT E. 15TH ST.    477-3728

WED 5-14 CBGB AND OMFUG
315 BOWERY AT BLEECKER ST.    982-4052

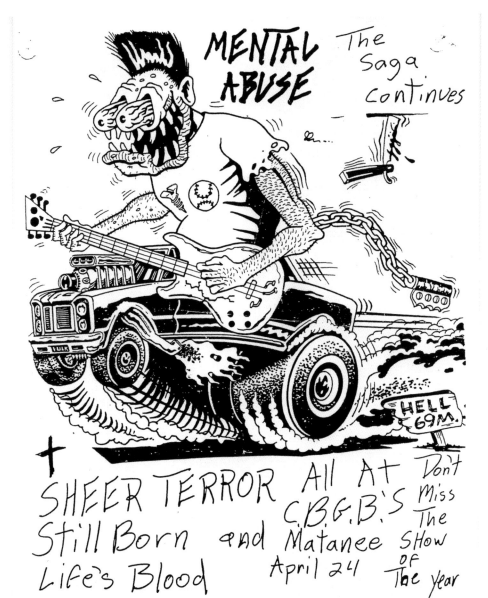

MENTAL ABUSE   The Saga Continues

SHEER TERROR   All At   Don't
Still Born   C.B.G.B'S   Miss
            and Matanee   The
Life's Blood   April 24   Show
                        of
                        The year

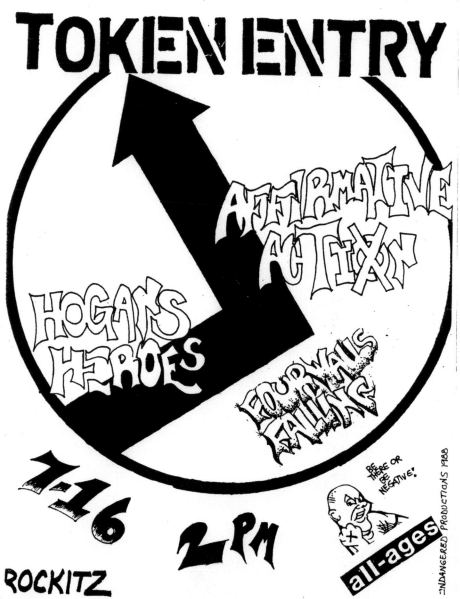

TOKEN ENTRY

AFFIRMATIVE ACTION

HOGANS HEROES

FOUR WALLS FALLING

7-16
2 PM
ROCKITZ

BE THERE OR BE NEGATIVE!

all-ages

ENDANGERED PRODUCTIONS 1988

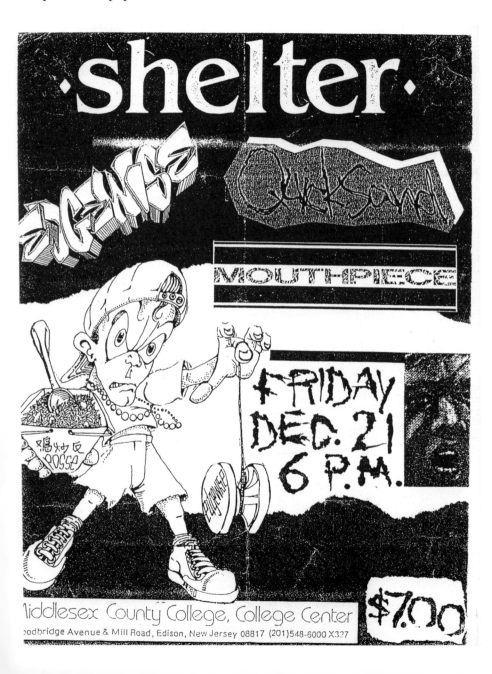

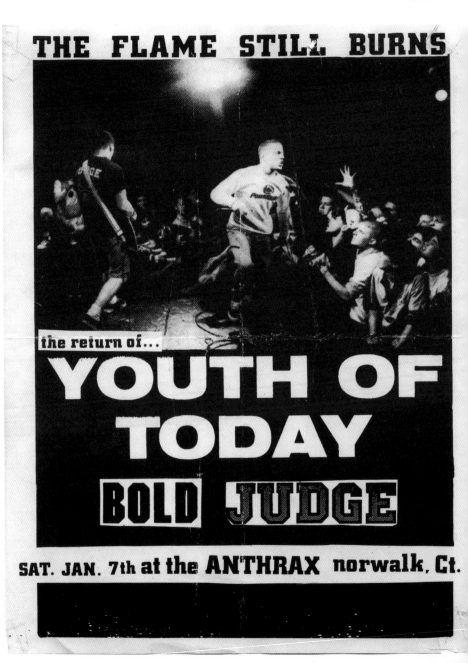

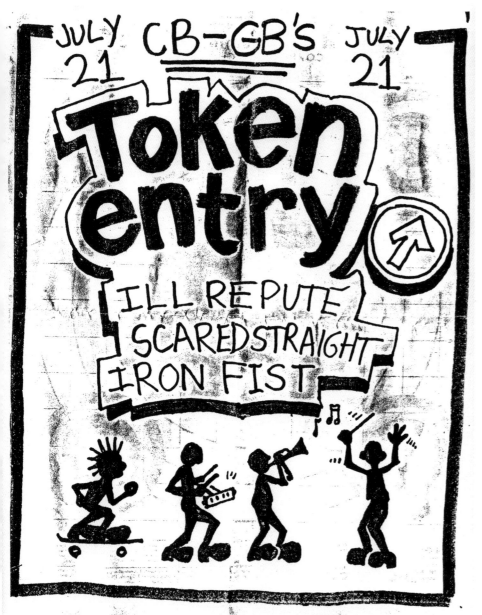

JULY 21 CB-GB's JULY 21

# Token entry

ILL REPUTE
SCARED STRAIGHT
IRON FIST

CBGB Sept. 7th

HARDCORE
WITH THE STARS MATINEE

ROT

DEATH BEFORE DISHONOR

$5.00
3PM
SUPPORT the Scene
BROTHERS + SISTERS

YOUTH OF TODAY

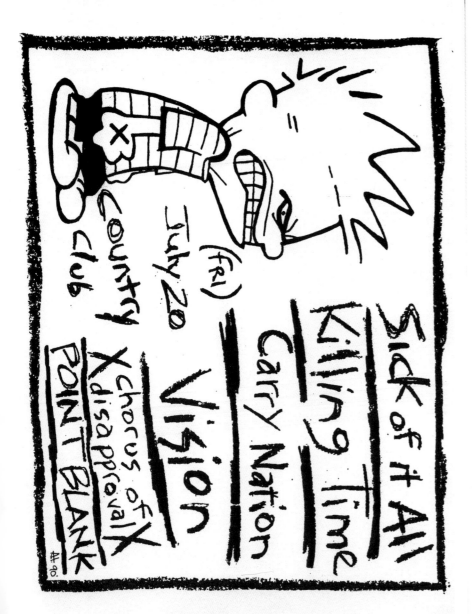

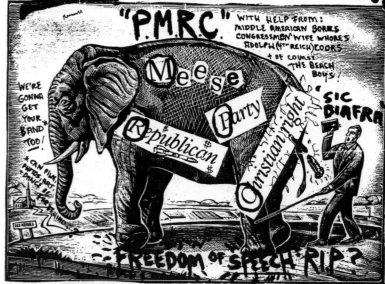

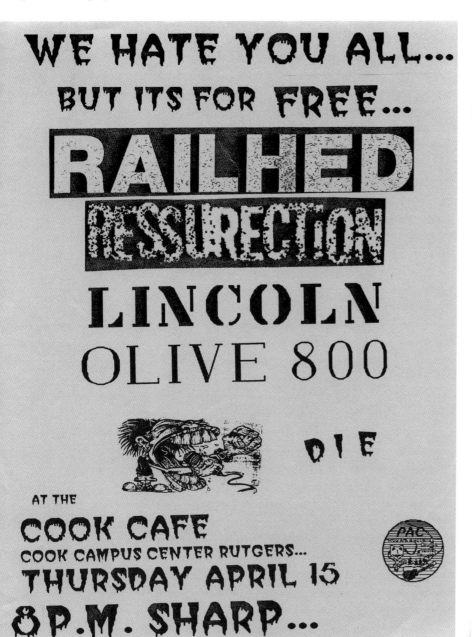

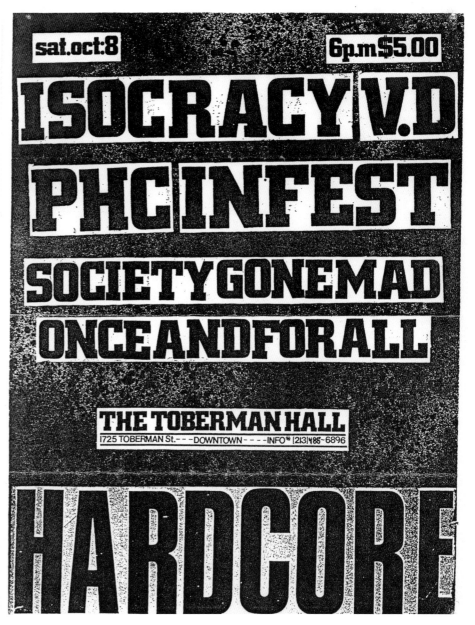

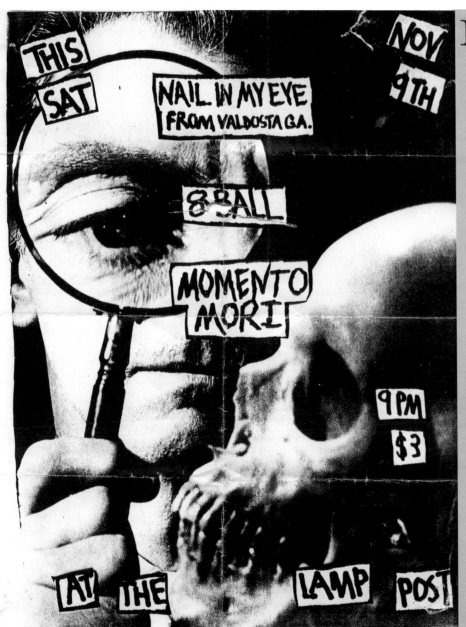

THIS SAT

NOV 9TH

NAIL IN MY EYE FROM VALDOSTA GA.

8 BALL

MOMENTO MORI

9 PM $3

AT THE LAMP POST

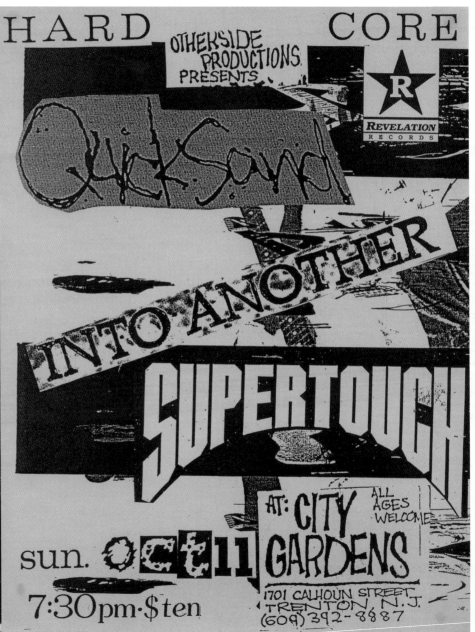

HARD CORE

OTHERSIDE PRODUCTIONS PRESENTS

REVELATION RECORDS

Quicksand

INTO ANOTHER

SUPERTOUGH

AT: CITY GARDENS

ALL AGES WELCOME

sun. OCT 11

7:30pm • $ten

1701 CALHOUN STREET TRENTON, N.J.
(609) 392-8887

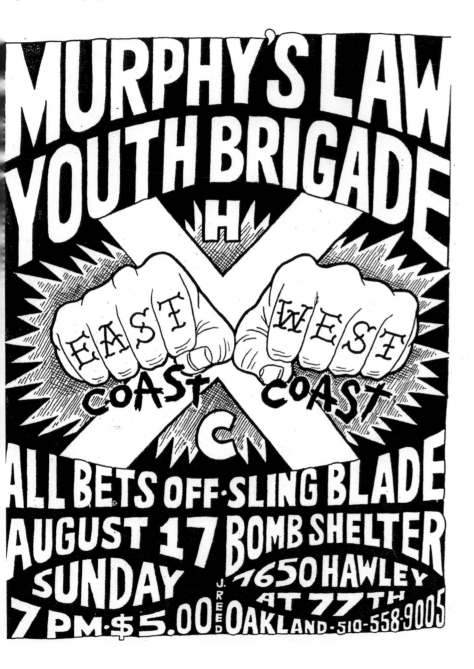

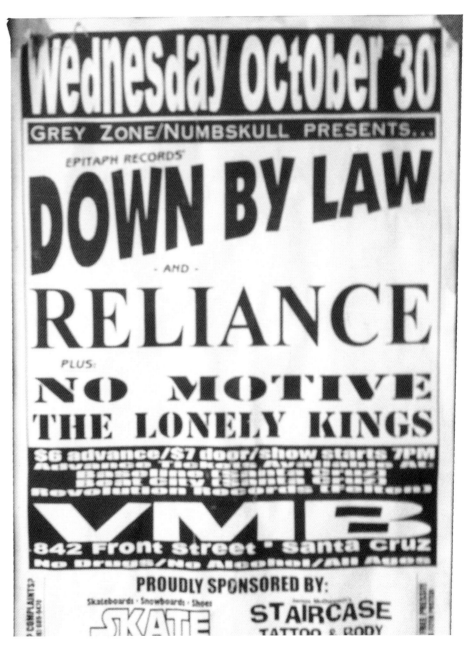

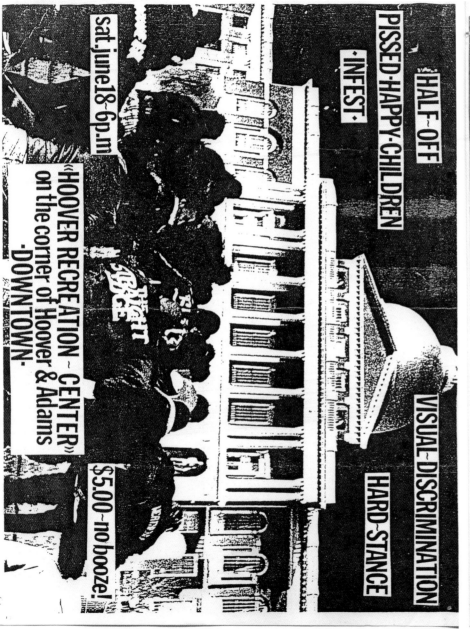

Sat. june 18~6p.m

·PISSED·HAPPY·CHILDREN

·INFEST·

·HALF~OFF·

"HOOVER RECREATION~CENTER"
on the corner of Hoover & Adams
·DOWNTOWN·

$5.00~no booze!

VISUAL~DISCRIMINATION

HARD~STANCE

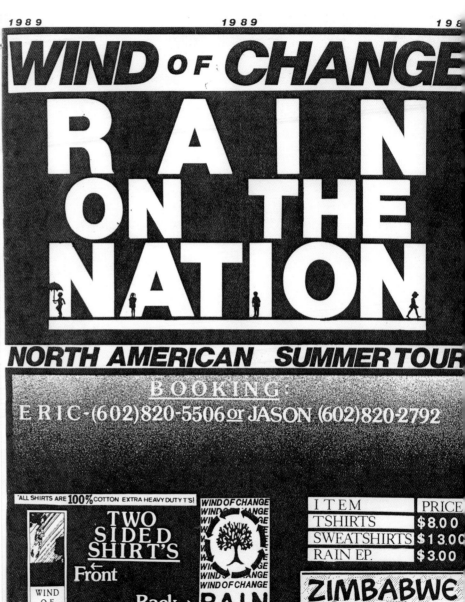

1989    1989    198

WIND OF CHANGE

RAIN

ON THE

NATION

NORTH AMERICAN SUMMER TOUR

BOOKING
ERIC·(602)820-5506 or JASON (602)820-2792

'ALL SHIRTS ARE 100% COTTON EXTRA HEAVY DUTY T'S!

WIND OF CHANGE
WIND OF CHANGE
WIND OF CHANGE

TWO
SIDED
SHIRT'S
←Front

Back→ RAIN

Checks payable to: JASON PETERSON

| ITEM | PRICE |
|---|---|
| TSHIRTS | $8.00 |
| SWEATSHIRTS | $13.00 |
| RAIN EP. | $3.00 |

ZIMBABWE
RECORDS
935 W. Olla    Mesa, AZ.    85210

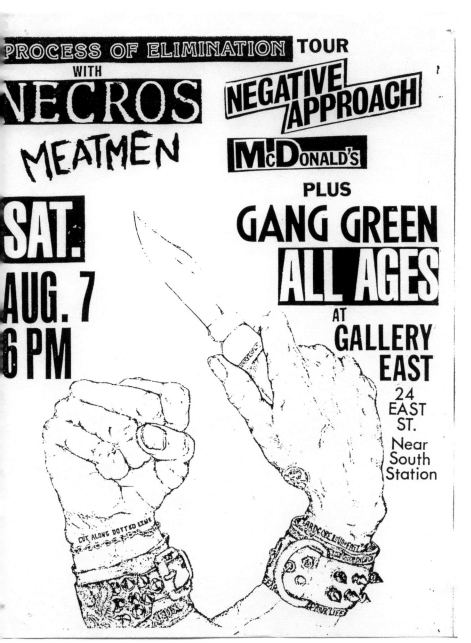

PROCESS OF ELIMINATION TOUR
WITH
NECROS NEGATIVE APPROACH
MEATMEN McDonald's
PLUS
GANG GREEN
SAT. ALL AGES
AUG. 7
6 PM
AT
GALLERY EAST
24 EAST ST.
Near South Station

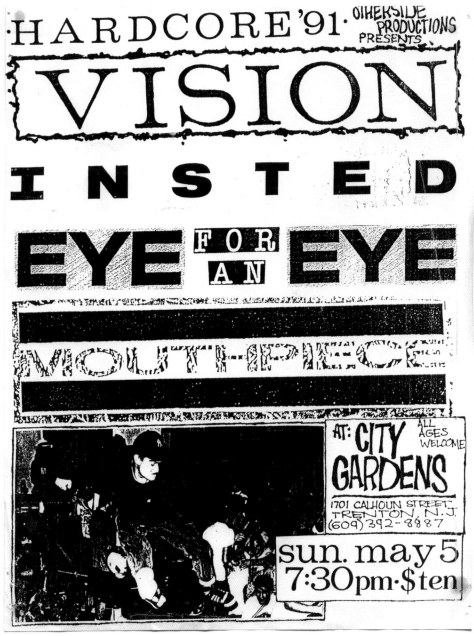

HARDCORE '91 OTHERSIDE PRODUCTIONS PRESENTS
VISION
INSTED
EYE FOR AN EYE
MOUTH-PIECE
AT: CITY GARDENS
ALL AGES WELCOME
1701 CALHOUN STREET
TRENTON, N.J.
(609) 392-8887
sun. may 5
7:30pm · $ten

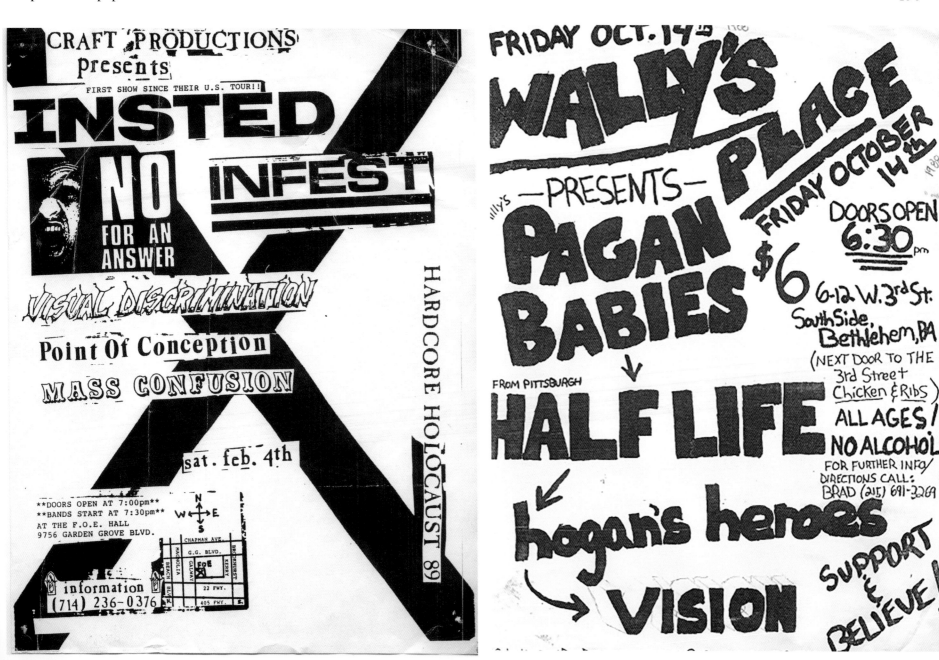

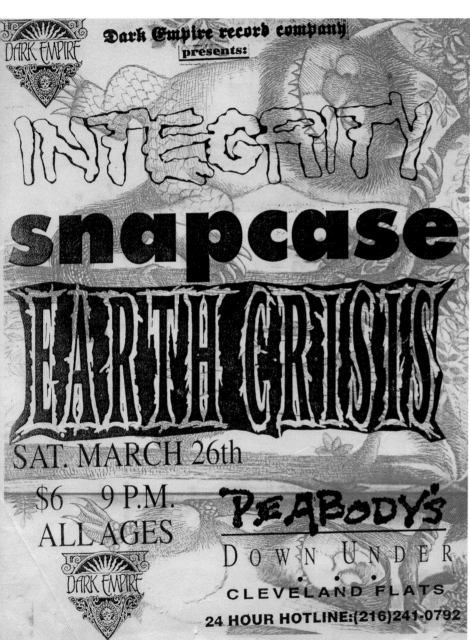

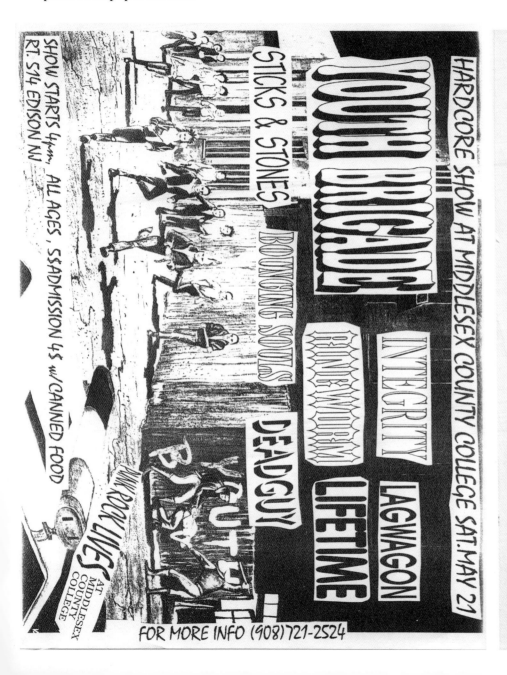

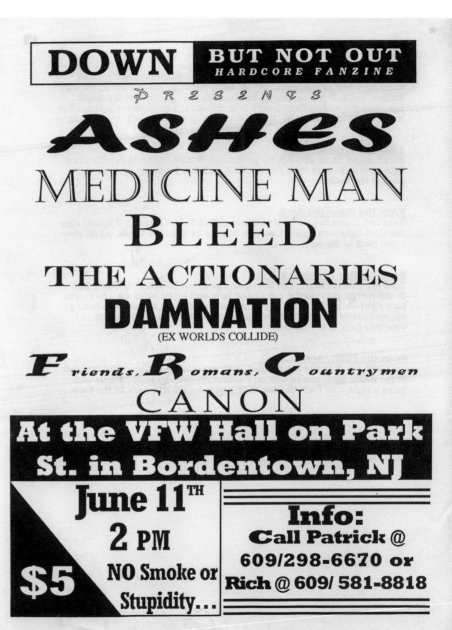

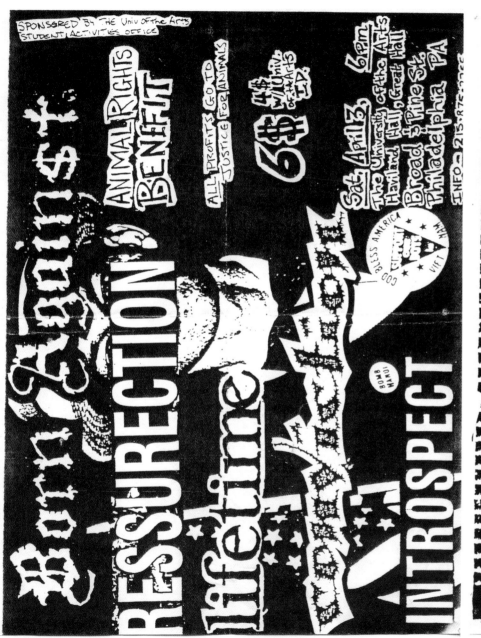

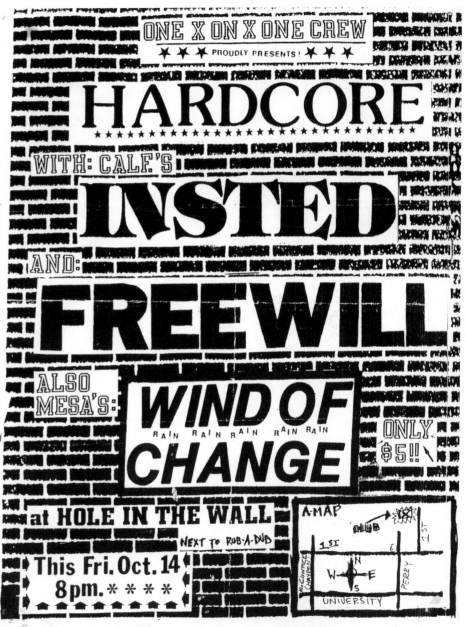

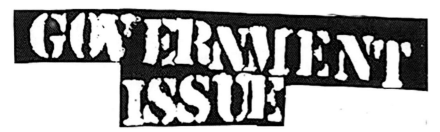

GOVERNMENT ISSUE

MEATPUPPETS
FROM ARIZ.

BLACK FLAG ||||
FROM CA.

the nig. heist
FROM CA.

FRI. ALL

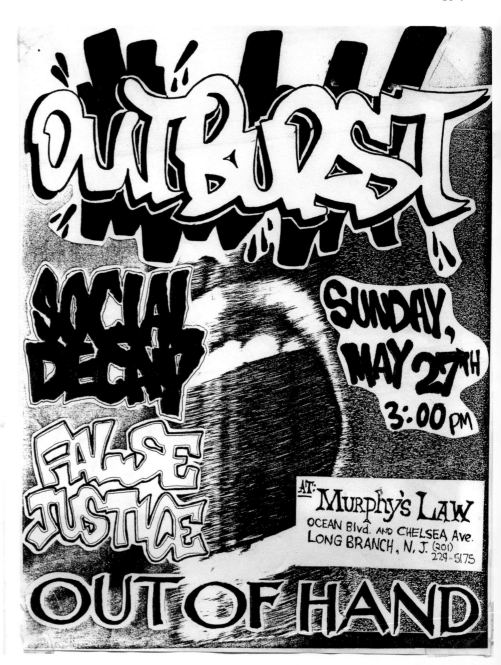

OUTBURST

SOCIAL DECAY

FALSE JUSTICE

OUT OF HAND

SUNDAY, MAY 27TH 3:00 PM

AT: MURPHY'S LAW
OCEAN Blvd. AND CHELSEA Ave.
LONG BRANCH, N.J. (201) 229-5175

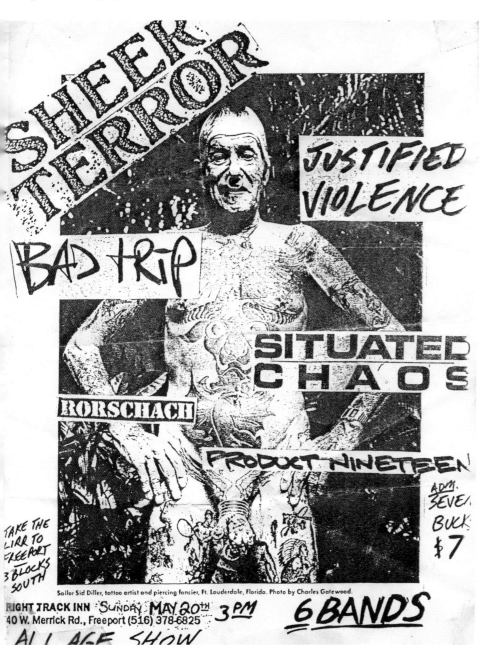

SHEER TERROR

JUSTIFIED VIOLENCE

BAD TRIP

SITUATED CHAOS

RORSCHACH

PRODUCT NINETEEN

ADM. SEVEN BUCKS $7

TAKE THE LIRR TO FREEPORT 3 BLOCKS SOUTH

Sailor Sid Diller, tattoo artist and piercing fancier, Ft. Lauderdale, Florida. Photo by Charles Gatewood.

RIGHT TRACK INN SUNDAY MAY 20th 3PM 6 BANDS
40 W. Merrick Rd., Freeport (516) 378-6825
ALL AGE SHOW

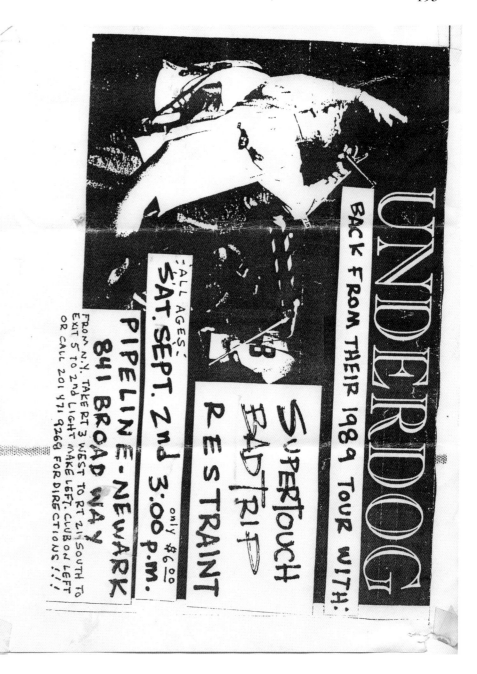

UNDERDOG

BACK FROM THEIR 1989 TOUR WITH:

SuperTouch
BAD TRIP
RESTRAINT

"ALL AGES" SAT. SEPT. 2nd 3:00 P.M.
only $6.00

PIPELINE - NEWARK
841 BROAD WAY

FROM N.Y. TAKE RT 3 WEST TO RT 21 SOUTH TO EXIT 5 TO 2nd LIGHT MAKE LEFT. CLUB ON LEFT. OR CALL 201 471 9268 FOR DIRECTIONS !!!

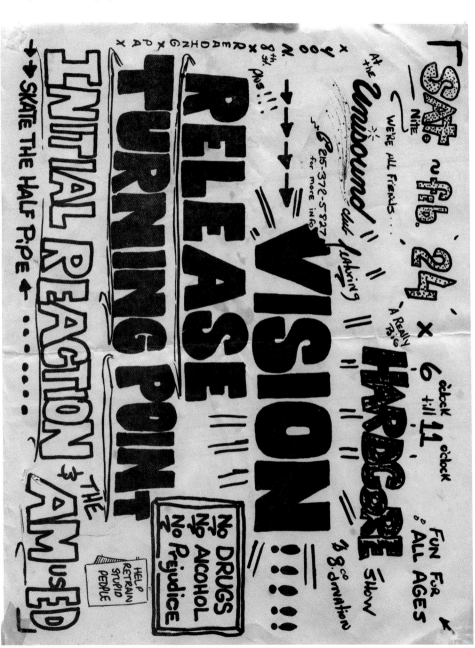

A PRE-CHRISTMAS SHOW TO CELEBRATE THE BIRTH OF JESUS

The Four Wise Men Bearing Gifts Will Be:

# s h e l t e r
(BRINGING GOLD FROM PHILADELPHIA)

# INTO ANOTHER
(BRINGING FRANKINCENSE FROM N.Y.)

# Triggerman
(BRINGING MYRRH FROM CALIFORNIA)

# Rain like the sound of trains
(BRINGING CHEWY CHOCOLATE JAMMERS FROM D.C.)

$5 + A CAN OF FOOD

YOU MUST BRING GIFTS ALSO!
Admission: Five Dollars and One Item of Canned Food

(all of the food will be donated to the Community for Creative Non-Violence, D.C.'s largest homeless shelter)

FOR MORE INFORMATION
CALL THE NATIVITY SCENE
AT 703-908-9347

"Saves...A Penny Saved Is A Penny Earned"

The Christening will be held on Sunday, December 20, 1992 A.D. at seven o'clock in the evening, at St. Stephen's Church, residing at 16th & Newton streets, N.W. D.C.

# railhed
## last show and funeral
## w/ **avail** and lean

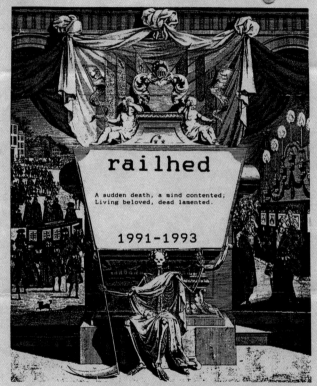

railhed

A sudden death, a mind contented;
Living beloved, dead lamented.

1991-1993

unitarian universalist church
420 willa rd.
newark, de.

directions
from 95 N. or S.: get off at Exit 1B South Newark(896). go
straight on 896. you will pass the car plant on the left
and then go over a small overpass, at the bottom of that is
a light, make a left here onto west park place. go thru 2
lights. then look for willa rd. on the left. make a turn
and go all the way to the back. unitarian church is on the
right, across from the school.

For more info. call(302)475-3701

sat. dec. 18th
$5 w/can of food
7:00 sharp.
Funeral attire is encouraged

---

# THE PIPELINE
841 BROADWAY
NEWARK NJ
(201) 481-0486

SAT. SEPT. 2  3:00 PM  $6.00

All AGES  MATINEE

# UNDERDOG
# SUPERTOUCH
## BAD tRiP
## RORSCHACH

## BACK TO SCHOOL EXTRAVAGANZA!

FROM N.Y. TAKE LIN.
TUNNEL TO RT ③
WEST TO RT ㉑ SOUTH
TO EXIT 5 MAKE
LEFT AT 2ND LIGHT
CLUB ON LEFT OR
TAKE PATH TRAIN
TO PENN STATION
NEWARK AND TAKE CAB

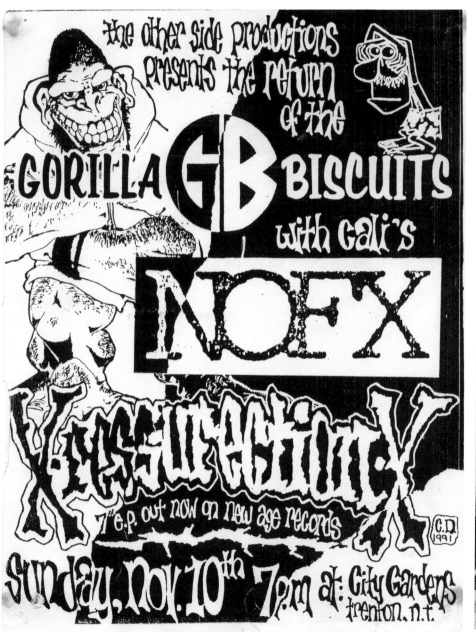

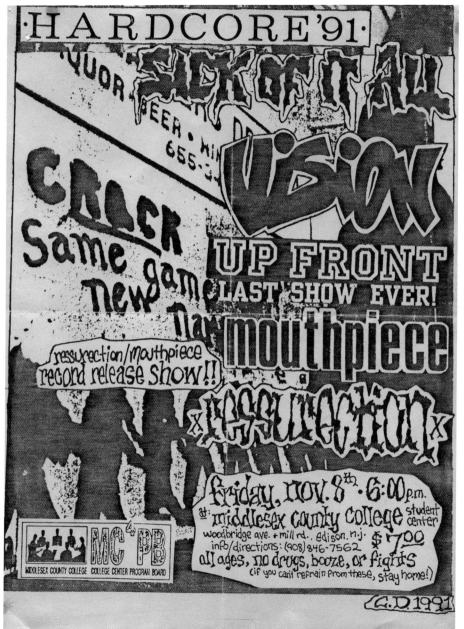

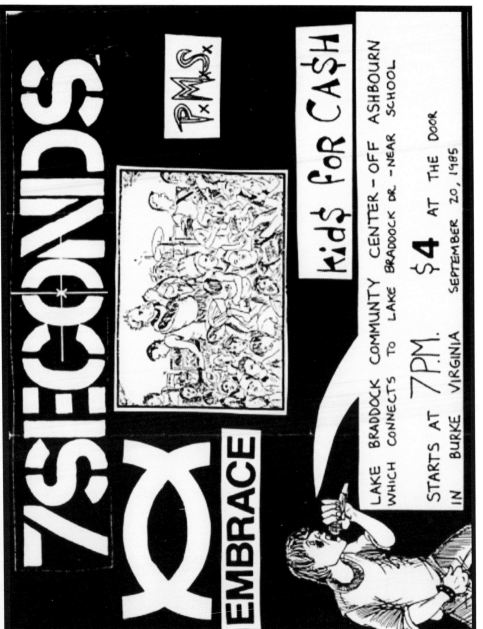

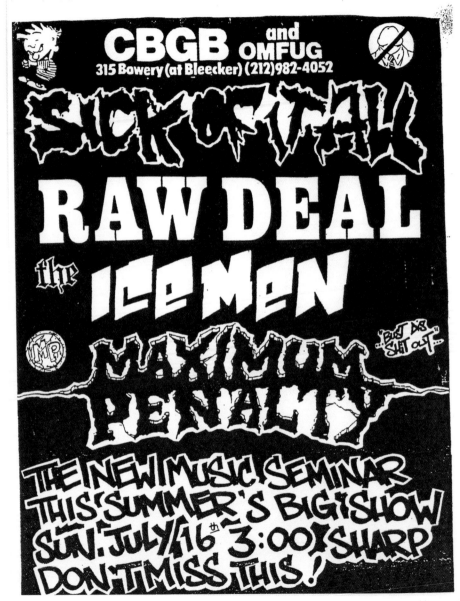

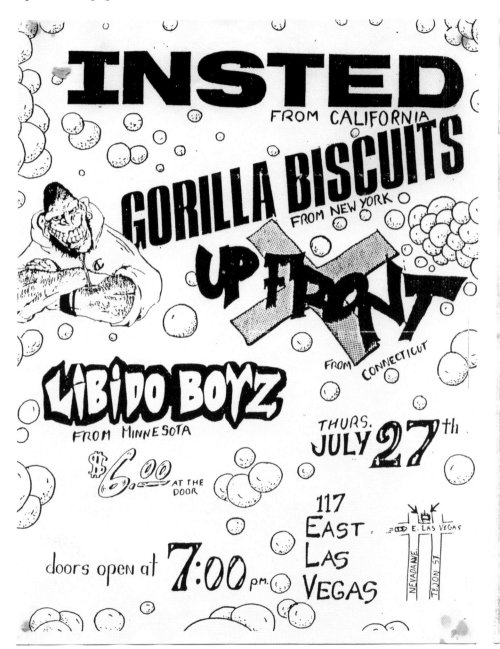

**INSTED**
FROM CALIFORNIA
**GORILLA BISCUITS**
FROM NEW YORK
**UP FRONT**
FROM CONNECTICUT
**LIBIDO BOYZ**
FROM MINNESOTA

$6.00 AT THE DOOR

THURS. JULY 27th

doors open at 7:00 pm.

117 EAST LAS VEGAS

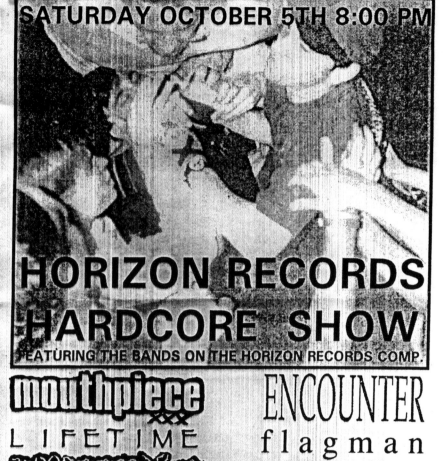

SATURDAY OCTOBER 5TH 8:00 PM

**HORIZON RECORDS HARDCORE SHOW**
FEATURING THE BANDS ON THE HORIZON RECORDS COMP.

mouthpiece xxx     ENCOUNTER
LIFETIME     flagman
resurrection     rancid posie

at the Unisound 400 N. 8th st. Reading, PA.
(215) 372-5827 for info. no drugs, no alcohol, no prejudice
$6 for all this excitement. Be there.

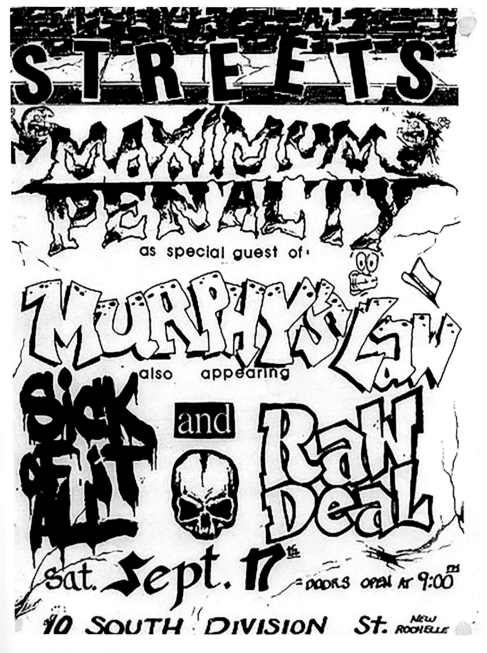

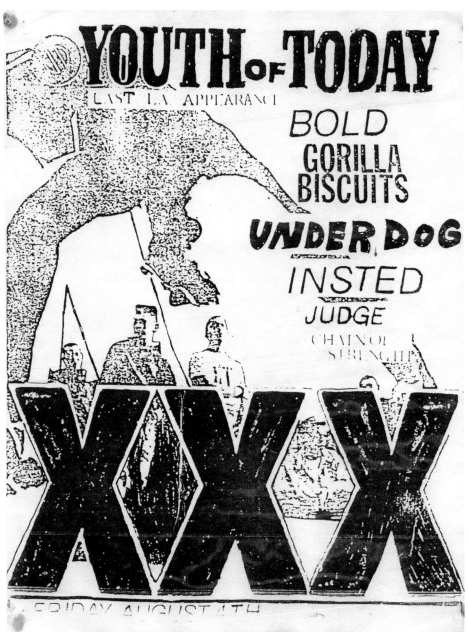

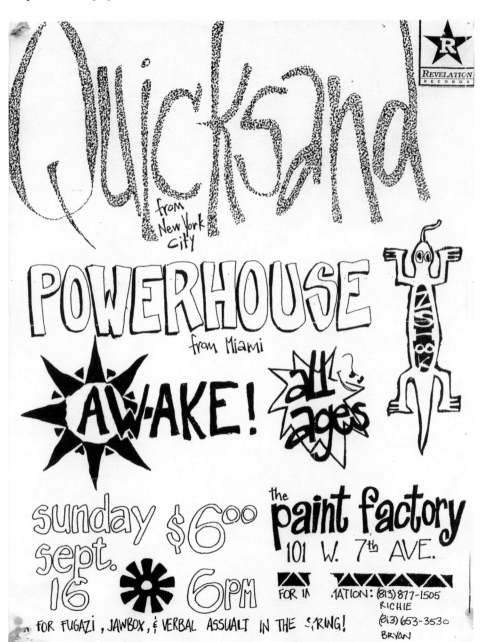

Quicksand
from New York City

POWERHOUSE
from Miami

AWAKE!

all ages

REVELATION RECORDS

sunday $6⁰⁰ sept. 16 6PM

the paint factory
101 W. 7th AVE.

FOR INFORMATION: (813) 877-1505
RICHIE
(813) 653-3530
BRYAN

FOR FUGAZI, JAWBOX, & VERBAL ASSUALT IN THE SPRING!

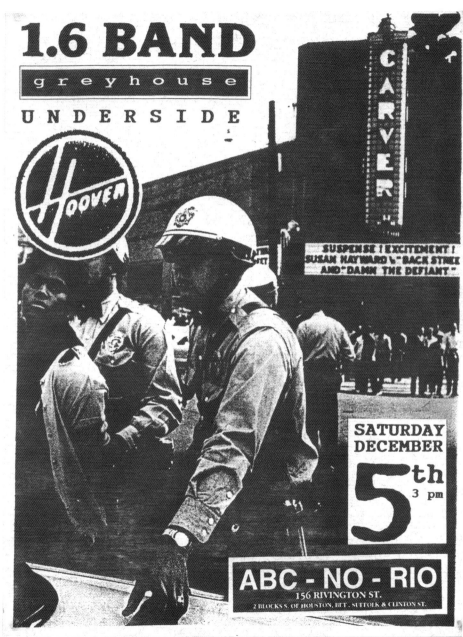

1.6 BAND
greyhouse
UNDERSIDE

Hoover

CARVER

SUSPENSE! EXCITEMENT!
SUSAN HAYWARD in "BACK STREET"
AND "DAMN THE DEFIANT"

SATURDAY DECEMBER 5th 3 pm

ABC - NO - RIO
156 RIVINGTON ST.
2 BLOCKS S. OF HOUSTON, BET. SUFFOLK & CLINTON ST.

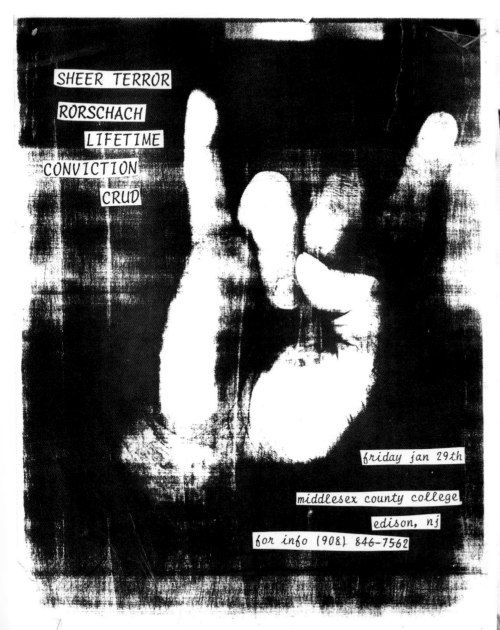

SHEER TERROR
RORSCHACH
LIFETIME
CONVICTION
CRUD

friday jan 29th

middlesex county college
edison, nj

for info (908) 846-7562

FRIDAY, DECEMBER 11. 1992.    6 O'CLOCK.

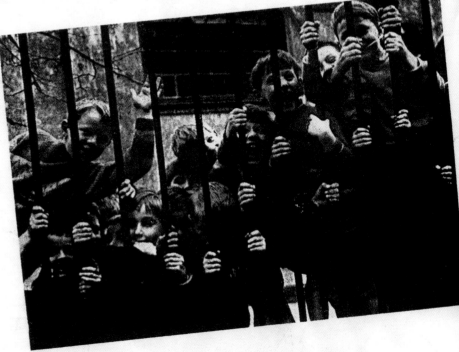

FACE VALUE. 4 WALLS FALLING. RESSURECTION.
MOUTHPIECE. AND MORE.

MIDDLESEX COUNTY COLLEGE. EDISON, NJ.
INFO. 908.846.7562.

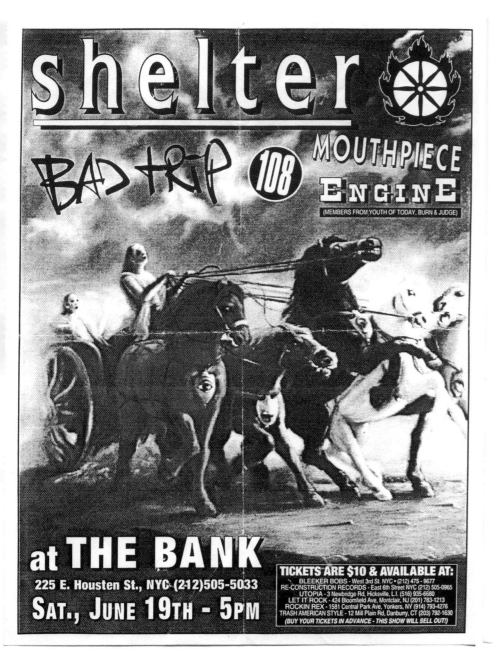

**shelter**

BAD TRIP  108  MOUTHPIECE ENGINE

(MEMBERS FROM YOUTH OF TODAY, BURN & JUDGE)

at THE BANK

225 E. Housten St., NYC (212)505-5033

SAT., JUNE 19TH - 5PM

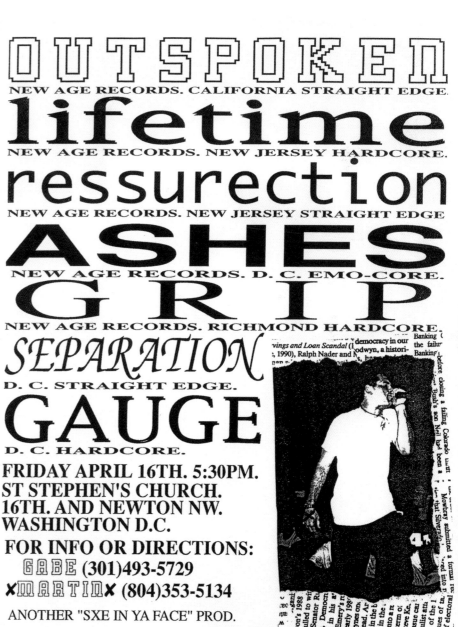

# OUTSPOKEN
NEW AGE RECORDS. CALIFORNIA STRAIGHT EDGE.

## lifetime
NEW AGE RECORDS. NEW JERSEY HARDCORE.

## ressurection
NEW AGE RECORDS. NEW JERSEY STRAIGHT EDGE

## ASHES
NEW AGE RECORDS. D. C. EMO-CORE.

## GRIP
NEW AGE RECORDS. RICHMOND HARDCORE.

## SEPARATION
D. C. STRAIGHT EDGE.

## GAUGE
D. C. HARDCORE.

FRIDAY APRIL 16TH. 5:30PM.
ST STEPHEN'S CHURCH.
16TH. AND NEWTON NW.
WASHINGTON D.C.
FOR INFO OR DIRECTIONS:
GABE (301)493-5729
✖MARTIN✖ (804)353-5134

ANOTHER "SXE IN YA FACE" PROD.

ALL HEADLINERS HIT THE STAGE AT 9PM
SHARP FOR EACH SHOW LISTED

# city gardens

1701 Calhoun St.
Trenton, NJ 08638

609-392-8887
609-695-2482

SAT MARCH 13   7:30PM   $8.50/ADV   $10/DOOR
CELEBRATE ST.PATRICK'S DAY TONIGHT WITH

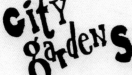

## BLACK 47

AMAZING
THRILL
SHOW

SAT MARCH 20   7:30PM   $12/ADV   $14/DOOR

# ADAM ANT

ZUZU'S PETALS

SUN APRIL 4   6:30PM   $10/ADV   $12/DOOR

# SICK OF IT ALL
# BIO HAZARD

SHEER TERROR        CORNPONE

SUN APRIL 11 7PM   $10/ADV   $12/DOOR
( EASTER SUNDAY )

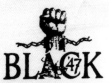

# THE MIGHTY MIGHTY BossTones

---

EVERY THUR & SAT  10PM  95¢ COVER  21 & UP
DJ / VJ CARLOS

EVERY FRIDAY NIGHT  9PM  18 & UP ADMITTED
$1 OVER 21  /  $3 FOR 18 TO 21 er'S
THE "ALL-TERNATIVE"  DANCE
DJ / VJ RANDY NOW
HIP HOP - TECHNO - POST MODERN - INDUSTRIAL

PLUS THE "HARD-HALF-HOUR" AT 1 A.M.
COME OUT & GIVE IT A TRY !

SUN MARCH 14   6:30PM   $7/ADV   $9/DOOR

# INTO ANOTHER
## SUBURBAN HOODZ
### ANOTHER STATE OF MIND

SUN MARCH 21   6:30PM   $6.50/ADV   $8/DOOR
(4 AREA BANDS - SUPPORT THIS SHOW !)

## CONFUSION
## BREAKDOWN
### HARD RESPONSE
### POWERMOVE

SAT APRIL 10   $7/ADV   $9/DOOR   7:30PM

# JAWBOX
## THE SEMI BEINGS

ADV TIX WITH NO SERVICE CHARGE AT CITY GARDENS,
NOW & THEN - NEW HOPE, PAT'S MUSIC - BENSALEM,
RECORD COLLECTER - TRENTON, ROCK DREAMS IV -
PLAINSBORO, & BURNING AIRLINES 2 - HAMILTON SQ.
ADV TIX WITH A SERVICE CHARGE AT ALL TICKET-
MASTER LOCATIONS OR CHARGE (609) 520-8383
coming - digable planets / 808 state & meat
beat manifesto / helmet / testament & green jell
ALL HEADLINERS HIT THE STAGE AT 9PM SHARE

another        other        side        punkcard

---

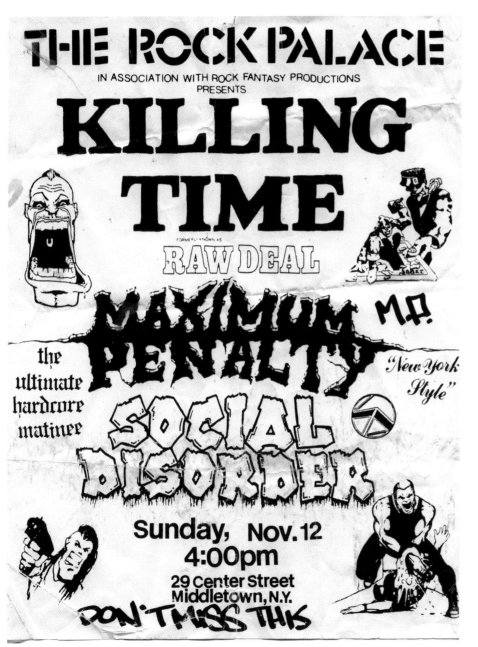

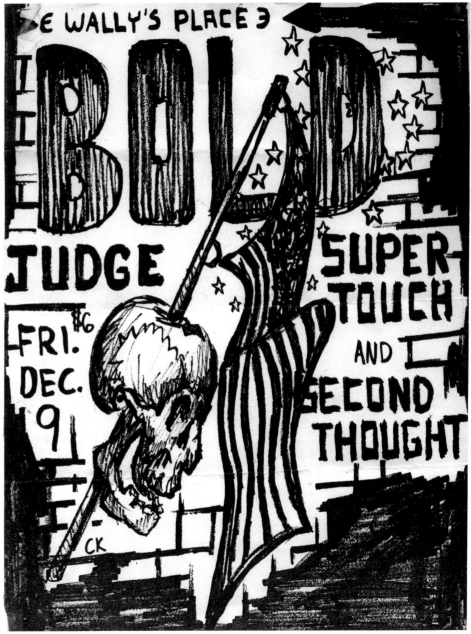

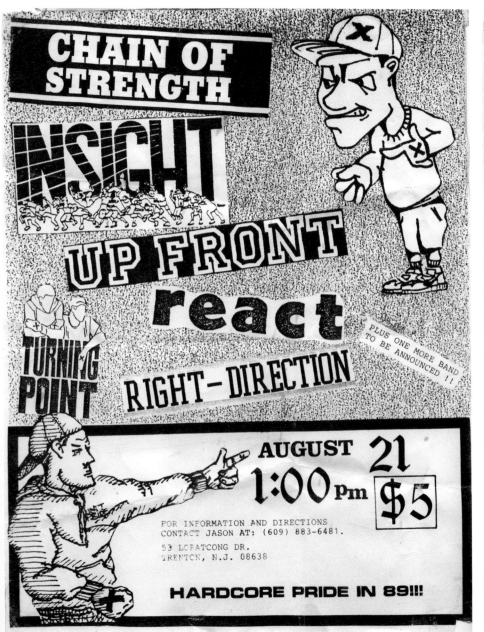

CHAIN OF STRENGTH

INSIGHT

UP FRONT

react

TURNING POINT

RIGHT-DIRECTION

PLUS ONE MORE BAND TO BE ANNOUNCED!!

AUGUST 21

1:00 pm $5

FOR INFORMATION AND DIRECTIONS
CONTACT JASON AT: (609) 883-6481.
53 LOPATCONG DR.
TRENTON, N.J. 08638

HARDCORE PRIDE IN 89!!!

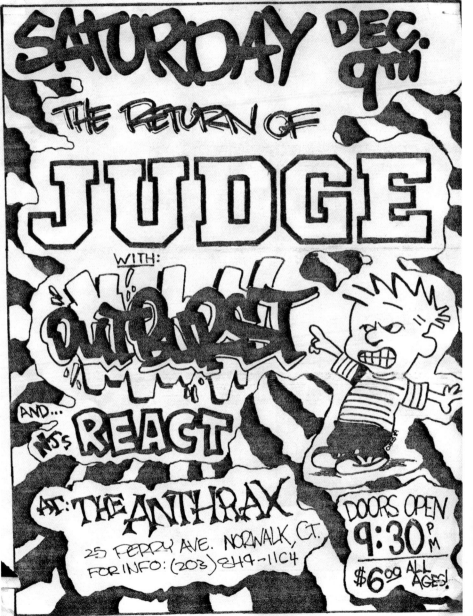

SATURDAY DEC. 9th

THE RETURN OF

JUDGE

WITH:

OUTBURST

AND...

NJ's REACT

AT: THE ANTHRAX
25 FERRY AVE. NORWALK, CT.
FOR INFO: (203) 847-1164

DOORS OPEN 9:30 PM

$6.00 ALL AGES!

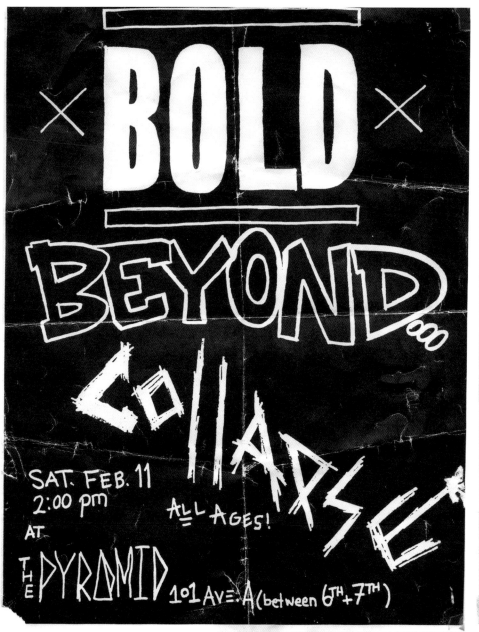

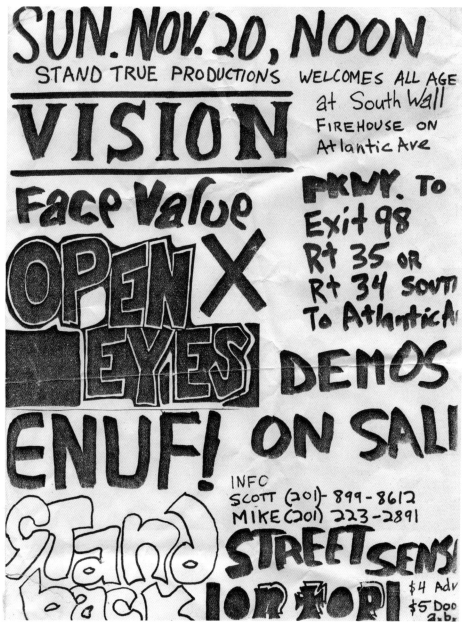

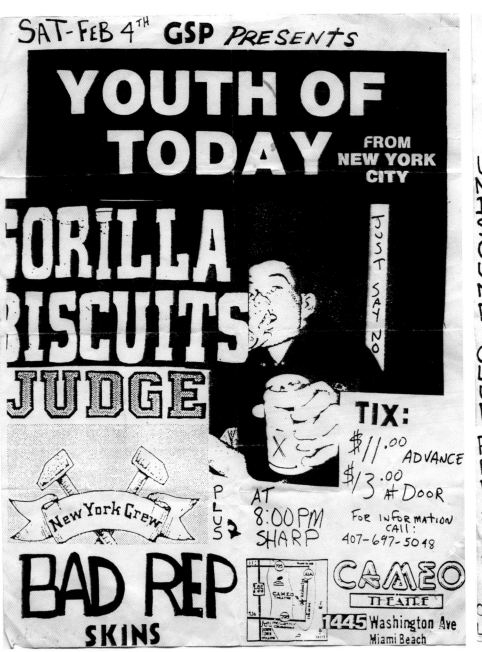

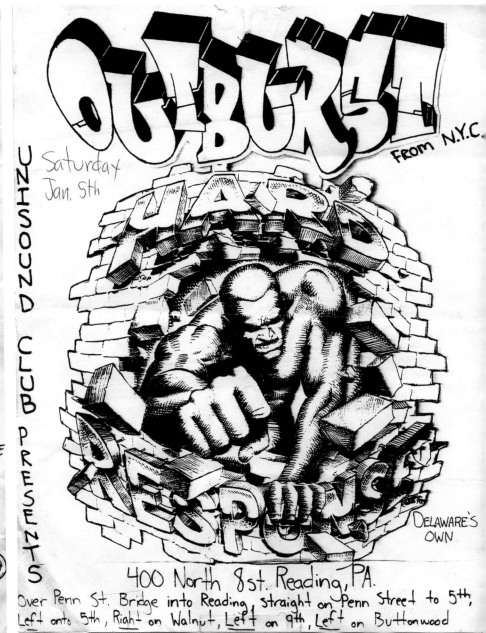

HARDWAY Prod. PRESENTS

**22 s 3 st REVIVAL ALL AGES REVIVAL 22 s 3 st**

SAT. DEC. 29

# RIPPING CORPSE

WITH DOMINANCE & KOHRUPTION $7 4pm

SAT JAN 5

# TOKEN ENTRY

with DIRGE $8 & THRONE OF CORRUPTION 4pm

THUR JAN 10  5pm

# AGNOSTIC FRONT

SICK OF IT ALL & BEYOND CONTROL $10

SAT JAN 12  4 P.M.

# the UNDEAD

& THE FIENDZ IMMACULATE HEARTS $8

---

Clockwise Productions Presents:

# X HARDCORE X
### SHOW

FEATURING:

## UPFRONT

CONVICTION
ENOUGH SAID
MOUTHPIECE
NO FUTURE
LIFETIME
STRUCTURE
DARE TO DEFY
ADMIRAL
GREYHOUSE
EDGEWISE
REDEMPTION
SECRET WRONG

When : March 23
Where: St. Peter's H.S. Gym
Time : 2:30 – ?

For Directions :
CALL
Eric  908-846-5943
or
Ron  908-757-7614

# ONLY $5.00 !

To Benefit the Juvenile Diabetes Foundation

# CLOCKWISE WorldWide Vibrations
productions x

St. Peter's, New Brunswick

e.j.d.

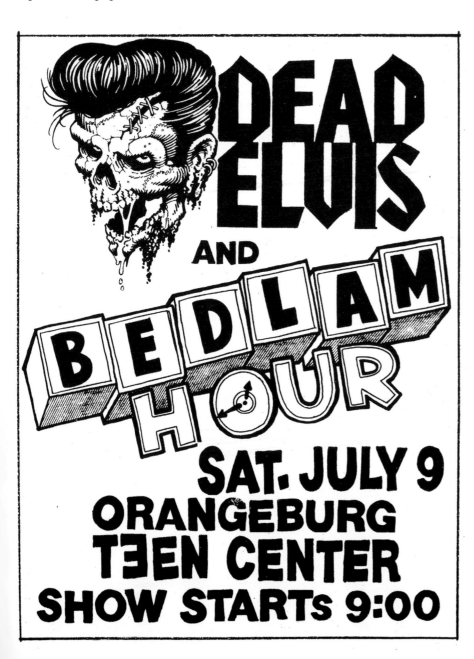

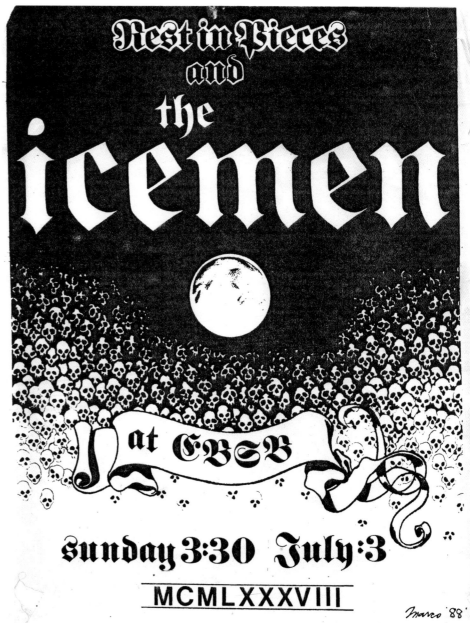

NYU'S AMNESTY CHAPTER PRESENTS AN

# AMNESTY INTERNATIONAL BENEFIT CONCERT

WITH SPEAKERS ALVIN WILSON OF AMNESTY INTERNATIONAL
AND NOMGCOMBO SANGWENI, A FORMER PRISONER OF CONSCIENCE

WITH

# TOKEN ENTRY
# SUPERTOUCH
# HEADS UP
# UPPERCUT
# AMERICAN STANDARD

$5 FEBRUARY 12 7PM 18 AND UP 566 LAGUARDIA PLACE NYU'S LOEI
NYU'S AMNESTY CHAPTER MEETS THURSDAYS AT 7PM IN ROOM 413
ALL WELCOME!!!

# D.C. Scenesters Unity Party
# HOOTENANNY
## August 1st, 1991 at d.c. space

Free Scene Credibility Check by Mike Hampton

Potential Scenarios:

Ian MacKaye tells a joke

Jeff Nelson highland jigs to Eugene Bogan's bagpipe

The Jeff Turner Experience

Amy Pickering channels Billie Holiday

Janis Joplin appears as Jenny Toomey

Cynthia plays harp, Bernie drinks tobbaco

Vicki Lynn James & Ian Spiv get married

Mark Jenkins reads from his collected prose critiques

Steve Niles introduces his new dance company, "Arcane Girls"

Joey and Mark do "Bridge Over Troubled Gardens"

Ted Nicely bake sale

Brent offers you a shot

and so much more...

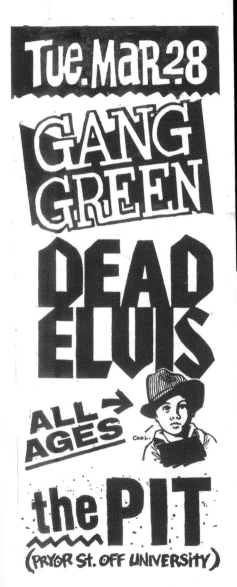

Tue. Mar 28
GANG GREEN
DEAD ELVIS
ALL → AGES
the PIT
(Pryor St. off University)

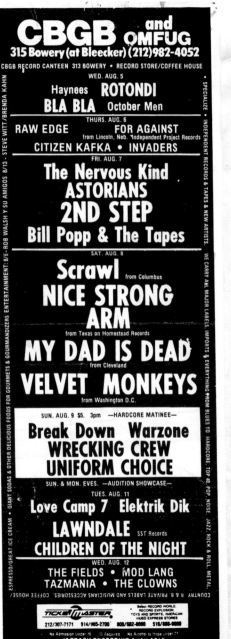

# CBGB and OMFUG
## 315 Bowery (at Bleecker) (212)982-4052
CBGB RECORD CANTEEN 313 BOWERY • RECORD STORE/COFFEE HOUSE

**WED. AUG. 5**

Haynees **ROTONDI**
**BLA BLA**   October Men

**THURS. AUG. 6**

RAW EDGE           **FOR AGAINST**
from Lincoln, Neb. Independent Project Records
CITIZEN KAFKA • INVADERS

**FRI. AUG. 7**

The Nervous Kind
ASTORIANS
2ND STEP
Bill Popp & The Tapes

**SAT. AUG. 8**

Scrawl   from Columbus
NICE STRONG ARM
from Texas on Homestead Records

MY DAD IS DEAD
from Cleveland

VELVET MONKEYS
from Washington D.C.

**SUN. AUG. 9  $5.  3pm  —Hardcore Matinee—**

Break Down  Warzone
WRECKING CREW
UNIFORM CHOICE

**SUN. & MON. EVES.  —AUDITION SHOWCASE—**

**TUES. AUG. 11**

Love Camp 7  Elektrik Dik
LAWNDALE   SST Records
CHILDREN OF THE NIGHT

**WED. AUG. 12**

THE FIELDS • MOD LANG
TAZMANIA • THE CLOWNS

TICKETMASTER
212/307-7171  914/965-2700  800/682-8080  516/888-9000
No Admission Under 16   ID Required   No Alcohol for those under 21
16 TRACK RECORDING AVAILABLE

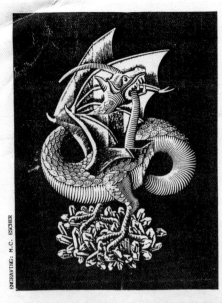

ENGRAVING: M.C. ESCHER

# VERBAL ASSAULT
## JUNGLE DOGS
### SWIZ
**SUN 1.14  7pm**
**ALL AGES  $5**
**LIVING ROOM**
PROVIDENCE, R.I.   INFO: (401)5212520

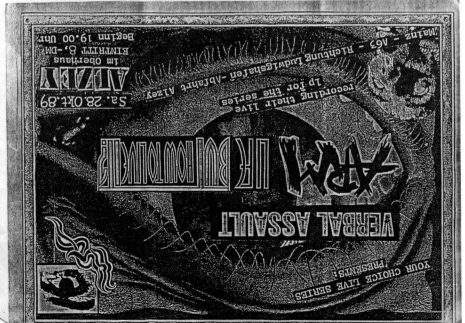

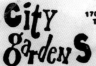

# City gardens

1701 Calhoun St.
Trenton, NJ 08638

609-392-8887
609-695-2482

TICKETS AT

(609) 520-8383
(201) 507-8900
(215) 336-2000

TICKETMASTER

TIX AT NOW & THEN - NEW HOPE
TRENTON RECORD COLLECTOR

**SAT NOV 24   7PM   $8/ADV   $10/DAY OF SHOW**

# AGNOSTIC FRONT
## Sick of it All
### Bouncing Souls

**SUN NOV 25   7PM   $13/ADV   $15/DAY OF SHOW**

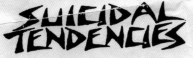
# SUICIDAL TENDENCIES

## LUCY BROWN

# BLITZSPEER

**SUN DEC 2   7PM   $7.50/ADV   $9/DAY OF SHOW**

# SHELTER
# QUICKSAND

**TURNING POINT          REDEMPTION**

**FRI DEC 14   9PM   $14/ADV   $16/DAY OF SHOW**

## SPECIAL
# THE beat
Two-Tone Reunion Tour of America

RANKING ROGER (X-ENGLISH BEAT & GENERAL PUBLIC)
NEVILLE STAPLES, JOHN BRADBURY,
& HORACE PANTER (X-THE SPECIALS)
BOBBY BIRD (X-THE SELECTOR)
SHAWN & FINN (X-THE LOAFERS)

plus special guests:

the Toasters

**SAT DEC 15   7PM   $7/ADV   $8.50/DAY OF SHOW**

## WPRB nite

# The MELVINS
# Helmet
## Surgery

**SUN DEC 16   7PM   $10/ADV   $12/DAY OF SHOW**

# GWAR

## TESCO VEE'S HATE POLICE

**FRI JAN 4 '91   9PM   $7.50/ADV   $9/DAY OF SHOW**

# SOLAR C9RCUS

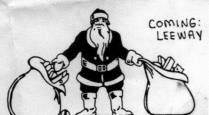

COMING: LEEWAY

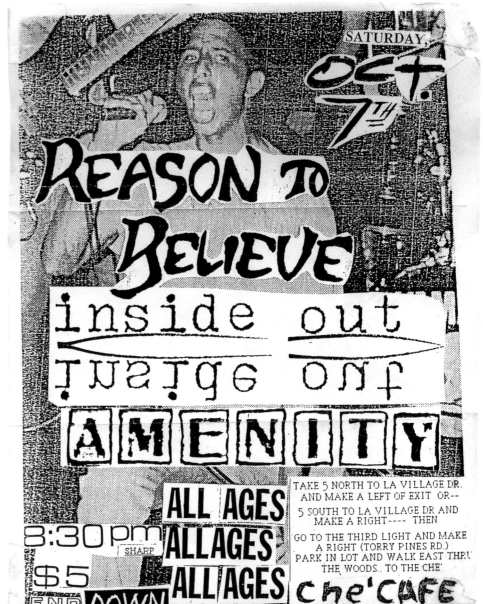

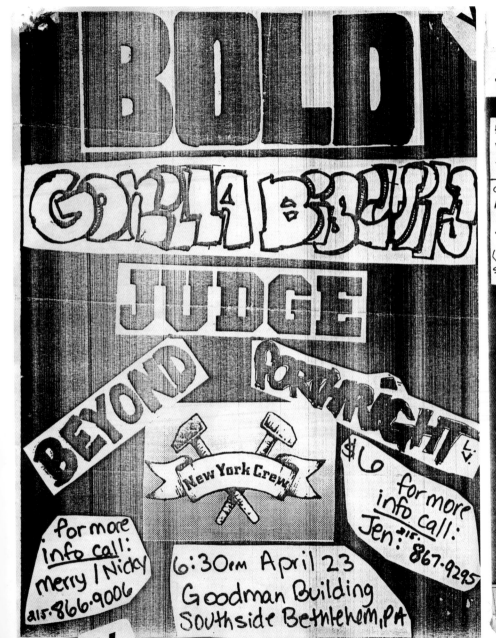

BOLD
GORILLA BISCUITS
JUDGE
BEYOND
FORTHRIGHT L.V.

New York Crew

$6 for more info call: Jen: 867-9295

for more info call: Merry / Nicky 215.866.9006

6:30pm April 23 Goodman Building Southside Bethlehem, PA

SUNDAY, APRIL 9th...
THERE'S A PARTY AT CBGB!

HAWKER IS VIDEOTAPING THE SHOW!!!!

CB'S IS LOCATED AT 315 BOWERY AT BLEECKER STS, NYC...

(212) 982-4052 SO, COME DOWN + JOIN THE FUN!!!!

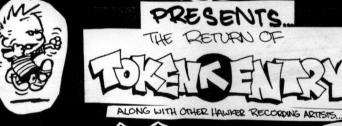

HAWKER RECORDS

3:30 PM BRING $5.00 AND PROOF OF 16...

PRESENTS...
THE RETURN OF
TOKEN ENTRY
ALONG WITH OTHER HAWKER RECORDING ARTISTS...

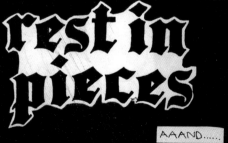

rest in pieces

AAAND......

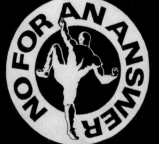

NO FOR AN ANSWER

WRECKING CREW

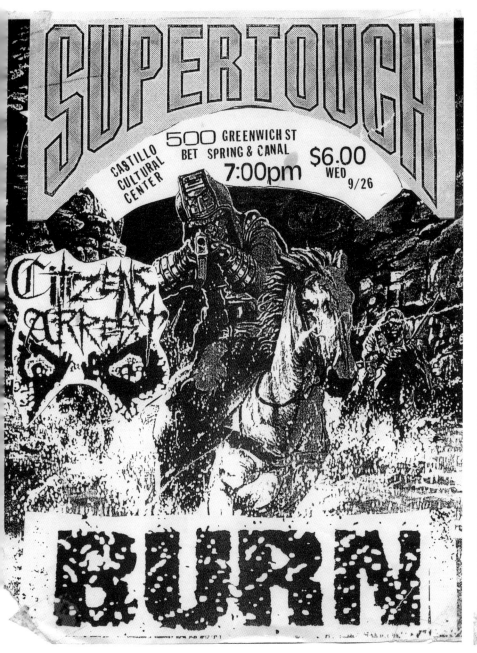

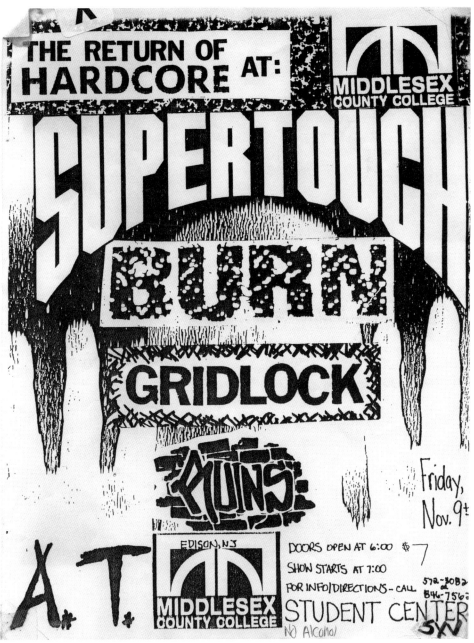

SUNDAY OCT. 22 3:30 P.M.

SUPERTOUCH
bad trip
OUTBURST
UPPERCUT
and
GO!
HARDCORE
MATINEE!

AT:
CBGB $6 BRING PROOF OF 16 YRS
315 BOWERY
AT BLEECKER 3:30 P.M.

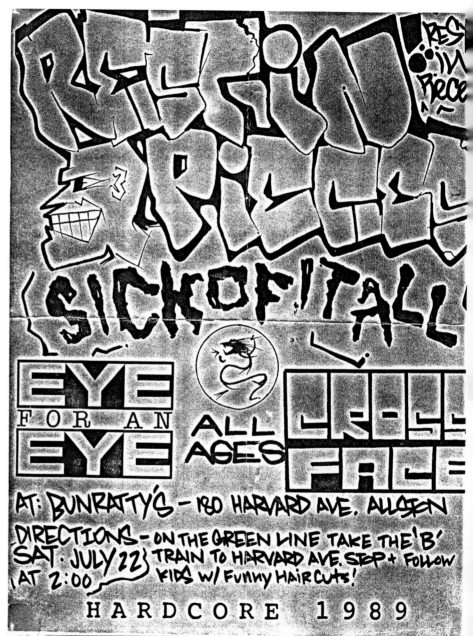

RESTIN PIECES
REST IN PIECE

SICK OF IT ALL

EYE FOR AN EYE
ALL AGES
CROSS FACE

AT: BUNRATTY'S - 180 HARVARD AVE. ALLSTON
DIRECTIONS - ON THE GREEN LINE TAKE THE 'B'
SAT. JULY 22 TRAIN TO HARVARD AVE. STOP + FOLLOW
AT 2:00 KIDS W/ FUNNY HAIRCUTS!

H A R D C O R E   1 9 8 9

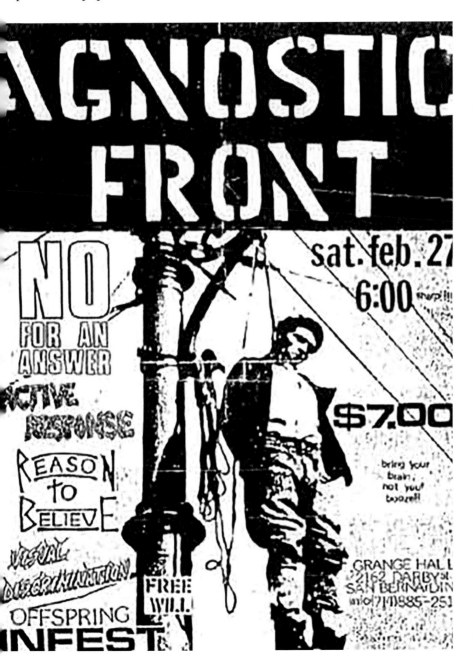

# AGNOSTIC FRONT

## NO FOR AN ANSWER

### ACTIVE RESPONSE

### REASON to BELIEVE

### VISUAL DISCRIMINATION

### OFFSPRING

### INFEST

sat. feb. 27
6:00

$7.00

bring your brain not your booze!

GRANGE HALL
2162 DARBY
SAN BERNARDINO
info (714)885-251

FREE WILL

---

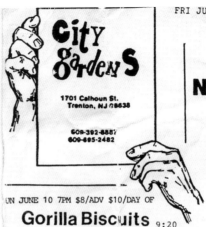

**City Gardens**
1701 Calhoun St.
Trenton, NJ 08638

609-392-8887
609-695-2482

FRI JUNE 8 (21 & UP ONLY!) 9PM $10/ADV $12/DAY OF

# robin trower

## NIX AND THE SIDE KIXX

### Win A FENDER STRATOCASTER GUITAR

STOP IN AT RUSSO'S MUSIC (EXIT 61-A OFF 295 OR EXIT 2 OFF 195) AND FILL OUT AN ENTRY BLANK !

SUN JUNE 10 7PM $8/ADV $10/DAY OF

**Gorilla Biscuits** 9:20

**Sick Of It All** 8:20

**Judge** 7:20

FRI JUNE 15 9PM $8/ADV $10/DAY OF

 **The Toasters**   **Bigger Thomas**

 JUST ADDED : THE HIGH-HATS

SUN JUNE 17 7PM $8/ADV $10/DAY OF

**7 SECONDS** 9:20

7:20 **The Fiendz**   **LUCY BROWN** 8:20

SUN JUNE 24 8:30PM $10/ADV $12/DAY OF

**PSYCHIC TV** 10:30PM

**CELEBRITY SKIN** 9PM

WED JUNE 13 9PM $15/ADV $17/DAY OF

# THE JESUS & MARY CHAIN 11:30PM

**Just A Boy** 10PM

THE J & M CHAIN ON AT 11:30PM SHARP
BRING YOUR SPECTRUM / DEPECHE TIX
STUB & GET IN FOR ADV TIX PRICE

FRI JUNE 22 9PM $6/ADV $8.50 DAY OF

## A FLOCK OF SEAGULLS 11:30

**CHUCKS!** 10:30  **1201** 9:30

FRI JUNE 29 9PM $8/ADV $10/DAY OF

## BAD RELIGION   ALL

## Vision  Shades Apart

THE EXTREMES &
COMING : WED JULY 11 - BEATNIK POP
COMING : SUN JULY 1 - SHELTER / QUICKSAND
FRI JULY 6 - BIM SKALA BIM /
SUN JULY 8 - FLOTSAM & JETSAM / PRONG
FRI JULY 13 - NINE INCH NAILS / M.B. MANIFESTO
SUN JULY 22 - DREAD ZEPPELIN / WEEN

NO DOC MARTEN BOOTS ALLOWED !
ANOTHER OTHER SIDE PUNKCARD
ADV TIX AT NOW & THEN - NEW HO
TRENTON RECORD COLLECTOR
ALL TICKETMASTER LOCATIONS
(609) 520-8383 / (215) 336-2000
(201) 507-8900

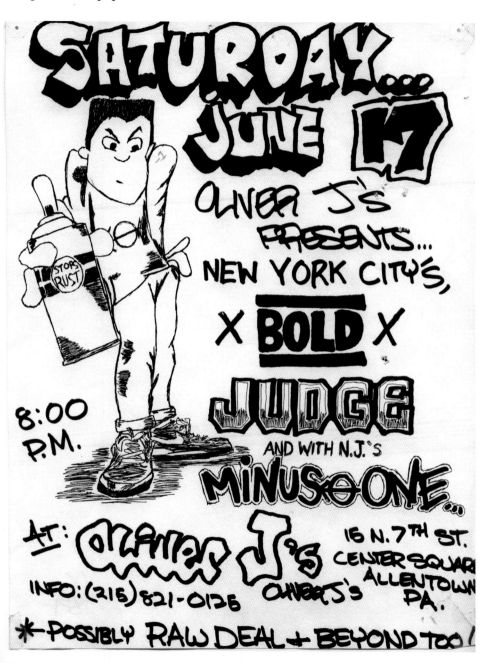

SATURDAY... JUNE 17
OLIVER J'S PRESENTS...
NEW YORK CITY'S,
X BOLD X
JUDGE
AND WITH N.J.'s
MINUS ONE...
8:00 P.M.
AT: OLIVER J's
15 N. 7TH ST.
CENTER SQUARE
ALLENTOWN PA.
OLIVER J's
INFO: (215) 821-0126
* POSSIBLY RAW DEAL + BEYOND TOO!

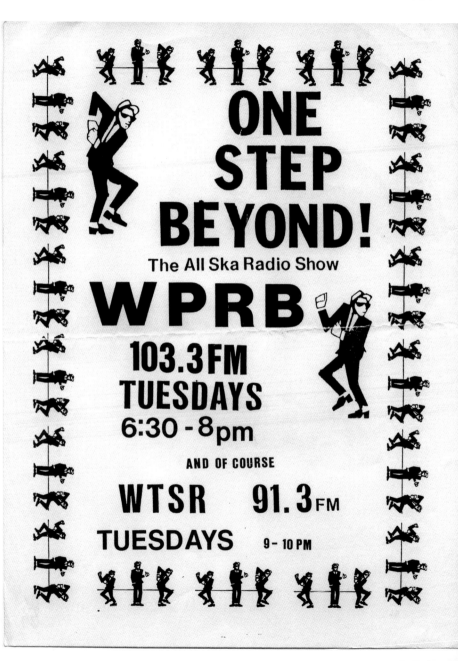

ONE STEP BEYOND!
The All Ska Radio Show
WPRB
103.3 FM
TUESDAYS
6:30 - 8pm
AND OF COURSE
WTSR 91.3 FM
TUESDAYS 9 - 10 PM

CITY gardens

1701 CALHOUN STREET
TRENTON, NJ 08638
HOTLINE:609-392-8887

SUN JULY 1   7pm   $8 adv   $10 door

# WARZONE

# SHELTER

# QUICKSAND

SHELTER FEATURES RAY , JOHN, & SAM FROM TODAY
QUICKSAND FEATURES WALTER FROM GORILLA GISCUITS &
EX-MEMBERS FROM BOLD AND BEYOND

ADV TIX AT NOW & THEN - NEW HOPE
TRENTON RECORD COLLECTOR
ALL TICKETMASTER LOCATIONS OR CALL
609-520-8383/201-507-8900/215-336-2000

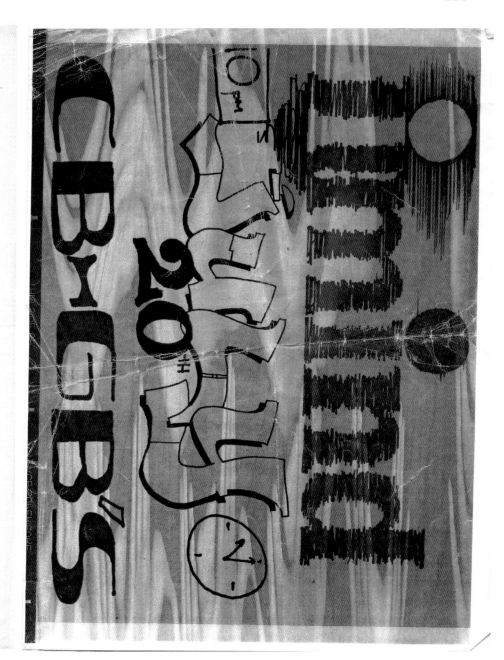

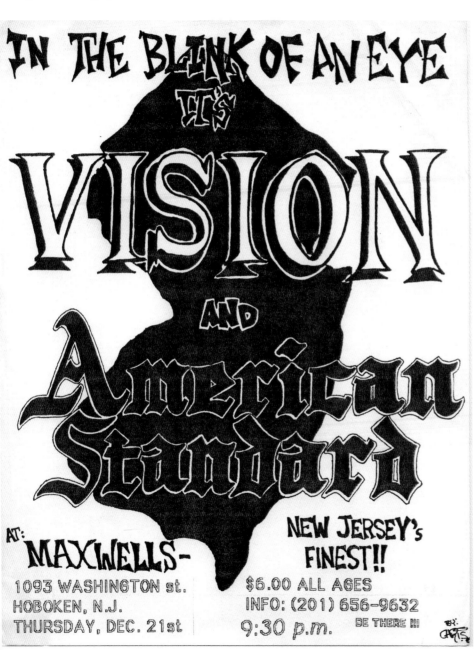

IN THE BLINK OF AN EYE IT'S

VISION
AND
American Standard

AT: MAXWELLS-
1093 WASHINGTON st.
HOBOKEN, N.J.
THURSDAY, DEC. 21st

NEW JERSEY'S FINEST!!
$6.00 ALL AGES
INFO: (201) 656-9632
9:30 p.m.    BE THERE !!!

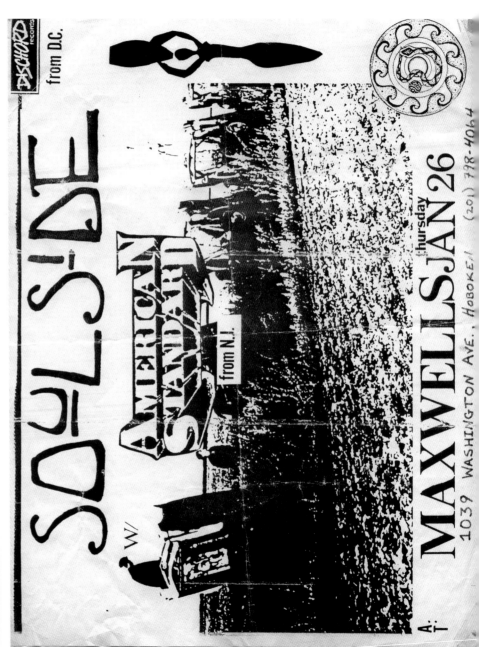

SOULSIDE    from D.C.

W/ AMERICAN STANDARD    from N.J.

MAXWELLS JAN 26    Thursday
1039 WASHINGTON AVE., HOBOKEN    (201) 798-4064

AT:

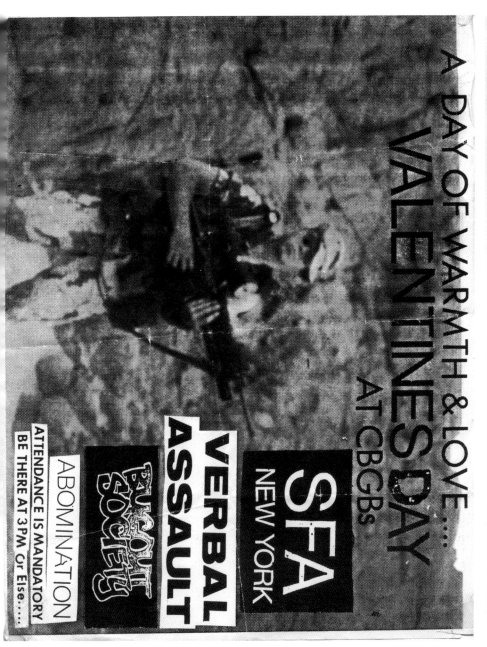

A DAY OF WARMTH & LOVE.....
VALENTINES DAY AT CBGBs

SFA
NEW YORK

VERBAL ASSAULT

BURNT SOCIETY

ABOMINATION

ATTENDANCE IS MANDATORY
BE THERE AT 3PM Or Else.....

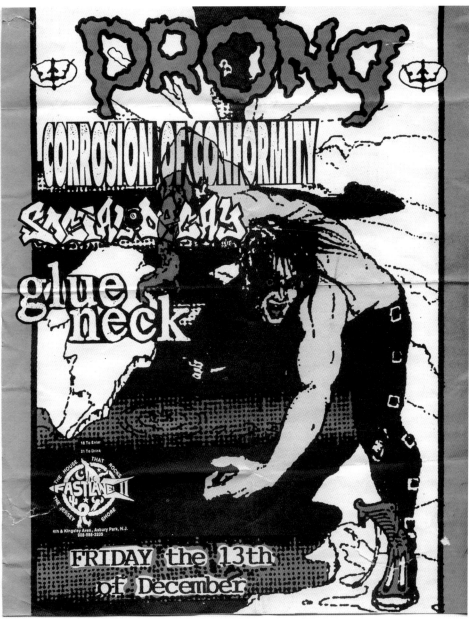

PRONG
CORROSION OF CONFORMITY
SOCIAL DECAY
glue neck

FASTLANE II
THE HOUSE THAT ROCKS
THE JERSEY SHORE
4th & Kingsley Aves, Asbury Park, N.J.
908-988-3205

18 To Enter
21 To Drink

FRIDAY the 13th
of December

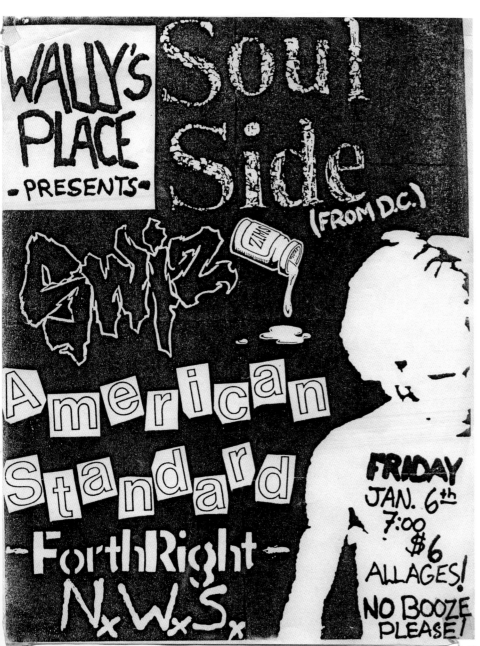

WALLY'S PLACE
-PRESENTS-

Soul Side
(FROM D.C.)

GWiZ

American Standard

ForthRight

NxWxSx

FRIDAY
JAN. 6th
7:00
$6
ALL AGES!

NO BOOZE
PLEASE!

WHERE 6 OUT OF 7 LOLLAPALOOZA ACTS HAVE PERFORMED

WHERE? AT

City gardens

1701 Calhoun St.
Trenton, NJ 08638

609-392-8887

EVERY THUR. & SAT. IS
THE 95¢ DANCE PARTY
95¢ ADMISSION

ADV TIX AT NOW & THEN - NEW HOPE
TRENTON RECORD COLLECTOR
ALL TICKETMASTER LOCATIONS OR CALL
609-520-8383/201-507-8900/215-336-2000

FRI AUG 30 9PM $10/ADV $12/DAY OF SHOW

XYMOX
stranger to stranger

FRI SEPT 6 9PM $16/ADV $17/DAY OF SHOW
SHOWTIME - 11PM
AN EVENING WITH

FRONT 242

SUN SEPT 8 6:30PM $8.50/ADV $10/DAY OF SHOW
8TH ANNUAL "BACK-IN-SCHOOL-SUX" PARTY

7 SECONDS
QUICKSAND
LOOSE

FRI SEPT 13 9PM $12/ADV $14/DAY OF SHOW
THE SPECIALS AND THE ENGLISH BEAT RETURN AS ...

SPECIAL
THE bEAT
Two-Tone Reunion Tour of America

RANKING ROGER (X-ENGLISH BEAT & GENERAL PUBLIC)
NEVILLE STAPLES, JOHN BRADBURY,
& HORACE PANTER (X-THE SPECIALS)

BIGGER THOMAS

MONDAY SEPT 16 7-10:30PM $8/ADV $10/DAY OF SHOW
NEW DATE / NEW TIME / LOWER PRICE

MUDHONEY
SUPERCHUNK
Gas Huffer

FRI SEPT 20 9PM $8.50/ADV $10/DAY OF SHOW
LOLLAPALOOZA JR.

Alice DONUT

LUNACHICKS

mentors

with THE fiendz

SUN SEPT 22 6:30PM $10/ADV $12/DAY OF SHOW

MORBID ANGEL
Entombed
Unleashed

CONFIRMED : FRI SEPT 27 9PM $7.50/ADV $9/DOOR - NIRVANA / DAS DAMEN /
SUN SEPT 29 6:30PM $8.50/ADV $10/DOOR - MIND FUNK / MUCKY PUP / TYPE-O NEGATIVE

SAT OCT 5 - 7PM→10:30PM →  "POP GOES THE WEASEL"

X SMORGASBORD X

AND

Flash n' Trash

PRESENTS

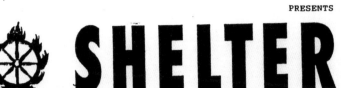
SHELTER
EDGEWISE

FROM PHILADELPHIA

EX-RELEASE
AND
EX-COURAGE
FROM NEW JERSEY

JOURNEYMEN

CONVICTION

FROM HERSHEY

DECEMBER 16, 1990

SUNDAY MATINEE       $8.00

2:00 SHARP!

($8.00 FOR THE FIRST SHOW ONLY, ALL OTHERS, IF SWIZZLES PERMITS
WILL BE LESS. SCOUTS HONOR!)

SWIZZLES

DIRECTIONS ON BACK

IF YOU HAVE ANY QUESTIONS CALL: (717) 845-8811

615 East Market Street
York, PA

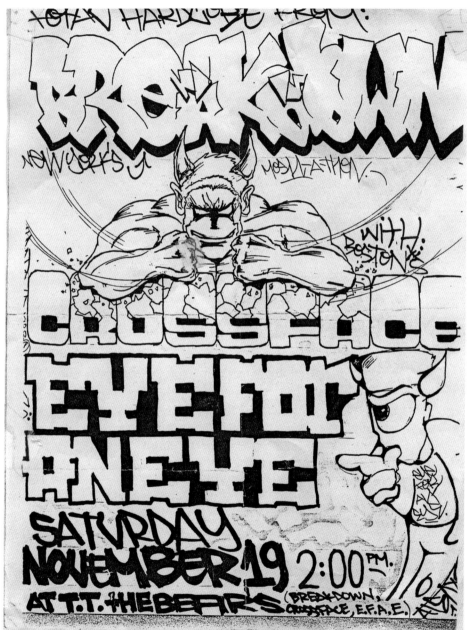

Total Hardcore Presents:
BREAKDOWN
New York's
with
Boston's
CROSSFACE
EYE FOR
AN EYE
SATURDAY
NOVEMBER 19  2:00 PM.
AT T.T. THE BEAR'S  (BREAKDOWN, CROSSFACE, E.F.A.E.)

THE OTHER SIDE
PRESENTS:

**City Gardens**

17 & up theater   21-Lounge
1701 Calhoun St.
Trenton, NJ 08638
609-392-8887
609-695-2482

---

**FRI JULY 14**
**9pm**
**$5**

the Toasters

**PANIC!**

**$5**

---

**SUN JULY 16   7:30PM   NO ALCOHOL   ALL TIX ONLY $7**

**ALL**   **The FIENDZ**                                      **$7**

---

**FRI JULY 21.**
**9pm**
**$5**

BAD MANNERS SKA

**BIM**
**SKALA**
**BIM**

6 FEET UNDER
LAUREL
AITKEN

**$5**

---

**$5**
**ADV**   **FRI JULY 28   9PM**
**KILLING JOKE**   SCROOGE

**$7 door**
**(very fair!)**

---

**SUN JULY 30   7:30PM   NO ALCOHOL   $7/ADV   $8.50/DOOR**

**24-7 SPYS   VISION   RAW DEAL   SHADES APART   SLAMMIN' WATUSIS**

V I S I O N   R E C O R D   R E L E A S E   P A R T Y

---

**$5**   **FRI AUG 4**
**THE**   **$5   9pm**
**CITIZENS**   **$5**

---

**SUN AUG 6   7:30PM   NO ALCOHOL   $10/ADV   $12/DOOR**

**BAD BRAINS         LEEWAY**

COMING UP IN AUGUST:   SUN AUG 13 - T O K E N     E N T R Y
SUN AUG 20 - M U R P H Y ' S   L A W
SUN AUG 27 - S O C I A L     D I S T O R T I O N
POSSIBILITIES IN CLUDE TOOTS & THE MAYTALS AND YELLOWMAN (LATE AUGUST)

---

DOWNSTAIRS IN THE SCHINE STUDENT CENTER

**THE UNDERGROUND**

**VISION**

IN THE BLINK OF AN EYE

**Sun.**
**Oct.**
**21st**

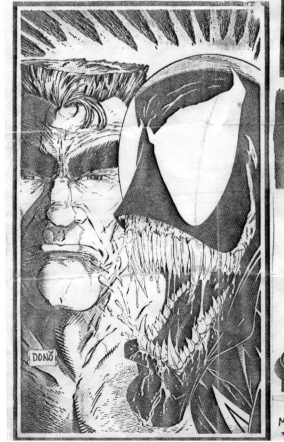

DONO

**SUPERTOUCH**

**WITHIN**

**LUNGFISH**

SHOW STARTS **4:00**

**$5.00**

More INFO:
PAT
424-9071

R.I.P
INDY

UNIVERSITY
UNION

MUCHO THANKS
TO CHRISSY!!!!   x2 YOUR STUDENT FEE
GOING BERZERK

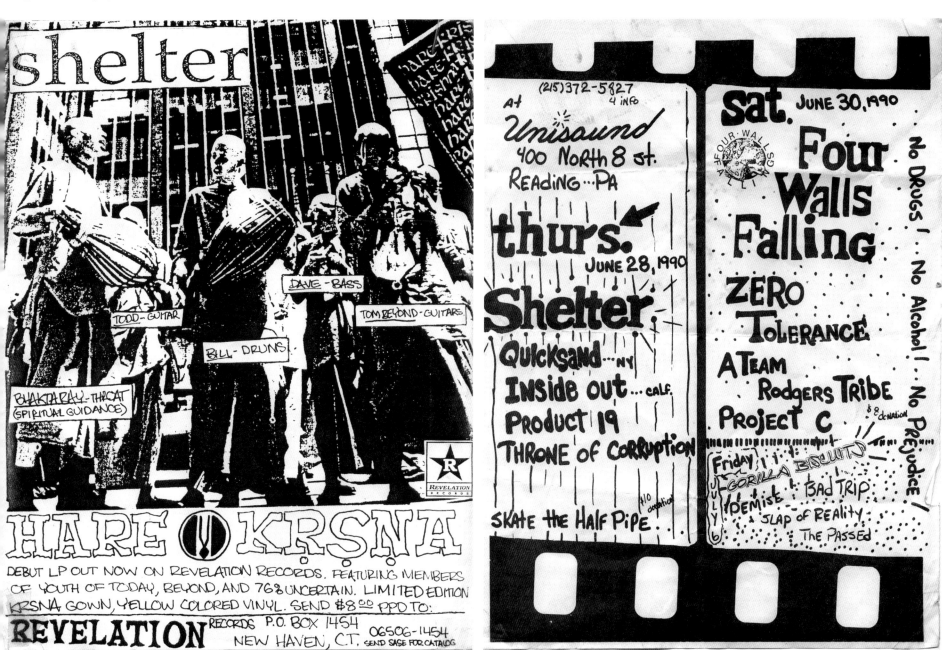

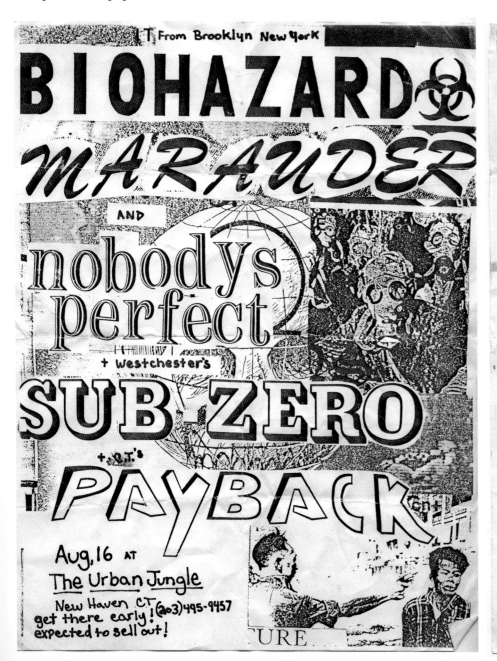

From Brooklyn New York

# BIOHAZARD

## MARAUDER

AND

## nobodys perfect

+ Westchester's

## SUB ZERO

+ C.T.'s

## PAYBACK

Aug. 16 at
The Urban Jungle
New Haven CT (203) 495-9457
get there early!
expected to sell out!

THE CABARET PRESENTS
SATURDAY AUG. 31

# LEEWAY

# QUICKSAND

WITH SPECIAL GUESTS:

# MERAUDER

the Cabaret is located at
2937 86th St. BKLYN
(one block from McDonald Ave.)
265-1147

$1 off with pass or flyer

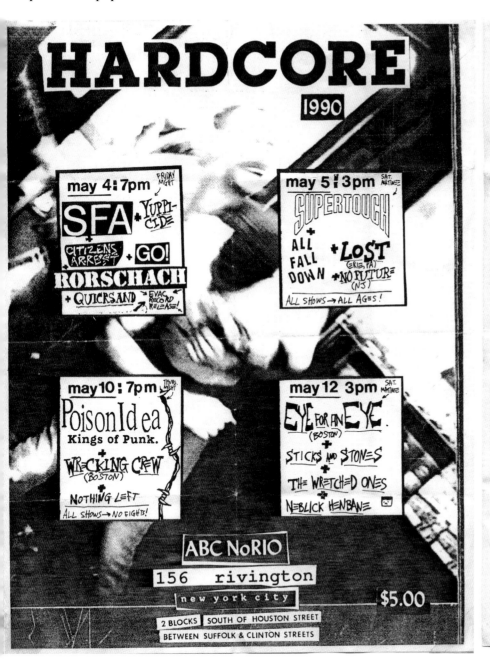

**HARDCORE** 1990

may 4: 7pm FRIDAY NIGHT
SFA + YUPPI-CIDE
CITIZENS ARREST + GO!
RORSCHACH
+ QUICKSAND EVAC RECORD RELEASE!

may 5: 3pm SAT. MATINEE
SUPERTOUCH
+ ALL FALL DOWN + LOST (ERIE, PA)
+ NO FUTURE (NJ)
ALL SHOWS → ALL AGES!

may 10: 7pm THURS. NIGHT
Poison Idea Kings of Punk.
+ WRECKING CREW (BOSTON)
+ NOTHING LEFT
ALL SHOWS → NO FIGHTS!

may 12 3pm SAT. MATINEE
EYE FOR AN EYE (BOSTON)
+ STICKS AND STONES
+ THE WRETCHED ONES
+ NEBLICK HENBANE

ABC NoRIO
156 rivington
new york city
$5.00
2 BLOCKS SOUTH OF HOUSTON STREET
BETWEEN SUFFOLK & CLINTON STREETS

American Standard
American Standard
American Standard
American Standard

October 24
With
Down By Law
&
7 League Boots
Maxwell's
9:00 pm
$5.

American Standard
American Standard

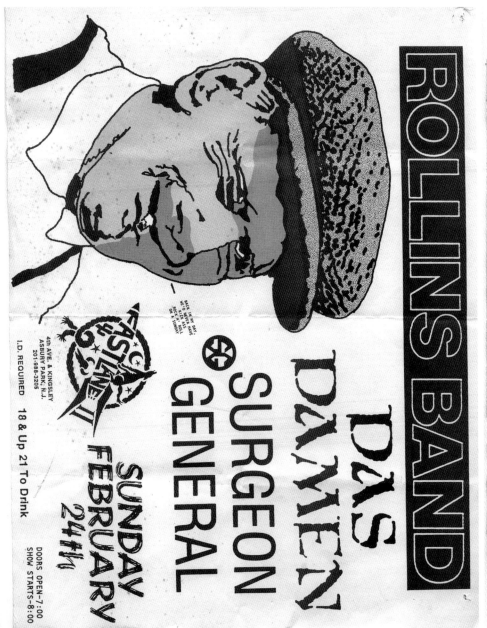

ROLLINS BAND

DAS DAMEN

SURGEON GENERAL

SUNDAY FEBRUARY 24th

4th AVE. & KINGSLEY
ASBURY PARK, N.J.
201-988-3205

I.D. REQUIRED    18 & Up 21 To Drink

DOORS OPEN-7:00
SHOW STARTS-8:00

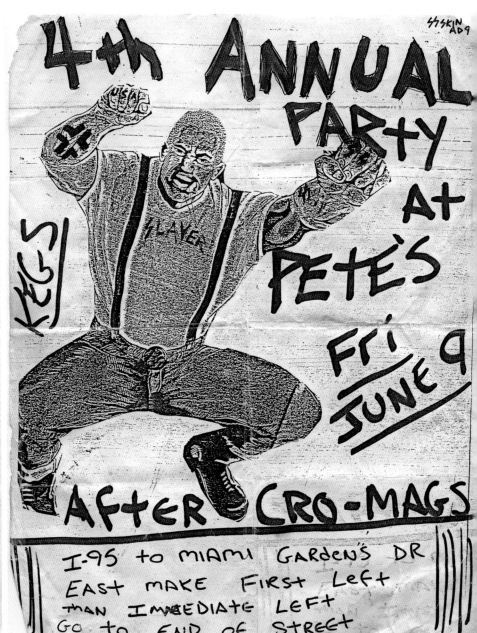

4th ANNUAL PARTY AT PETE'S

KEGS

SLAYER

Fri JUNE 9

AFTER CRO-MAGS

I-95 to MIAMI GARDEN'S DR
EAST MAKE FIRST LEFT
THAN IMMEDIATE LEFT
GO TO END OF STREET

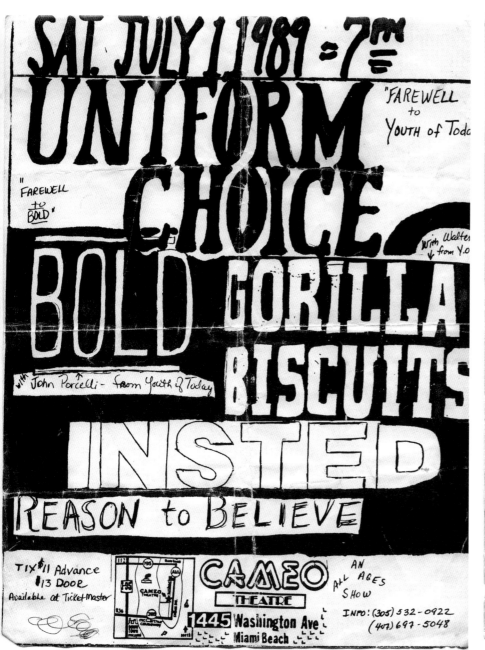

SAT JULY 1 1989 = 7ᴾᴹ

UNIFORM CHOICE

"FAREWELL to YOUTH of Today

"FAREWELL to BOLD"

With Walter from Y.O.

BOLD GORILLA BISCUITS

with John Porcelli - from Youth of Today

INSTED

REASON to BELIEVE

TIX $11 Advance $13 Door Available at Ticketmaster

CAMEO THEATRE

AN ALL AGES SHOW

INFO: (305) 532-0922 (407) 697-5048

1445 Washington Ave Miami Beach

MIDDLESEX COUNTY COLLEGE

Concert Committee

PRESENTS

Tuesday SEPT. 15 8 P.M.

ADOLESCENTS

GUEST BANDS:

There's a youth culture rising in front of your eyes,

S H E C HARDCORE 1987

YOUTH OF TODAY

AND

VISION!!

$5.00

Middlesex County College, College Center

Woodbridge Avenue & Mill Road, Edison, New Jersey 08817 (201)548-6000 X327

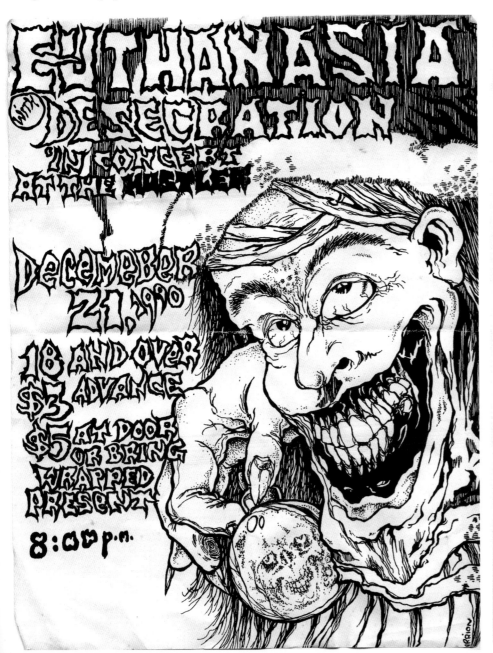

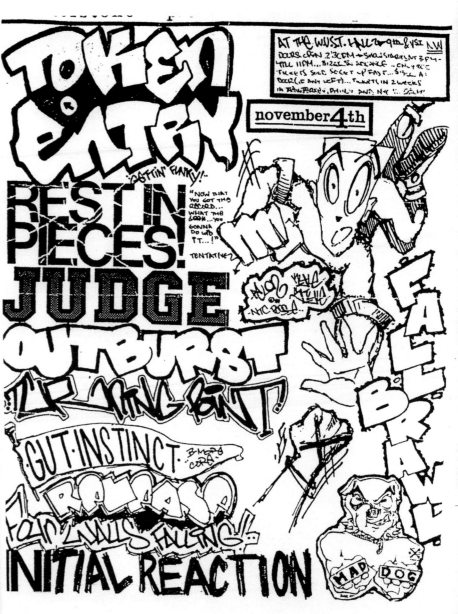

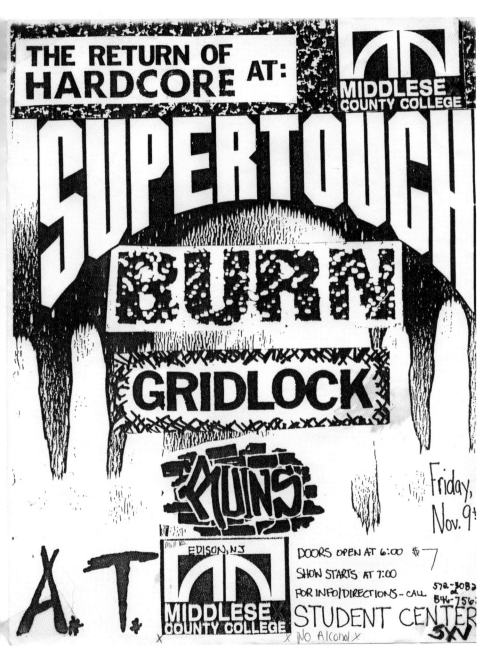

THE RETURN OF HARDCORE AT:

MIDDLESEX COUNTY COLLEGE

SUPERTOUCH
BURN
GRIDLOCK
GUNS
A.T.

Friday, Nov. 9

DOORS OPEN AT 6:00 $7
SHOW STARTS AT 7:00
FOR INFO/DIRECTIONS - CALL 572-3082 846-756

EDISON, NJ
MIDDLESEX COUNTY COLLEGE
STUDENT CENTER
No Alcohol

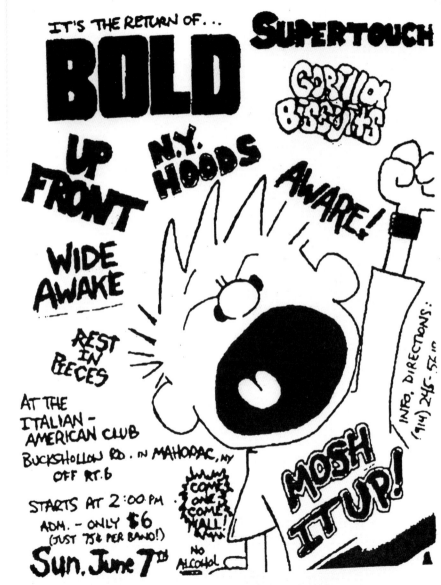

IT'S THE RETURN OF...
BOLD
SUPERTOUCH
GORILLA BISCUITS
UP FRONT
N.Y. HOODS
AWARE!
WIDE AWAKE
REST IN PIECES

AT THE ITALIAN-AMERICAN CLUB
BUCKSHOLLOW RD. IN MAHOPAC, NY
OFF RT. 6

STARTS AT 2:00 PM
ADM. - ONLY $6
(JUST 75¢ PER BAND!)
Sun. June 7th

COME ONE COME ALL!

NO ALCOHOL

MOSH IT UP!

INFO. DIRECTIONS: (914) 246-52..

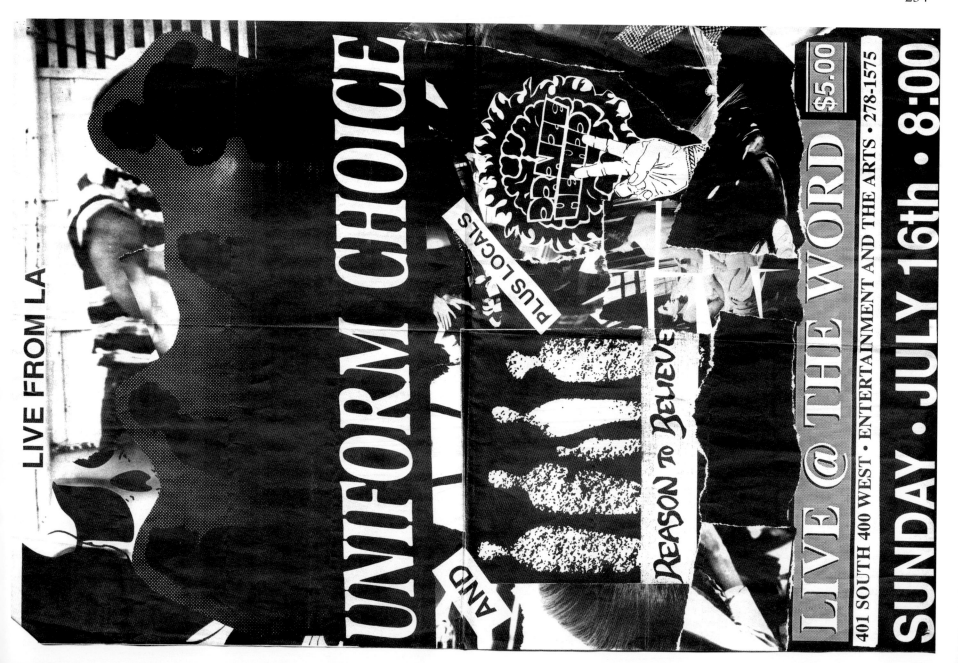

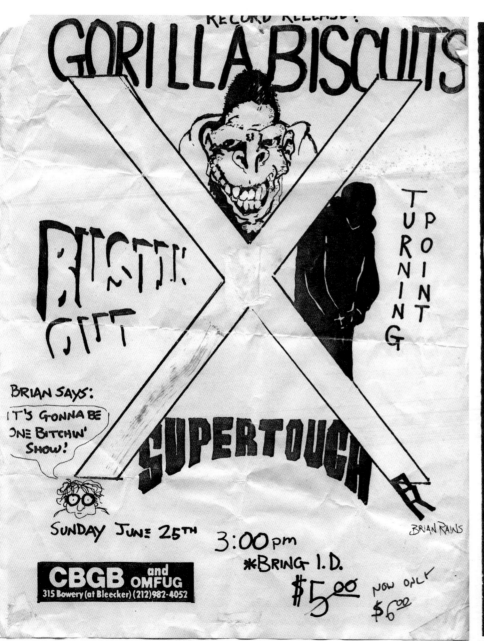

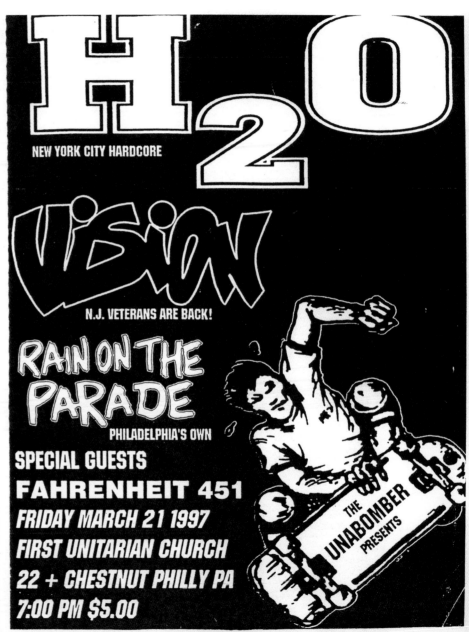

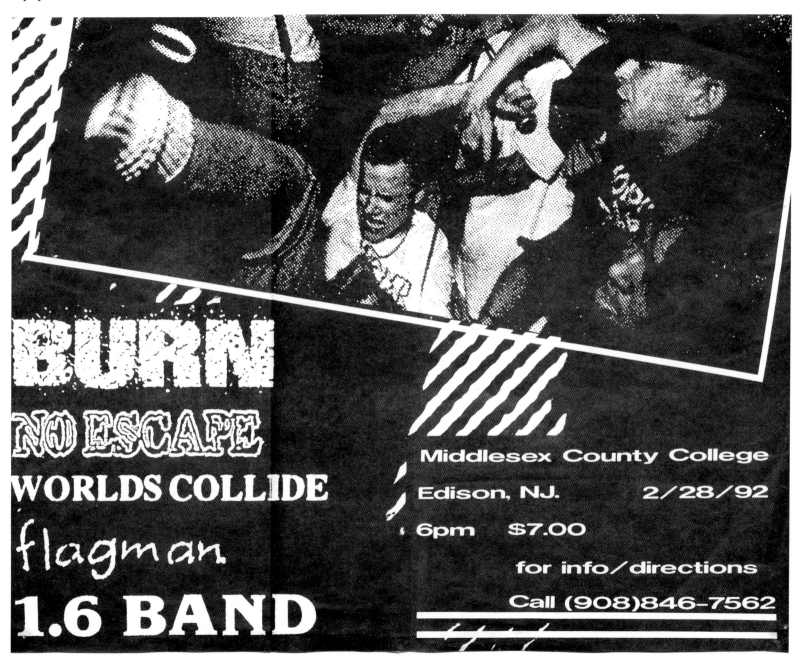

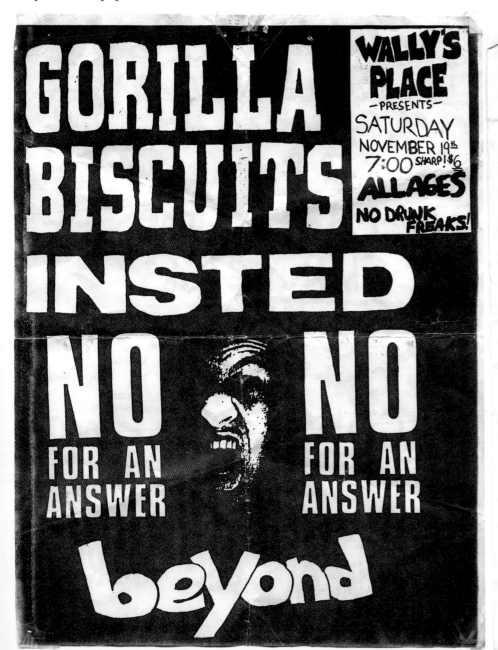

GORILLA BISCUITS
INSTED
NO FOR AN ANSWER NO FOR AN ANSWER
beyond

WALLY'S PLACE
—PRESENTS—
SATURDAY
NOVEMBER 19th
7:00 SHARP! $6
ALL AGES
NO DRUNK FREAKS!

ROREE KREVOLIN & THE MARQUEE PRESENT

AT THE marquee
NEW YORK

# SICK OF IT ALL

LAST N.Y. APPEARANCE BEFORE TOUR

VISION

BURN

EYE FOR AN EYE

MERAUDER

FRIDAY JUNE 21st. 8:00 pm. All TICKETS $9.00
TICKETS AVAILABLE AT: TICKETMASTER (212) 307 7171
TOWER VIDEO, BLEECKER BOB'S, HMV, AND AT
THE MARQUEE -- NIGHT OF THE SHOW

MARQUEE HOTLINE (212) 459 - 4442

# The Jerusalem Fund

## A Positive Force Benefit for Palestine

**VERBAL ASSAULT**

**HIGH BACK CHAIRS**

**QUILL &**

**Special Guests**

Saturday, July 13
8:00 p.m.   $5

All Souls Church
15th & Harvard, N.W.

For information call (703) 276-9768

*The Jerusalem Fund is a relief organization for Palestinians in the Occupied Territories*

Printed on Recycled Paper

VERBAL ASSAULT
c/o Christopher Jones

Newport, RI 02840  USA

18 August 1991

Folks,

This newsletter is to let you know that Verbal Assault is no longer--sad, but true. Our last show was played on August 4 of this year at the Blue Pelican in Newport.

As I've explained before, there are a number of different reasons for the band's amicable end at this time. School and other parts of our lives have made it difficult to keep the band a full-time project, which was necessary in order to keep moving ahead creatively. Though the shows that we played and the new songs that we wrote were solid and progressive, it still seemed that, in the end, it was better just to end it right now on a good note, rather than let VA drag on forever and become stale.

As I've mentioned, during the month of July, the band returned to Inner Ear Studio in Washington to record three songs for our final release, Exit. We plan to put this out tentatively as a ten-inch EP on Groove records in North America, and on Konkurrel in Europe. The three songs will also appear on the upcoming CD releases of the VA discography; the Groove (i.e. North American) version will contain all of the studio material since Trial, and the Konk/European release will include that LP as well.

As far as future projects go, Pete has relocated to Olympia, WA, to start school and a new project with Dug (recently of Fidelity Jones). Doug and Dylan are jamming with local groups in the area, but with no definite plans as of yet. I have no plans to be in another band. I'm going to school, fucking around, and seeing what happens. Perhaps I'll write.

And if you feel like writing, that's cool too, but **PLEASE** enclose a self-addressed, stamped envelope, because I'm going to have to answer the mail without any band money, so no SASE, no reply.

That's about it. Again, we just want to give our final thanks to everyone--and you are far to numerous to mention at this late date--for all of the love and assistance that has been given to us in so many places all across the world. As much as we worked to make VA possible, it would have never happened the way it did if it weren't for you.

Most of all, thank you to everyone that came to our shows, listened to our music, and communicated. You are the ones who really made it happen.

Peace,

CHRISTOPHER JONES

Christopher Jones

Published by Zylonol.

Layout and design by Lee Loughridge w/ Angelo Pournaras
Contributors- Lee Loughridge, Art Ottimo,
Danny Sternaimolo, Joe Rosso, Kevin Rej
Dave Schwartzman and Greg "Fish" Pontner R.I.P
Photos- Laura Pleasants
Contact- leeloughridge@gmail.com